Eratica 1

Summer 2001

waterloo press

Eratica 1

Edited by Simon Jenner

Editorial Address:
Waterloo Press (Hove), 51 Waterloo Street,
Hove, East Sussex, BN3 1AN

Typesetting by Tristan Green Design
Printed by Antony Rowe Ltd, Chippenham, Wiltshire

ISBN 1-902-731-12-3

Acknowledgements

Particular thanks to Dr Sarah Smith for efforts in securing permission from the estate of Drummond Allison and literary executors of Sidney Keyes for permission to include unpublished material. Her generosity and scholarship has helped bring about what merit there is in *Eratica*. Similarly to Nigel Nicholson, for permission to publish Vita Sackville-West's 'Elegy to Sidney Keyes', and Michael Hamburger for his 'Elegy'. To Charlotte and Miranda Seymour-Smith for renewing permission given verbally by the late Martin Seymour-Smith to reprint poems of his. To Mick Imlah for allowing me to expand material originally commissioned for the TLS 'In Brief' column. To Gerald Fiebig for his unstinting support in translating and shaping the initial draft. To all other contributors for their patience and in many cases helpful suggestions. Emphatically to both Andrew Duncan who proof-read and made many valuable suggestions (all errors are my own); and to David Kendall for similar support, and practical suggestions over the initial monster of a periodical, now split in two; and for taking much of the editorial weight off my shoulders at crucial times when sifting fiction. Blanche Donnery and Kay Early made enormous typing contributions at a crucial time - and brought valuable aesthetic judgements. More tangible proof of this will emerge in their own artwork in future editions, as well as Early's short stories. Aesthetically too, Tristan Green has designed this and all other Waterloo publications with unstinting verve, vigour, and generosity of spirit. His work otherwise speaks for itself. I have another personal debt. At a very late stage Kathleen Walne with immense kindness and forebearance agreed to let us replicate some of her paintings, in part derived from her book *Mixed Palette,* tracing the joint career of herself and her late husband Frank Ward. Recognition of her genius as a painter cannot be much longer delayed. Finally, to Sonja Ctvrtecka above all for encouraging and backing the project over so long a period, and through much illness.

Contents

Contributors

Editorial: Up for Grabs

There's something here to annoy everybody. Though the spine of this magazine breaks onto art, and music and short stories all have real representation, the backbone of *Eratica* is poetry, and even more fun, writing about poets as if they were still snapping. Apart from the other art forms, then, the poetry is divided with gall into three parts. One section focuses on a particular country or region's literature. And another on one decade or epoch; these introduce themselves. Naturally, a third slices into contemporary poetry. But this poetry is peculiarly divided, quite apart from representing writing not at all favoured currently.

The trouble is a great British miscegenation: two wholly differing kinds of poetry between the same sheets. It's still there, like splinters of the Revolutionary Communists falling out fifty years ago in time for the Festival of Britain. The saying goes: *On or about May 1979, British poetry changed.* There's some poetry here that doesn't speak to the rest; modernist and (so-called) post-modernist writing in this country have each denied the existence of the other for over 20 years, and only acknowledge each other at funerals. Indeed, certain mainstream publications and even poetry guides treated the Seventies-stuck modernists as if they'd died and were a band of marauding ghosts out of *Omen I* come back from the Anglian wilderness to snatch poetic virgins à la M.R. James from Cambridge Colleges. Call for Harry Potter or medallioned Craig Raine. Cross-fertilisation of either camp is about as rich as weeds in the shade of yew trees; some Gothic and hammer hearers. But no-one likes to talk of Jeremy Reed and the decade that waste-baskets forgot. There are exceptions (Reed at his best), and some poets snatch stray spent magazines from beyond the parapet. A few poets occupy a perilous way-out-in-the-middle ground, like Medbh McGuckian, Ian Duhig, W. N. Herbert and John Goodby. Otherwise, neither learns from the other; a pity. A plagiarism on both your houses.

The modernists have become the moral majority, less visible, with a narrower but more dedicated hard drive. Tim Allen, finding both camps in danger of 'sleeping' writes in this journal of Andrew Duncan's editing *Angel Exhaust* as an act of vigilance on his own people:

> When loyalty to the cause is more important than trying to break down walls then what is the point of being involved in criticism? The rebels who felt secure in their rebellion were confronted in Andrew Duncan by someone who felt unsafe in his rebel status and who wanted to find out exactly why that should be. British poetry is up for grabs, let's go back into history and grab some, while all the time moving, moving sidelong, moving forward? And look what happens when you grab a handful – it's attached

to Europe: the sea falls away to reveal sticky tendrils of sediment.

The mainstream magazines pay millennial lisp service to J.H. Prynne and the Cambridge School, and *Poetry Review* gives them an issue, or a dusty cover - fifteen minutes of shame - as they would to Australia or the USA. This paradoxically arises from one of their most laudable attributes, a focus on one country's or even continent's poetry. Necessarily a soundbite, it at least draws cogent attention to other poetic cultures, as magazines like *ADAM* almost alone did in the more parochial post-war climate. The trouble is needing to apply such criteria to work in your own country. Cambridge, and the not-waving bit of it in London and elsewhere, is another country, from whose bourne no ambitious editor returns. Besides, the free lunch is dead. As for the Cam, it keeps on chuckling along about the Revolutionary Communists - a little acronymic joke in the CCCP: Cambridge Conference of Contemporary Poetry. Like *Parsifal*, it whales around late for Easter. If you've not heard of it, you don't belong. The worst of it is that so many readers don't even know what to do with modernists on the page. Aren't they full of ampersands and weird illustrations like William Blake?

Put at its baldest (and I can't assume the luxury of one kind of readership), recent modernist writing tends both to press linguistic and perceptual innovation, and burn away the biographical notes to engage with the hidden assumptions that created such a sinful feel-good environment; the Cambridge straight-backed exam chair. But it's also wide enough to seat pure avant-garde writing, concentrating on language and language-theory, and far more recognisable forms that incorporate some of this more broadly. In this country, post-modernity as a creative or disruptive force owns little of its original continental rigours; in this context I take it as simply a smartening-up of the reactionary impulses that Larkin made famous in his Three Ps (Parker, Picasso, Pound). Post-modern theory hasn't really entered British poetry *practice* as it has American (except where modernists gather of course, and academics retrospectively deconstruct often harmless texts).

This isn't the place to define any special site of modernism, or what makes up its poetry. The following pages do some of that. But it is true that if you made some modernist the butt of parodic in-jokes, the kind featuring benignly in (yet again) *Poetry Review*, it would fall flat. One, because the parody would flop on the uncomprehending; two because the joker might not be up to the job; and three because of the first two: why shoot a decomposing target? And there's the Ern Malley test: if it's not read, it won't make a good hoax.

If you think that's excessive, try their latest offering (Winter 2000/1), the sneering parody 'Whinge' by Nigel Ferrier Collins, talented enough to know someone had to do it, and it was worth doing badly; a deeply patronising,

arhythmical, reactionary response to Ginsberg's 'Howl', nearly 50 years late and more old-fashioned, despite the sassy 'ligged' (his term) language. The editor must approve. Proving all the prejudices just mentioned, it's an insultingly confused attack on his 'generation', not Ginsberg's, conflating dole-fed 'poseurs' in squats and New Age rants with 'pretentious' modernists, by someone inside the establishment ethos - enough to feel both secure, and so potentially charitable in all senses. So hippie poets into 'Celtic fringelands' and UFOs make 'random outbursts of aischrolgia and gratuitous use of/obscure language cross-referencing'? The Celtic Cam? Blood-soaked Royston perimeter? Tarot at King's: London and Cambridge. Why mention it? Because its automatic conflations show a wrist-jerk on the whole of the 1960s not in Penguin. With a 50s poem. There was - to use a New Age term - at least a homeopathic pinch of Blake in Ginsberg; the rhythms are real. 'Whinge' might be amusing if it wasn't silly and a dangerous fermata to thought. Like saying the 1940s were Dylan Thomas and the Apocalypse (see below), not Keith Douglas, Drummond Allison, and the Audenesque Larkin. It's London calling and preening itself. It proved time really stopped in 1955 when 'Howl' appeared - in time for the Movement and Robert Conquest's *New Lines*. Parody can be blisteringly funny and instructive. But 'Whinge' only scatter-guns easy targets for mild guffaws at 'my generation fastened in the tit of Nanny State'. Dole-less poets? Where is he? 1955? Whinge over.

The Rudeness of Health

Such a vulgar introduction demands dull codicils. But there are duller positions. British mainstream poetry in its pseudo-cocky, deeply cowed 'I'm-too-clever-to-take-risks' phase has died down a little. Huddersfield has returned to being the centre of what it has been since 1978: contemporary music, not contemporary poetry (for the Music Festival every year, see below). Scottish poetry (and its magazines like *Gairfish* and *Verse*) was till recently the liveliest, because it re-mixed all isms with Lallans and flared up wonderfully. The fickleness of the phoenix, as Duncan said of that Jersey hot potato, Jeremy Reed... Elegant variations of what is mainstream poetry exist to confound the kind of general anathemas some L-A-N-G-U-A-G-E Poets pronounce on it; but not wholly. Elliptical narratives, middle-European fables ('oh please let me purse myself into Samizdat suffering, it's so crepuscular'), the rich off-mulch of Paul Muldoon and (far more engaging) Irish writing, all fed the British poetry scene around 1990. The next decade consolidated it, pin-striping hair and suits, pluming its exemplars (Don Paterson, who deserved better than embalming in the T.S. Eliot prize and whispered writing-off) and patronising, finally damning those who looked pretentious because they couldn't be understood at the all-important read-through, like Ian Duhig. Poetry to go through on the nod-off. Such main-line mystification as occurred was often little to do with complexity,

just something left out. The well-crafted verse, freighted with nifty adjectives and neat feet that twist at the end, isn't exactly a terminal case. The modernists tend to think it is, and in the following pages some will tell you eloquently why.

The one thing to squash is charges of elitism in poetry, made against anything than looks difficult after a second glance. If this means chasing one chain of words over another to the exclusion of prose order, poetry is an elitist act. Excellence is confused with exclusion, because it might take more attentive effort than reading it on TV allows. The trouble is, history is elitist. It gets very exclusive and tends to weed out the non-elitist avowedly popular writer, or the pretentiously solemn one. Take the Victorians Bayly & Bailey. Thomas Haynes Bayly (1797-1839) was a once hugely popular lyric poet, recited everywhere for years after his death, and because badness dates has been wholly forgotten. The Nottingham-born Philip James Bailey (1816-1902) wrote the vastly-read British Faustus, *Festus,* a book-length poetic drama published and constantly revised from 1839 to 1893. It was hailed in Britain, and even more in America, as a masterpiece for more than sixty years. Its title should give some clue to its faint flashiness (Clough's attempt, *Dipsychus,* was so much more courageous that his wife suppressed it). More cogent but less memorable than Beddoes, though linguistically striking, its sentimental rhetoric has dated too, though preferable by far to Bayly. Only elite scholars read it now. How will smart street cred date, or cool detached intimacy? There's more than an act of faith, catching the tone of an age, and not getting caught by it.

But there is a distinct resemblance between the 1950s and now. And with the removal of much of the superb critical and theory-laden muscle to the margins, one can see why. In 1979, British poetry really did change. Most simply put, the delta of British poetry that had so widened in the 1960s and 1970s, so there was no one movement any more, dried up, or rather there was a dam built by the Martians and their satellites. When Eric Mottram - *Poetry Review* editor 1972-77 - led out modernists from the Poetry Society snubbed by new formalist reps, both groups pronounced anathema. The one was deemed irrelevant government-fed pap, and the other an irrelevant backwater, namely the Cam, spawning nasty L-A-N-G-U-A-G-E Poetry. So quiet flowed the dons.

The gentility principle that Al Alvarez so inveighed against in 1962, introducing the Penguin *New Poetry,* has triumphed. And in a way gentility never sneeringly intended. Because ever since Mottram's walk-out with his *petite bande,* the avant-garde lost something too: A certain garrulity, naive generosity of impulse, warmth. Biography. Narcissism. The personal pronoun, except when off-duty, like positivists only reading Sartre in the Long Vac.

Modernist poetry owns in fact a far wider range than the conventional arena. The politics-marbled lucidity of Andrew Duncan (see below), or dream-haunted

clarity of Denise Riley (in 'Stair Spirit', *Angel Exhaust 8*) contrast light-seconds away from someone like John Wilkinson, whose procedures are wholly different. Fellow poets might interview him, but some confess - after a glass, or in their sleep - to not understanding him at all.

The rudeness of health is over-population. In one sense there's been no better time for poetry than now, as the Poetry Society, or its end-of-phone staff (Sophie or Hannah) will tell you. The dissemination of really good practical criticism, workshops, and opportunity is in one sense unequalled and welcoming. Running two of these for the past six years I would say that. But at another level it's a curious commentary on pacification, a kind of flattening out. Over the past 20 years poetry has seemingly boomed. But in fact the outlets are fewer, and the kind of poets published and work encouraged, narrower still. There really are set books for wannabe poets to read. This became codified with the amiable future Pet Laureate.

New Herods

Andrew Motion was the youngest poet at 30 included in his own co-edited *Penguin Book of Contemporary British Poetry* in 1982. This contrasted dramatically with the youngest, Spike Hawkins, 22 in Edward Lucie-Smith's 1970 survey, ignored by the later team, when hearking back to the great Al in 1962 as the last mission statement. Sure, Hawkins now goes round the old converts with an interesting looking suitcase, but he was one of a batch of typically young poets with the usual hit-or-miss quotient resulting in scooping the Rupert Brookes, or Droop-it Looks of 1968. But that's what anthologies of new poetry do, take risks, not parade establishment poets, poetasters, and cronies, all of mature age and solidly recommended. When the other co-editor Blake Morrison said 'we're looking for new poets' you knew it was Affable Herod time and made for the M1. Morrison himself, after the 1986 revision of the book (following Alvarez's 1966 revision of his book to a tee-time) when two contributors said they wanted no more part of the circus, was noticeably softer-grained, and admitted the whole enterprise was dated. Certainly there's been little to equal a contemporary anthology made up of older poets than the two editors, and speaks for itself.

The editors have now grown up and turned benign. But their book has never been superseded in the mainstream; despite some rather watery attempts, even the decent hacking anthologies at Bloodaxe. 20 years on, the anthology isn't *really* dated, except in not representing the grandchildren, and what some have learned from Medbh McGuckian, but not surpassed; the commercially-driven 'New Generation' promotion of 20 poets from 1994 was swiftly lucrative and thus a forgotten non-event in poetry. Only Carol Ann Duffy, Michael Hofmann,

Jo Shapcott, W.N. Herbert, and possibly Robert Crawford - before and after his baleful success years - all coming up just after the anthology, can be said to have permanently added something to its dream of itself (Duhig too dangerous; Goodby dodgy; Sean O'Brien and Don Paterson continue to fascinate and frustrate). That is, really altering the poetic bloodstream by a homeopathic amount, rather than what many younger poets manage: just writing individ-ually good poems like Lavinia Greenlaw or Kate Clanchy (hardly a bad fate), or someone like Jackie Wills who might well develop startlingly. Re-invokers of Auden like Simon Armitage and Glyn Maxwell took his balladic élan but little of his exciting early confusion (his truest modernist impulse), GOMs before the facts. Maxwell no longer plays the MacNeice role and is now taken the more seriously (a speeded-up re-run of the MacNeice revival?)

Poets do what they can. But the commercial pressure to pull off something reassuringly significant has long invaded from the fictional world, with its beefy literary prizes. Hence one reason for 80s narratives, and the more compressed gestures of the 90s. It's the subtle pressure to deliver (not create and test under pressure) a successful language, a significant statement. If Craig Raine's moving to Penguin for (allegedly) nomination for the Booker for *History: the Home Movie* was the reductio ad nauseam for many, then who put the pressures there? Well, Raine perhaps for a start as Faber editor, with one new poet a decade, but not wholly. Now the vomit has returned to its own dog, and protégés have bitten him back. Hofmann has joined in, with his special line in attacking fathers, and spat off his ex-mentor Raine in the bitterest turn of its kind. But both fathers - his own German novelist one, whom he might end by translating - and Raine - at least proved resilient. Hofmann *fils* has tragically almost dried up. One wonders what impulses led him to savage the now ignored Raine, beyond the perennial literary bitching. Do some 80s poets feel obscurely used, however they rationalise their disdain in aesthetics, by the glitz Raine brought in the late 70s? That's mischievous; but one easily forgets the praise Raine garnered, and what he promised. He deserved better than himself as well as Hofmann, but forgot that magic formulas are meant to be applied; an object lesson in what happens when you ignore history outside the home movie: real linguistic innovation, not displaying one frozen in its own breath. And Muldoon door-stopped himself and others with the book-length *Madoc* in 1990.

Such recent book-length poems had it both ways. Ostensibly demurring at the idea of a modernist epic, they might play with contused notions of what these were, underlining their status of rambling, often open-ended sequences; like the *Cantos, Briggflats, The Anathemata, Paterson,* or *The Maximus Poems,* which no-one respectable reads now the foreign recording angel Lyotard finally declared the end of reading-time in the death of the Grand Narrative; the foundational Enlightenment myth of progress. This might parody a reading

position underway for years, but post-modern theory can be recruited for natty intellectual laziness, whilst ironically such recent narratives with smart 'without prejudice' inserts are allowed their stainless coffee tables. So they invented Speculative History. Parallel to superior history romances like Rose Tremaine, this is a winner, especially in Britain where re-casting history and heritage has become something of a national sport since *Our Island Story*. Real people are shot through with post-modern magenta silk, *people like us* who lived in more interesting times; the educated version of Channel 4's *Victorian House,* or *1940s House;* almost painless peep-shows, the art of tickling the past and being bored. Small wonder that poets like Greenlaw et al seem to have side-stepped such pressures, even given the altered chill on big gestures: it didn't deter Raine. It gave us Sophie Hannah's sonnet sequence instead.

Some Language Poets again deny Duffy is a poet at all - narrowing disdain to sclerotic levels, and rather missing her point. And theirs. A century ago, you couldn't admire both Bruckner and Brahms in some circles, just like Bax and Boulez in William Glock's BBC of 1959-72; or the Beatles with the Stones. A few years on, the battle-lines blur like committee ink in Auntie's Archives. The same reader will stack Duncan and Duffy's foxed editions. One might well be exalted. But Duncan trawls Wilfrid Gibson's sea pieces to find a good poem (there are some in *Fuel*), and Duffy probably does the same. To deny significant life outside one's crater is as silly as Eliot's snobbery over Burns, appreciation of whom had disturbing implications for him. It smacks of religion. More than Leavis saying: 'I don't want followers, I want disciples.' In fact if the modernists=puritans is patronisingly obvious, the mainstream C of E is more fun. The polite ignoring by a dying establishment that doesn't believe in poetry any more (though permitted to hope), granting toleration before it expires in a haemorrhage of well-funded indifference. So this is all healthy for the '82 anthology's lifespan, but not for contemporary poetry. As Tim Allen has said in *Terrible Work 8:* 'it's the mainstream replicating itself in its sleep' and only those younger poets who promise to do this are really taken up. Benign self-selection for Herod's tea parties.

Nothing much has been allowed to happen to disturb the mainstream, and nothing much has been allowed to knock the exiles off their perches. Both ossify like a couple of mirror Medusas, spitting headstones at each other. Spike's suitcase might have something to recommend it. Happily, the modernists have at least been well-served in their anthologies. Andrew Crozier and Tim Longville's *A Various Art* (1987) has become a classic, and *Conductors of Chaos,* nine years later, looks set for the same status. This would be a good place to start.

A Climate of Warm Indifference

Those poets on the continent who engage with British poetry are often baffled by this weird split. For most German writers, there can be no comfortable break with a modernist past, because its procedures and histories are so bound up with History, and post-modern theory often invokes historical relativisms that German writing hasn't the luxury of accommodating. One of the magazines edited by two of the Bavarian poets appearing below had as its first issue a cover photo of a row of rail trucks. We all know where this was taken, where the tracks led, and you simply can't be post-modern about that or you end up in a rail carriage with David Irving. For many Germans, these pressures and traumas are raw enough to generate momentum (one might mischievously add that post-modernism could be more easily born in a France of isms because France kept nationally having to re-invent itself as Fourth and Fifth Republic in a space of 13 years, like a series of failed Imperial and post-Imperial narratives; particularly on the war).

British writers, in what Martin Seymour-Smith referred to as 'a climate of warm indifference' to modernism, could ignore it because of our more fortunate history, innate anti-intellectual conservatism, a love of homespun (not real) Edwardiana, itself more interestingly disturbed; National Trust poetry. So long as they're underneath their aitches, or signal in a quaint way that they're not, like the Collins 'Whinge' - someone who chooses not to write as well as he clearly can. This penetrates far deeper than even stylistic gestures, but is often there. Despite all the sassiness, you often feel a Wedgwood blue circular plaque coming on; never what some might term the blue circle cement of concrete poets. That's of course going *too far*. But everything can be as *neo* as picnicking outside the Marabar Caves, hearing vaguely that everything exists and - pass the Darjeeling - not a lot has value beyond the floppy collar or forelock. Modernism is again subliminally confused with the Victorian notion of Progress and where that led. In some work you can hear the small still sigh of relief that neo-Georgianism has returned, that give or take some sassy Northern injections, a Top Shop-grabbing opener, insular possession has triumphed.

That we prefer British post-Shostakovich composers like James Macmillan to one of 'the new complexity' like Brian Ferneyhough, who's fêted naturally in Germany and France, expresses this. Or what happened to painters like Christopher Le Brun, now soused in painting legendary scenes at RA Summer exhibitions. Or the Saatchi generation of British painters, where smart but well-worn concept often replaces any engagement with material. But at least in general music and art have a far healthier relationship with their own cutting tools; and British music, despite the promoters, is healthier than it has been for forty years.

Similarly, many modernists, thus fenced off, damn all literary procedures that evince colloquial artefacts and relaxed self-indulgence; spinning one's web from one's guts and sitting there fifty years till the dust trembles on it. They're not alone. Peter Porter has lamented the culture of 'end-sharpened anecdotes'. Duncan, below, sounds as if he's on a witch-hunt: 'The more poetry rejects the traditional means of literature, the more literary it is... poetry close to conversation and jokes is conservative, narrowly repetitive, and not fit to print.' Rather like those hopeless amateur poets who don't read because they want to be 'wholly original' and thus end up regurgitating nursery rhymes, pop jingles, and school-approved poets. If they were wholly original they'd invent rhyme at ninety and die of the shock. One knows what Duncan means without going all the way. Harold Munro fashioned startling modernist poetry (that still reads as modernist) using just such conversational blocks, as in 'Bitter Sanctuary'. Jokes have their place, and personal and related voicings blow in and out of poems. Duncan means here particularly the mere lifting of personal bric-a-brac and arranging it more or less artfully. What's needed is the art of alienating one's own conversation into discovery. Which takes, among other things, the courage to make a bloody fool of yourself. Millennial UK PLC isn't the place to take bursaried risks. Super-funded celebs develop 'exciting' unrisky projects instead. Like ghosts walking on eggshells.

And...

The rest of the journal is taken up with something wholly different and represents the strategy and shape to be followed. A wodge of art, music criticism, this time all mine I'm afraid, to be remedied in the next issue on the 1960s by others like Nick Burbridge; and to return to narcissism, there's a poem of mine under the umbrella of music criticism, accepted by three magazines before each closed: an exorcism. But the material, Huddersfield Festival-featured giants like Xenakis, or even Carter or Boulez, get little enough attention except in anniversary concerts and CDs. The same applies to the cornucopia of British music, often unknown through chance. And Alan Bush, the banned communist composer, is a special case. All these need a forum.

This time too the Germans and 1940s poetry, a speciality of the editor - lending another example of retrospective historicism. Apart from my fantastically vulgarly entitled 'Dreaming Fires' essay, others give particular attention to individual poets. The focus is on the vital but neglected relationship between the Oxford poets who took on the Auden generation's legacy and developed a poetic internationalism. Politically and linguistically alert to the 1940s, they did something very different to the neo-romantics - represented here by essays on other poets like Burns Singer, whose response was equally fascinating and was

to have unforeseen consequences in the 1960s. This Audenesque line included not only poets who got killed, like Keith Douglas, the extraordinary Drummond Allison and Sidney Keyes. But because they died the obscuring of their relationship to those who survived: like Larkin, Kingsley Amis, David Wright, John Heath-Stubbs, Alan Ross. And those who swiftly followed and were influenced by them like Elizabeth Jennings, Christopher Middleton, Seymour-Smith, Alvarez, Geoffrey Hill and others. The second issue, already completed, contains commentary and work on American literature, and that bickering burning ground, the cusp of the 1960s-70s.

As for the Bavarians, they introduce themselves with Gerald Fiebig (b. 1973), a jokey and wholly serious master of ceremonies. Editor of *Zeitriss*, it was he who coined 'Hove Actually, Brighton Virtually', whilst living in Brunswick Square; and I only regret not having more of his poems to hand. As it is, he introduces Brighton at a Bavarian bar angle; a good way in, and never before 10am.

New Bavarians at the Gates

Gerald Fiebig

New Bavarian Poets: Introduction

The 1998 Brecht centenary could have come a lot sooner - the German government might have thought so anyway, since one of its major problems from 1989 has been how to accommodate the experiences (and growing resistance) of people who grew up in socialist East Germany under the conditions of a reunified capitalist country declaring itself victorious. The approach towards celebrating Brecht's centenary taken in most quarters of the cultural establishment (including the established fringes) offers a good occasion for symbolically anticipating the desired effacement of alternative German histories of the 20th century - e.g. the history of anti-fascist cultural resistance of which Brecht was a major exponent. These, however, are taken to be coterminous with the totalitarian system of 'actually existing socialism' erected in the GDR, a state of whose cultural life the late Brecht was a major exponent as well. Still, nobody would deny - Germany is a liberally-minded country, after all - that he's a classic and therefore worth being celebrated. The logical conclusion is to blow up the image of this genius as much as possible, to blow this icon up to a format so much larger than life that any political content of possibly disturbing contemporary significance gets lost in the process.

Brecht's native town of Augsburg offers a microcosm for this strategy in that it wouldn't recognise its prodigal son till way into the 80s when even the rest of the free world had long conceded him the status quo of classic. Since 1995, however, the authorities have been cashing in on a marketable de-politicised tourist version of Brecht with a folkloric vengeance. Jürgen Jäcklin's short story gives you an impression of events which, in the centenary year, went further along towards that climax he fictionally anticipated.

Contemporary German poetry and its official reception through literary awards etc. has aided this depoliticization-by-proxy by depoliticizing itself. The uncrowned poet laureate of postcoital Germany's status quo, Durs Gruenbein, is a point in case, if simply by choosing to write about the stasis of severed nerve-ends rather than what lies beyond them in the outside world.

While Gruenbein regurgitates the poetics of Brecht's great West German 50s antipode and one-time wehrmacht medic G. Benn, the less established fringe rehearses, under the label of Social Beat, a late German version of the Beat movement which did not quite find German-speaking followers as it existed. The dire necessity to (re)invent a dissenting cultural/literary politics, however, seem to have drawn attention to the Beats' countercultural credentials. These

being of merely historical significance, the result of the would-be revival is mortification rather than anything else: for the most part, Social Beat's artfully unskilled writing about drinking, screwing and writing because there's nothing else to do proudly re-enacts the boredom of life on the dole rather than pointing a way to resistance. In Germany, a whole generation of writers seems to be missing a beat.

The three German poets (from *Zeitriss*) presented in this volume are clearly not representative of either strand, which is why we chose to translate them in the first place. Neither aligned with any faction, facetious or factitious movement nor with the politics of non-commitment, their very different modes of writing do share a keen awareness of the fact that 'all criticism has, first and foremost, to be a criticism of language. Where the deficits of language and artic-ulation/communication have been pointed out, the deficits of reality outside language have been "voiced"', writes Klaus D. Post, senior lecturer in German literature at the University of Augsburg where Martin Droschke, Martin Langanke and Tom Schulz were *visiting writers* in 1997. (Post, Klaus D. : Langanke, Schulz, Droschke und Nikolov. In: UniPress 02/97 [ISSN 0937-6466], pp. 57-63.)

Gerald Fiebig

Heart of Darkness

It seemed to me that the house would collapse before I could escape, that the heavens would fall upon my head. But nothing happened. The heavens do not fall for such a trifle.
Joseph Conrad

upstairs a hoover is choking on words
old letters flooding back have silenced the toilet
someone keeps their diary in the fire-safety record
in a handwriting no one can read
while I fix another teacup with band aid

my blood's coagulated into small change
& sucked out of my head & body
by the payphone in the hall
the radiator's frozen to the wall
if you turn it on it comes running

in the mercurochrome-flavoured streetlight
the shadows of the fire escape look like waste DNA
& every night at three o'clock the alarm bell starts screaming
because the sane man in the basement is frying his eggs
home is where the heart attack is.

sudden death

the sky's the colour of a monochrome personal computer screen
night comes on like an irreparable disk error
help save the screens of europe
black out the moiré of the screams
of the ice hockey fans down in front of the rink
& the friday evening backwash of commuters' cars
that tightens like an iron-knit shirt round my chest
my heart leans on the front wall like your skeletal bike
too tired to rust. lock the door
the weekend's prowling round every corner.

reinforced concrete poetry

for Simon Jenner

there's no inspiration. just outrage
at the way they're jumping other people's trains of thought
that makes me keep my rhymeless feet on the gas
& write to the end of the line
till my voice hits the concrete
poetry of differences eventually bursting out into screams
that turn into songs & hopefully back into screams again
when they tell me I ran a red light

composing poetry over the phone

please hold the lifeline
or I'll drown in the dead din of the channel
that says *this is the mental health line*
quel numéro avez-vous composé? cross the channel
& please hold the live line
that sends electric metaphors through
the static noise of statistical voices

white noise album

your words in my ear in short circuit
always out of synch with my monochrome dreams
the other half of our bodies gone deaf
life after stroke
of luck with your breath on the line
suffocating in static after metrified minutes
this phonecard contains two separate 100 unit tracks
our skins separated into chromed mono tapes
our lips moving mute in the white noise
voice-reduced by dolby stereo to keep all frequencies clear
for capital radio FM

Martin Droschke

b. Augsburg 1972, where he was a co-founder of the literary magazine *Zeitriss* in 1991. He now lives in Fürth, Bavaria as one of the editors of *Laufschrift* magazine. He contributes prose, poetry and criticism to several magazines and newspapers and has so far published two volumes of prose, the first being an electronic 'Bookware' publication for PCs.

Hauptstraßenachse
High Street Axis: Brass Band Truants

The entries in the land register have been all-cleared, so
they say. A cattle-truck's en route to the abattoir on the
Augsburger Straße, just when we've quit -
for the savings bank - waiting for the green light, taking
a beer from the freezer at the Aral filling station;
the railroad construction site back there where you put slugs
between my naked thighs - our town's brass
band is playing at a spring beer fest in another town - while
a schoolboy pushes glossy circulars into numbered mail-
boxes, policed by patrols
of dog-handlers, the commuting traffic
on the Augsburger Straße.

Am Einkaufszentrum
Near the Shopping Centre

My semi-detached neighbour, you marched
towards the roast chicken stand
behind the waste-glass container:
trodden path amidst hazelnut leaves: what's
not yet ripe for autumn,
towards the herbicide-less parking lot;
while I slipped under the skirts of
mannequins the town's brass band over there
gurgled our very own local marching song
into the inn: it's servers
swinging hips in the pews,
the mayor's entry into the beer tent.

Käme ein Zeuge
If a Witness Came Around

I'd stand before him like this - dressing-gown with
a morning stiffy maybe and hangover already
parching my tongue, flat door
in my right hand. Would you really
justify to a stranger with no credentials
your door draughts, bottles of
vodka underneath the roof, missing steps of
your own staircase? Surely I'd

talk at him with a stinking
oral cavity: chapel of rest
for roast chickens from the *Wienerwald* takeaway.
Something like: 'Which they
cut up half price in the evenings and
wrap in foil. The roll though
costs extra.' Consecutively

I'd have to listen, under pressure,
as my bladder's calling. While
his black suit sucks in the light in
the staircase: suddenly
a light switch might flick,
circulars sort
into mailboxes downstairs,
advertising
a DIY superstore, chainsaw occasions,
wooden sticks, cudgels.

DIY superstore with snack bar - have mercy
Lord, keep down
the price of beer:
four marks fifty for a
Mariahilfberger Fastenbier in the
pub; the place next to the entrance-door
I straddled was draughty; responsibility, however,
was not accepted.

Die Fruchtbarkeit des Amerikanischen Südens
The Fertility of the American South
after Hölderlin's Half of Life

for Damien Ecols*, 19, son, Satanist, suspected murderer of three infants, death row

so Arkansas is being counted out by
men
who beat -
till everyone's boxed in, counted out
into professions and registry office. Arkansas's
known by blood
on the towel; by a way of walking
between parked cars

tell me a stranger: harm of life
clattering hard in the wind, and:
wind is whipping sternly across
Arkansas

a boy must
take a test, once
a month a stick dictates exercises
on his bottom:

Why don't any worms bite
the pears in Arkansas? Pears
protect themselves in Arkansas
with a skin that's hard.
Why, in Arkansas, does putrefaction
not befall pears? In Arkansas
pears with skins still have
cores. What kind
of pears grow in Arkansas? Windfall pears
striped
by the continual whipping
of branches. Do pears nod
under branches in the wind of Arkansas?
Do they just nod or do they wriggle?
For how many hours do pears wriggle under
branches in the wind of Arkansas?

* Damien Ecols was sentenced to death in the early 90s for killing three boys in a satanic ritual, but the murder could never be proved and the jury only convicted because he was the one teenager in the region listening to bands like *Metallica* or *Paradise Lost*.

Schottische Abende
Scottish Evenings

It could really happen
that everything's snuffed,
the rabbits' readiness to run
into the road when
a car goes by: speckles
on the asphalt - and the sun
takes off her makeup. Fog will
rise with the night's chill, if
rabbits are to withdraw today, to ponder
where the missing ones are,
exhaling appeasement, till
the cigarettes burn
out: might not a king
of the air...? All of us?
While the mapped land
doubles up
as the rising tide
reaches for its privates;
really:
aborted cast-away islands
near the western flank,
beat-up pieces of coast.

Martin Langanke

b. Augsburg 1972, where he co-founded the cultural journal *stück/werk werk/stück* and co-edited *Zeitriss*. He now lives in Erlangen where he is currently writing a doctoral thesis in philosophy and co-editing the literary magazine *Laufschrift*.

Im Revier
Industrial Landscape

Above the rivulets
the steelworks.
The tanks.

A heavy sky
scuppers itself
into grimy rust.
Day
oozing into sulphuric soil.

How can there be talk
of trees?
Breath-chemistry.

Augsburg: Alter Flugplatz/Universität
Augsburg: Former Airfield/University*

For Gerald

Inside the hollowed-out concrete block
next to the yellow boxes of the lecturing theatres.

Drill-hole windows
open up an outside view.

Where a shallow trickle
sends the ducks piddling
towards the runway.

A sealed-over area: the campus.

Behind it the huge cubic bunker
with the central storage unit.
Storerooms and dead rooms:
Library.

I look out on the taxiway:
My grandfather
sends out the record Me 262 flight. -
Iron face
by the runway.

You've read
of the *Battle of Britain*.

* The University of Augsburg was erected on the site of the former Messerschmidt test airfield.

Wundverschluß/Abend
Closing Wound/Evening

The evening wound
encrusted by night.

The sun's haemorrhage
stilled,

where the ulcer of light
broke open
at the edge of day.

Blackened blood count:
Red that's already hardened
into sky. -
The sky
a crust of night.

Day
heals up.
Prognosis: autumn.

Day
has bled out
its summer.

Lagerwärts
To the Store-room

A coffin
is a drawer in a high-rise shelf.

Basement
as day-free zone.
The storeman
in a slit of artificial light.

Cage-box:
Red beard
behind wire-netting.
And hands
pass through the counter aperture.

Minimum exchange of words,
the kind you push across
a wooden board:

Language
loses itself
towards ground-water level.

A seam of serial numbers:

NO UNAUTHORISED PERSONNEL!

Montage/Wörter
Assembly/Words

Words like *ratchet* or *steam-hammer*.

I'm standing at the workbench:
self-portrait
with electric screw-driver and segments of felt.

A black squad
invades the shop floor:
heads on stiff flannel
looks sharpened into blankness.

Who proceed
when somebody puts on a welding-mask.

And every month
puts another girl
naked into the sands of Hawaii:
the green locker door
with a paradise
between switchbox and fridge.

I'm getting myself a beer.
The electricians
eat from trays.

Later:
Stocking the lunch break
with words like *Queen* and *Trump*.

Man führt dein Aderwerk
They carry your arterial system

through the cable-shaft to the pump station.
You're phased.

Then nerve fibres must be inserted.
Erogenous zones are demarcated.

EMPLOYEES
ARE FORBIDDEN TO MASTURBATE
OVER THE DUMMIES!

Total hosification.

After preliminary assembly: into the shed
where you're fitted with your intercom system:
speaking noises
and the demo words
on the gold-plated soundtrack.

On the right-hand side: the plug for the arts.

You're operational
when your basic software
has been installed:

Provisions, Nuclear Family.

Tom Schulz

b. Saxony 1970, grew up in East Berlin. He now lives in Berlin as one of the founders of a small publishing outfit. His poetry is published in several literary magazines and one collection that appeared in 1997.

Ich bin eine geräuschlose Maschine
I am a soundless machine

maintained with the promise of time.

I wait for one metallic hour -
wait between two phases:
combustion and standstill.
I wait for a change.

Seeing eyes see the time:
it's a severed hand -
bodiless, it sticks up a middle finger.

Hearing the talking clock
and calculating the integer of missing hours.
Knowing anyway one can neither go ahead nor go back.
Forwards and backwards
are cancelled directions.
Unmeridianed - umbilical cords to both cut off.

Working behind glass-proof doors
on the statistics of miscarriages.
Boredly eating tinned bread
with a temporary contract.
Sitting at the quarantine table
inhaling smoke; waiting
till the lung's blackened.

Knowing the future is the diagnosticians' child.

It starts with impaired vision.
What's thought harmless ends up under the knife.
At thirty-eight: sterilised.
At forty-two: complaining over a bad blood count.

In a few years' time lying there for good -
keeping eyes closed
pretending to be dead.

Knowing one's a soundless machine
maintained with the promise of time.
Waiting for one metallic hour -
waiting between two phases:
combustion and standstill -
waiting for a change.

Durch den Brechtbau
Digging through the Brecht Wing

For Klaus D. Post; Augsburg / 07-97

Following the moles
That have disappeared
In the book-counters

The knowledge of flies behind
Windowpanes; don't turn around
Paper-faced spectre

Level-headquarters; at fifteen
I wrote school essays about
Communism's landing on the moon
And crumpled up
My fists in my pockets

Digging through the Brecht Wing
For wisdom teeth and hair-
Line cracks in the structure
Change the world, it needs ...
In lecturing theatres memorial groups sing
From a requiem
In the refectory, Christian students wrestle
With the roaches

The death-free period, the closing
Choirs singing on till October;

the fac-

Totems are enrolled
In the sacramentalia
Now swear on the Bible
The Red Cross and the *gaus* -
Re-register
Before tetanus locks in!

Close the corridors
Seal the dogma

Somebody shouts: Evacuation

'There's no shooting outside
The streets are cleared for the reflux...'

gau: A tribal territory, later an administrative district under the Nazis.

Am See, wenn der Mond sich erhellt
Die Weichbilder auflöst
By the lakeside, when the moon lights up
Softly dissolving images of the city precincts

Holding fingerless hands up to its face
In the water boats are crackling
Like floes breaking at the burr
Now the rivers hide their privates
In municipal sewage systems; over Zurich
The sky's a left-luggage locker/The lakeside
Garages they call gardens
With sprinklers; so it doesn't rain
When I lie still/Like a rail-less train station
-:
And you don't reach a footbridge anywhere
And you can't walk across the water
But look at the bottom of the lake: epiphanic fish
Will appear to you, thick as fingers severed from the hand
With golden rings around their rumps

Wieder ist die Nacht
Again, the night is

A woman sawed in half in a dream.
Again, tears are falling
Out of your mouth like sawdust shavings.

I hear you
Whispering with the rain.
Nobody will be silent for long
Without their tongues cut out.

With my tongue
Half-empty glasses speak
At night:

Drink flames from my eyes!

Drinking too many bottles
To find the oblivious letter at last.

We'll saw the dreams in half once and for all.
On the trees, no bread grows
Into no sky.
Every dream treads with iron shoes
Through sleep.

-:
Behold the land.
Nothing comes true.
The night's got blue lips
Sometimes a strip of desert
Burns behind them.

In the windows
The gaslamps gutter.
With the next kiss
There's blood in your mouth.

Bist du zuhause
Are you at home

In the heart valves of flowers?
Many-coloured rhododendrons give you kisses for presents
Labiates encircle you with their tongues

I shall move into silence
Drink light from petals of cup-shaped blossoms
Since I've stopped listening out for words
At the days' opening hours
Between mixer taps and relays
When monitor screens go black
And you braille the silhouettes of love
With your hands, like everything
We answer something like a call of nature
But I've got a stinging nettle on my tongue
That tickles me; so I'll be laughing from now on
Already bankrupt with words
Renounce all canons that coat the land
With their filters and their white-washed smoke

Leave the paths
Fields of rain will find you tomorrow
Darker clouds swell in your eyes

Are you at home
In the shells of snails
Breathe like grass, stand in the water
Like reed; out of the earth
And into the air;
 look
The lake sends you roses

Kisses; like butterflies
For so many summers

Jürgen Jäcklin

b. Schwabmünchen, Bavaria 1967, grew up in Augsburg, studied in Munich. A social worker by training, he now lives in Augsburg as a co-founder and editor of the literary magazine *Zeitriss*. Apart from his poetry and prose, published in magazines and anthologies, the range of his work includes performance art, DJing and singing/song writing.

A Folk Legend: 'Brecht's Smokin' a Virginia Again'

When steam trails out of the mountain woods, locals say 'the foxes are cooking'. When fog rises from the black forests in and around Augsburg, old Augsburgers have it that 'Brecht's smokin' a Virginia again'. As an amateur of local lore, I was keen to find the source of this expression. I checked the municipal archive and those of several newspapers, and interviewed senior Augsburgers on Brecht. After a whole year of laborious and detailed research, I can now present the results of my inquiry to the public.

The Swabian folk-saying 'Brecht's smokin' a Virginia again' is based on the following events: Eugen Berthold Friedrich Brecht was born in Augsburg in 1898 and died in East Berlin in 1956. East Berlin, back then, was still the capital of the German Democratic Republic which, as we all know, was to be associated to the Federal Republic of Germany in the early 90s of the last century, after communism, a political ideology from the 19th century, had been declared a failure. Eugen Berthold Friedrich Brecht left his unloved home town in the 1920s to become a famous stage director and writer. Being a communist, Bert Brecht was ignored in his bourgeois hometown, home also to the ancient mercantile dynasty of the Fuggers. In the mid 1980s, Augsburg celebrated its 2000th anniversary. As the town wanted to promote itself not only as a site of Roman antiquity, but as a contemporary metropolis, the city fathers decided to renovate the house where Bert Brecht was born. They put up a wash-stand from his childhood days, framed by a few hoardings and opened the rooms to the public. It was then that Augsburg realised its famous son might prove valuable in fostering its image of a contemporary creative city. He was now forgiven his communism. After all, he only became a proselyte of this ideology after leaving his home town, having met Munich and Berlin-based cultural workers like Karl Valentin and Max Schmeling[1].

Approximately 10 years later, in 1995, when the world was celebrating Elvis Presley's 60th birthday, Augsburg's love for its poetically gifted son reached its climax. A Bert Brecht Year was proclaimed, featuring recitals and numerous symposiums on topics like 'Bert Brecht and his ambivalent relationship with his motor car'. The bells of the *Perlach,* a clock tower formerly adjacent to

Augsburg's town hall, would play a tune from Bert Brecht's *Threepenny Opera* every hour: 'Mack the Knife'. That was until - according to all German-speaking newspapers - a mentally ill inner-city resident blew up the tower at 4.32 am on the 5th October, 1995.

A Bert Brecht shop was opened, selling amongst other things Brecht's favourite cigars, Virginias. On the shop's opening, a person whose identity is no longer known delivered a speech in which Bert Brecht was referred to as the Augsburgers' guardian angel. Hearing this, the director of the local tourist authority, present on this occasion, had a stroke of marketing genius. The idea was to borrow Bert Brecht's physical remains from the municipal authorities of Berlin and to lay him out in state in a glass coffin in the Golden Chamber of the town hall for one year. He was hoping Bert Brecht's fans from all over the world would go on a pilgrimage to Augsburg, like Presley fans going to Memphis or Catholics annually visiting the tomb of St. Ulrich on his name day. 'Bert Brecht - Augsburg's Patron Saint' - this slogan was to draw tourists from all over the world. The then bishop of Augsburg at first considered this morally dubious, especially in light of the fact that the town already had three saints, but after having consulted with the Vatican, he gave his assent. The then Pope John Paul II was euphoric after 4 million young people had given him an ecstatic reception in the Philippines, where - according to a Jan. 1995 report of the newspaper *Bild* [2] - 30 people died of heat stroke, 145 were crushed to death and thousands of young girls swooned. He offered to read a mass for the dead poet at Augsburg Cathedral in the hope of mobilising millions of people in Europe as well. He withdrew this offer, however, after his counsellors informed him that Bert Brecht had been a communist, and the Pope could not possibly strike South American liberation theologians off the theological teaching register and relieve them of priesthood whilst simultaneously praying for a communist poet. The Pope, nearing 80, finally recognized this and settled for sending a benign greeting card to the Augsburg authorities.

The publisher holding the rights over Bert Brecht also consented to the temporary removal of Bert Brecht after being granted a fixed sum from the municipal takings during the Brecht Year. Thus Bert Brecht was disinterred, at least the distinctive skull and a few bones belonging to the left leg, and transported from Berlin to Augsburg in an Intercity train bearing his name. In Augsburg, the coffin was carried to the town hall by four boxers from the Post Office Sports Club, accompanied by a brass band from the nearby town of Dillingen, a school choir and almost the entire town council, as well as a vociferous crowd of at least 50,000 people shouting 'Viva Bert Brecht'. After the school choir had sung the patriotic 'Song of the Seven Swabians', the then mayor delivered a moving speech where he quoted from the gospel the parable of the prodigal son and rounded it off by kissing the glass coffin, accompanied by the roaring of the crowd. From the documents on the number of daily

visitors catalogued in the municipal archive I gleaned that the tourism manager had a coup with this physical repatriation and the lying in state of Brecht. Every day tens of thousands flooded into the Golden Chamber to have themselves shoved past Brecht's skull and bones.

On the night of the 23rd/24th of February, the unbelievable seems to have occurred. Marcel Reineke[3], literary pundit of the German-speaking world at that time, renowned for his rhetoric, was holding court in the town that evening with his Literary Quartet, a discussion panel on the latest books on the literary scene. Marking the occasion, the panel was held in the luxury hotel 'Three Moors' and broadcast on a large screen in the town hall. Thus Bert Brecht's coffin had to defer to Mr Reineke's popularity for a few hours. The town hall caretaker temporarily stored it in a basement room. The next day at noon, Brecht was to be laid out in state in the Chamber again. But his remains had vanished. The police at first presumed criminals had stolen Bert Brecht to blackmail the authorities. Since neither ransom note nor phone call was received, this was discounted. Police inquiries led nowhere. Bert Brecht never reappeared. Bert Brecht's publisher claimed millions of marks' compensation from the municipality of Augsburg for negligent temporary storage of the corpse. The court ruled against the plaintiff, the publisher only being in possession of Bert Brecht's intellectual substance. As a result, the local press suspected the publisher of having stolen Brecht's physical remains to get possession of the complete entity known as 'Brecht'. Augsburg's local daily was obliged to withdraw this allegation in a subsequent edition. Likewise, it was forbidden to disseminate the theory according to which Marcel Reineke had nicked the poet's remains that night, as a souvenir, so to speak.

Whilst officials and media were at a complete loss over Brecht's disap-pearance, the locals found their own explanation, mainly based on the following event. On the night of Brecht's disappearance, Augsburg's B.B. Shop was burgled; 63 cartons of 200 Virginia cigars each were stolen. Augsburgers were convinced the perpetrator was Bert Brecht. Fed up with the hype over his person, he pieced the remains of his body together and escaped. Before hiding in the black forests, Brecht broke into the B.B. Shop to stock up with his beloved cigars. Even to the press this theory seemed too fantastic to be published. But the locals pass on this story from generation to generation, and when the fog clings to the forests, say: "Brecht's smokin' a Virginia again."

1 These examples seem errant. Karl Valentin was in fact a comedian, and Max Schmeling a boxer - *ed.*
2 *Bild* was a tabloid of the period, analogous to the contemporary *Sun* in the UK. It is curious the author hardly qualifies his source with the spice of scepticism - *ed.*
3 This name seems an anagram of contemporary critic Marcel Reich-Ranicki. The unintentional pun is possibly a Freudian slip of the author's. Reich-Ranicki's undoubted literary foxiness, the pun on Reineke, or Renard the fox, indeed conjures the very 'foxes cooking when steam rises from the wood' the author began with - *ed.*

Pictures of a Hometown

Picture 1: Candy-coloured clock towers and church towers
 With pink ribbons flying from their tops
 Jutting from dun swamps and cesspools
 Between arsenic-green sewers

Picture 2: A fuddled bishop strutting the roofs
 Of the congregation of churches
 Eternally graciously grinning and looking
 For stray little lambs of his clergy

Picture 3: A poet from the early years of this century
 Disinterred from Roman relics
 Just in time for the 2000th anniversary
 Some placards and a wash-stand
 In the house he was born in
 Commemorate him now

Picture 4: Citizens of this town dance the past
 A renaissance of the Renaissance
 The present's jammed up with traffic
 Between two roadworks
 And the future lives 60 km to the south-east
 The trains there - to Munich - always packed

Rosemary Drescher

Chemistry in the Dept. of Linguistics

Talking to you, I soon find
the pulse of my thoughts
scrambling my phrases falling

out of their controlling grammar
I see myself like a German comma

Deserting its clause
For a sudden loose-limbed parenthesis.

Sole to sole

Just look at these brisk feet,
splayed and cracking
in emulation of naked natures -
only sort of white still.
Visiting.

On arrival
I wish to kiss new soil,
presenting unceremoniously
the press of my bare feet.
Sole to sole, so to say.

Dirt cleaves in the grooves of my feet
down a slough of my skin is planted.

The truth is the feet are shod
the earth in turn needs paving.

Look at these stripped feet now,
piqued and flinching.
Shoes do that.

The Lecture

Across the concrete floor

the floor is tidy fundament
fundament to settled knowledge
the knowledge held by chairs in rows

across the concrete is a cat track,
it is a planless trail of pads
trails from the window (drop)
surrounds legs (where legs)
and out the door (rub)
with a purpose
prints follow-me on the soundly seated.

'See You Later'

Harry is lathering the toilet seat, or,
quarrelling with its broad lobe.
He takes elbow grease to stubborn words.

Gareth scours the bath;
in his back
the world is at turning.

Phil grabs pegs pants
clasps sheets that will flap
repeatedly emptily

Amanda smiles:
'Alligator', smiles Amanda.

Addicts

with this syringe
I'nject
I own wombwork

batter this bottleneck
and flood
I own sorrows

I e jaculate
Hermaphrodite tight.

Dialogue

The baby cries for hours:
have a 2-year old in a fit.
Mob speaks mobspeak unspoken to,
dialogue is dead.

Know a woman who talks, but talks.
The man I know is shouting at the kids to
turn down their noise!
My radio is an alarm clock.

I dream motion, silent,
and wake up
screaming.

Caro Rusch

Veneto - Lombardia

I

Coldly green, stone-pines grow skyward
like blue posts far into the cloudy lake.
A resting place for hushed seagulls. For a minute
their eyes reflect
just one image: how a crane's rusty arm
rises above the rippling waves, where a boat
drifts measuredly to and fro
almost inaudibly humming back... and forth.

II

A red terrace made of wet stone.
The tanner's sumach
is a freezing host.
A table is assigned to the guest
laid only with rain.
Damp fallen leaves
the cushion's fabric.

III

Gently, the Mincio overflowed its banks, a silent spread
of muddy silver. For both here and there the Heliads
mourn their brother... trickling
from tree-tops, dripping along leaves,
tracing stems with pearls down to the soil.
At the mountain's foot the fog was caught
in utter stillness.

Mantova

Her beauty lies masked beneath
the shiny wetness of ancient stones.
A shared fate, a common fate:
she's like any other old maid.
Everyone's gone. The furniture's piled up;
papers are read by the fireside.
It's the end of the season. One last glow,
however,
is sulkily sweeping the humped alleyways,
suddenly kindling a profound sweetness...
Trembling hard, the Duke stepped out on the Piazza.

Bacoli

For this voyage only: a mate,
bearishly unearthed, embraced in wrath
just as the frothing sea ferociously
drives into trembling stone; how out of
Triton's deep breast the sound of the conch
curves the first notes so endlessly
far away... so somewhere far.

Think of an evil wind, a brimstone wind,
propelling hot waves of sand. Go ahead,
walk that narrow road to the village,
in the stench of burnt leaves, of seaweed.
The mad buoy out there for company.

... Listen how tin to tin the railings bang in
the onslaught and find in the gutter
a fish with its dead beautiful eye
toward the sky. And all this could never boil
a worse poison than any heart.

Caserta

I

Above, all smiles, a homespun Venus
for love's made - where else? - in heaven.
She's so buxom and joyous; the plump boy
by her side. Coyly, he cocks his small head,
shushing, a finger on his rosy lips:
a mediocre conspiracy by the Gods
against that four-poster bed below where,
rather flushed, the King of Naples dreams of his beloved.

II

And behind a column a glowing face
lit up by sunlight. Only briefly
taken by the eye, possessed in between
by visitors, prattling and then gone
and Oh! and Ah! in the boudoir of mirrors.

Cumae

Gently, a hand seizes the distorted leaves
getting hold of one deliberately. Turning up
your collar, you leave
ignoring the rosy mushrooms, half shrouded
in the foliage. How much you do have to forget
to read the blurred script: the
woman's raving mouth, her hair and
the trial of all who ask questions:
the palm leaf.

Lake Avernus

They say that birds here
tumble into the sea as if carved out of lava.
The silence, too, feels just like it. Only at times
a small green bubble bouquet blossoms
from the umbrous, glassy surface,
caressing quilts with weeds spun around them...

At a safe distance
people are being followed by a yellow dog.

All translations Didi Rusch.

Uta Fuchs-Prestle

The Answerphone

Perhaps I should call mother. Ask her if she'll help me out for the rest of the month. Or Ria. She'll be surprised and ask questions. But I can avoid those. Somehow. I can't lie to Ria. Yet I can remain silent. Hide myself like a chameleon in the green phase of the traffic lights. Sit black in the tar and breathe hot cracks.

Ria will lend me the money. I'll give it back to her as soon as the transfer from Andreas' bank has been credited to my household account. On the whole, I'll then have to use the household money more economically, not buy the cheese in the market where it's much more expensive. The owner of the cheese stall looks like the grocer in my first form reader. He wears a blond moustache that separates his lips from his eyes. It's bushy, and sometimes his forefinger rests in it. I can buy the cheese at the supermarket and offer it to Andreas with raisins. This way he won't notice it's cheap. Because after all, *a real treat should be a treat to look at too.* Says Andreas.

Yesterday, that was sheer luck! Andreas had browsed through my wardrobe to prove that the green underwear set I'd admired in the shop-window really wasn't necessary. Only about an hour before I'd taken the half-empty bottle from the wardrobe and thrust it amongst the detergents under the sink. As if I'd scented the danger. It was a wonderful feeling when he reached into the wicker baskets where I keep my underwear and found nothing but vests, bras and pants.

This secret between me and the hideaways, all over the flat.

I could confide in Ria. It's only that I'm afraid to. I'll step out of my picture-frame. And find myself without my reflection. Without any depth. I'm clutching onto the frame as if it were an anchor. I'd like to run the water afresh. One ladle of Ria and one ladle of me, taking turns. Andreas doesn't think much of her. A weird bird. A ripe one for the bin. We both attended the advanced Italian course.

'You're speaking the language of the gutter!' Signora Mancini laughingly said to Ria who'd been on a few weeks' holiday with her friends in Apulia.

'One doesn't say "aspe". You must say "aspeta".'

Ria didn't observe the instruction, though the rest of the participants worthily pronounced their "aspeta" in posed role-play exercises.

'All the people in the village shout "Aspe!" I can hear it, see their faces and return for a moment!' Ria said. And: 'You must accentuate your lips. They're worth it.'

Saying this, she nudged my elbow and offered me her lipstick. In the mirror of the ladies' room I read her face's laughter.

I take the receiver off the hook and silently intone Ria's number into my oral cavity. Swallow down the figures. Stand up and fetch the bottle propped among the clothes to be ironed and those to be mended. Rinse my mouth clear.

I'll disgrace Andreas if I ask a stranger for money. It'll look as if he kept me short. That's not true. He's budgeted my household money in such a way that I can buy an extra little something each month. Last year, I quite often brought back a CD from town. Or some costume jewellery.

But since I've been taking some top-up wine - or sparkling wine - for myself whenever I do the shopping, nothing remains for much else.

I'll visit mother at the weekend and ask her if she'd lend me the two hundred marks. She'd give me the money as a present. She'd put it in the side pocket of my handbag and tell me with her grey eyes that she doesn't expect anything from life anymore. On that occasion, mother will take the photos of the dancing course from the flowered box and dream back. Not me. I don't want it anymore. At no price will I listen to how my waist is still so slim, while all the time I'm aware that, sooner or later, the shops will close and that I want to fill up my belly with wine. Inside me, I'll drown the letters of all her words. Drown the nice dancing teacher whose sticky hand remained glued to the light summer garments and whose leg moved between my legs during the foxtrot. And drown dear aunt Sophie who, when mother was lying in hospital, had plaited my hair so tightly that tears flooded my eyes.

A couple of weeks ago I went to the cinema with Ria. We watched a film from Kirghizia. There was hardly any dialogue, and the few words spoken weren't dubbed. You could only listen to the faces and the landscapes. Ria had left her glasses in the car. I saw her narrow her eyes and move far towards the edge of her seat. Then she reached for the ear-piece of my glasses and asked if she might try my lenses. 'That can't be true. We must have the same sight defect!' she whispered and looked at me through my glasses. During the whole film we took turns wearing the glasses. And when Ria gave them back to me as the lights slowly brightened the cinema, for a short moment I hoped that, along with the glasses, I'd be able to put on Ria's way of seeing.

When Andreas comes home from work, I rinse my mouth with water and brush my teeth. Put on my evening face as best I can. Since we moved house six months ago I've been out of work. My place at the nursery school was taken over by Elli. I liked being there. But perhaps it's better the way it is now. After all, Andreas earns more than he used to. He's an important man in the company. He talks about it over dinner and wipes a contented smile into the napkin. Along with the chicken bones and wipe-cleans, I throw it into the dustbin's transparent liner. This is where I look for it when he goes on about Ria with thin lips.

Sometimes I pick her up from the library. I watch her before entering. Through the thick glass pane of the door. Like a bookmark she stands between the books. Colourful and slim.

Ria's laughter sounds like metal plates moved to imitate thunder. That was in third form.

'Thunder's coming!' the others greeted me at rehearsals.

Even grandfather came to see the piece. He wore his grey-striped suit whose rear seam grandmother had vented to insert a piece of cloth. His hands clapped against each other, and while he did that, his jacket would gape and close in time. I lifted my hand to wave at him, but Isolde next to me pressed it tightly against her. Isolde was the rain. She bowed and beamed all over her dark-painted face.

I really don't think Ria's laughter is vulgar. It's never as much fun as when she's there. She tells me about the people who come to the library. About the school classes whose murmuring runs down the spines of the books. About the many heads standing behind the shelves. Visible only as heads, as if they were hanging down from the ceiling. About old women keeping to a fixed day for borrowing novels. That many of them even come at the same hour. Ria claims that some of the returned books smell of warm beds. And she's convinced there are people who use books as hot-water bottles so they can get to sleep. I don't know. But the way she tells her stories is so priceless.

After two glasses I can't drive to Ria anymore. And I don't take the bus. Even at the thought of buying a ticket, I feel sick.

'That's completely unreal!' Andreas doesn't want to hear it.

'You can't die of nothing at all!'

I don't talk about it anymore. He's right, after all. But that afternoon when I rode home after shopping and couldn't make my way to the door between the dark coat sleeves, I thought my knees were about to fold perfectly flat under my legs. Like a broken hinge. And my heart was chiselling against my chest like a fist opening and closing. The bus drove on. Pale breath from the parched mouths punched me in the face. And the bus drove on. Doors tightly closed. The line of houses in our street moved past me. Right through my brain. Constricting every single vessel in me. I started thinking only in colours. Red and black. When the bus stopped at the next station, I got off. But I can't remember how. Heard the hum of the motor while I sat down on the bench next to the bus stop. I was cold. I can remember that. And that I waited to fall off the bench and never wake up again. At the feet of the young woman who sat next to me reading.

When Andreas came home I was lying in bed. All tucked up. No, I wasn't ill. He put his hand on my forehead. The glass of sparkling wine he offered me to stimulate my circulation took away my anxiety.

The doctor couldn't find anything. All laboratory tests came back normal.

'Why, pull yourself together! It's nothing! Look here, this even certifies it in writing.'

From the street I see the people who use the bus sitting behind the screens. And the black and red glue up my throat. They are silent or talk or just ride along.

Ria listens to me when I tell her about it. Her lips lay on top of each other and don't move till I've stopped talking. She's offered to drive me in her car. Sometimes I accept. I like sitting next to her. We imagine going on a long journey. Ria talks about it so seriously that one time I asked her if we were really going to Italy.

'Shall we?'

But after all I couldn't. Not just like that.

I can't leave the house anymore without this fog in my head. One glass at least. I need it like a stick so I can walk, feel the ground beneath my feet. I hold on to it.

The phone rings. It's Hanna. Our former neighbour. How I'm doing. Fine. That Andreas is satisfied with his new job. Hanna tells me about the people who moved into our old flat.

A couple with a young child. Certainly they've turned Andreas' study into the child's bedroom. I often think back to the flat. There was always a smell of fresh oranges. Perhaps that was due to the orange-painted house that's opposite the kitchen. Or I never completely mopped up the juice when it spilled from the broken bottle and ran under the cooker and the fridge. The floor was still sticky in these places when, on moving house, we cleared out the kitchen.

The bottle had fallen from my hand. Had slipped through my fingers and burst on the stone tiles. My tears had melted down the coloured fragments of glass and thickened in blobs, like the blood behind the plastic film when we'd grouped our blood in school.

'I didn't really mean it, baby. But you'll understand that this really isn't a good time for it!' Andreas apologised and took me into his arms.

When three weeks later the blood wouldn't stop dripping into the beige toilet, he drove me to the hospital. He brought me a big bouquet of spring flowers. Bigger than the one the woman next to me got for the birth of her daughter.

Mother cried on the phone. The main thing is that you're well again. That's the most important thing. But my belly lay between my hips like a wooden shack. Skin over it. Invisible splinters of wood stabbed into my flesh.

I need some more money for the rest of the week to buy food. The provisions from the freezer won't do. What's more, Andreas wanted to bring a colleague on Friday whose wife is yet to move in with him here. I'll have to cook a decent meal then. What kind of fool will Andreas look if I don't. When he phones me from the office I can hear his secretary typing letters for him while he gives me little instructions. In the end he always says: 'Well then!'

Every time.

Ria leaves a message on the answerphone.

She's got her very own way of pronouncing some letters. The letter "A", for instance. It sounds as if a door were opening. I can't express it any other way. Ria laughs and says that she often feels the same way. And that, after all, some people hear with their eyes.

'Don't tell them anything at school. You understand me?' mother said sternly. 'Or they won't like you anymore!'

Father had lost his job. Every morning he left the house as usual, drove the car in the direction of his workplace and walked around somewhere. At the time work would end he returned. Grandfather came at the beginning of each month and slipped mother an envelope. He stroked my hair. His big hand put a one-mark coin in mine.

There are five hundred marks left in my savings account. I'll get them this afternoon. Before that, I must take the empty bottles to the waste-glass container. It hurts me to deceive Andreas. He doesn't deserve this. I'll walk to the bank. It takes longer, but I've got the time. Then I'll visit Ria at the library. Perhaps she'll take me home in her car. Definitely.

I want to see Ria. Once more I wind back her words and listen to her:

'Will I see you today? Eh?'

'Will I see you today? Eh?'

'Will I see you today? Eh!'

Uta Fuchs-Prestele

Evening of Leaves

where she sleeps, my love is hit by the storm

You don't see it lying down. I've turned Udo around so he faces the wall. He lies sleeping on my sofa. The day before yesterday when Anita came to visit she spoke in a very low voice as she didn't want to wake him. She wasn't even surprised that Udo was already at my place in the morning. Most of the time he drops by after office hours, we drink coffee together and have sex. Afterwards, Udo drives to his flat. It's the first time since we met that Udo's stayed overnight. At the bank they think he's ill. Yesterday I made his excuses over the phone. His secretary sent warm regards and wished him a speedy recovery. I've put leaves together to form the letters "Get well soon". Udo and I collected them last autumn. When we took them from the plastic bag they smelled of rain and late afternoons that creep into one's pores like falling wafts of mist. In the evening Udo laid the humid leaves on my naked back. He built a tower on my skin till it was so high it fell over onto the bed. The sheet smelled of moss and mushrooms. I think its colour is an earthy green.

Since last night I've been spraying Udo with his eau de Cologne every four hours. It's necessary, since if I don't do it the sweet smell will get through to Anita's flat below mine. Then they'll take him away from me.

Udo will have a good time of it at my place. I'd like him to be able to read his secretary's good wishes. So I pin the leaves to the wallpaper opposite the couch so they read "Get well soon" as before. Then I lift Udo up a little and sit down behind his back to support him. He's ungainly and shapeless like a half-empty hot-water bottle grown cold. I'm afraid his head will fall off his neck because it always topples over to the front. I turn Udo to the side so his legs fall onto the carpet and press his torso against the back of the couch with both hands. Now he can read the words made of leaves from the wall.

Red doesn't suit him. It never did, and today it suits his pale skin even less. He sits there in the warm living room like a snowman doused with red dye. I'll go and get the blue sweater from the bedroom in a minute. Actually, it was meant as a present for his birthday, but there's still two weeks to go, and I don't know if I can keep him here that long. But he won't leave me. He'll stay till I let them come and take him. He'll sleep in my flat for as long as I want.

The blue of the sweater is the blue of his eyes. I closed them this morning. In films, I've seen women close the eyes of their husbands, fathers or lovers dozens of times. You just push the upper eyelid over the lower one. It's quite simple. The only scary thing about it was when one eye was already covered while the other still stood open. Yet I was more embarrassed than scared because I'd

already taken off my make-up. It was just after midnight and actually I'd wanted to go to bed. I hope he didn't look too closely, I seem like an empty white sheet of paper when I don't wear any make-up on my face.

If I dress Udo in the blue sweater, I'll have to open his eyes again so one can see how well the colour suits his eyes. He's slid down to one side. His head beats against the wooden backrest. He doesn't make a sound, though his mouth has been gaping open all the while. I haven't tied up his lower jaw. At first I'd forgotten about it and then it was already too late. I'd better support him on both sides with the chunky coffee-table books from the shelf. On top of the pile, I put Udo's favourite book, 'Film Stars of the 50s'. Udo thinks Gina Lollobridgida is great. 'She's the greatest,' he says. I open the book at the page with her photograph and hold it in front of Udo's face. 'She's beautiful,' I say and stroke her cleavage. And: 'You shouldn't have said it, Udo.'

If only he'd buttoned up his coat and left my flat. Perhaps I would have sat crying at the table for days, drinking red wine and some day forgetting him after all. But he said it.

I fetch the mirror from the bathroom wall. Quickly, I sit down on Udo's lap, as far as it's possible, move forward a little onto his knees and smile in the mirror. We're well suited to each other. I like his sandy hair, especially when it's cropped very short like now. His eyes are glued behind the eyelids like marbles. What a pity he can't see we're a beautiful couple. He'd certainly take it back! He'd recognise that what he said isn't true. The room's warm, I roll the sleeves of his sweater up to his elbows. The purple stains on his forearms won't go away. When spring comes, he won't be able to wear short sleeves. I lift up his left arm, the mirror is coloured purple and blue. One time Udo showed me old pictures. On one photo he lay under a huge duvet wearing a warm shawl. His face was strewn with red spots. 'I think it was the chickenpox,' Udo said and kept his mouth open while he thought about it. Now again, his mouth lies in his face as an 'O', sunken very deeply, as if the skull could swallow it any moment like a crater. In the bathroom, next to the washing machine, there's the bag with the leaves. I slide down off Udo's knees, push the books so closely towards him that they keep him in place and fetch the plastic bag. The leaves smell warm. Udo's laughter lies between them. I stuff a handful into his mouth, then I kiss his lips. With safety-pins, I pin leaves on his red sweater. I read the words 'I love you'. And somebody sings from the tape recorder. Udo slides off the couch towards me. His mouth is open because he sings.

Everything will be alright, I know that. From the door through which Udo wanted to go, words hang like clouds breaking up. Every letter dissolves into blue colour.

The leaves from Udo's sweater crumble onto my chest and fall on my skirt. My lap reads them and heaves a sigh of relief.

Uta Fuchs-Prestele

Sounds of Open Stones

For Reiner Benthele

Sometimes I dial Severin's number. Mostly Marianne answers the phone. She says 'Hello!' or 'Yes, please!' Her voice sounds as if she were speaking through a piece of linen. Or as if somebody held her mouth at both ends, pulling it apart.

I imagine her walking through the workshop with her hair stuck up, humming. The smell of the new glazes squeezes through the holes of the receiver like a mincer.

When Severin answers I think of the afternoon when I sat next to him as he was processing his mail. I saw his mouth that named people, streets and towns aloud. And while I quickly kissed Severin, he traced letters like rows of houses onto my lips.

Sometimes I don't hang up the phone but put the receiver next to it. Then I imagine Severin's dark hair and spread it across my bed like a cushion. I stuff a handful of it under my armpits to make me warm, thinking of Severin's hands with wet clay oozing out from between their fingers.

The clay had dried on my blouse. Later on, it fell like dust onto the carpet in my room. When Marianne came into the workshop humming, Severin went to the shelves with vases and pretended to look for something. Marianne got a jug from the cupboard and took it out into the shop. Severin turned to me again and smiled at the door I was standing in front of. He looked through it and through me. Marianne's voice penetrated from outside. On my back, the clay contracted and grew hard.

In the evening we stood together in the shop for a while. Severin bandaged Marianne's finger. Earlier, I'd pushed a cup off the table by mistake. Marianne and I had bent down together to pick up the pieces. Marianne had cut her forefinger on it. The blood dripped like red lacquer onto the stone floor and over the broken cup.

Severin's hands were still grey and speckled with clay. On my back, I wore the imprint of his touch like a patch of hard horn skin.

When Severin sat in the workshop with Marianne, I used to watch them work. His hands would turn in time with the wheel and form some sort of vessel. Marianne would paint the crockery after it had been fired. From the shop I'd see their faces through the glass door. Sometimes I went out into the yard to watch them from the other side. They didn't have faces anymore. But I knew they were thinking of shapes and patterns for new services. Plates and cups that anybody would then be able to just buy in the shop to drink coffee and eat cake

from on Sundays. Marianne sat in front of the photo that showed herself and Severin in the South of France. Her belly almost completely concealed it but I knew Severin took her in his arms from behind, his head laughing above her head. His black curls were hanging over her temples.

'That was ages ago!' he said evasively whenever I asked him about it.

Marianne sometimes talked about the pottery workshop where she and Severin had worked together.

When she did, she looked the same as in the picture in front of her belly.

I couldn't stop thinking of Severin undressing in front of my bed. Marianne spoke about him until he stood naked before me. And I began to put away his trousers, his undershirt, his socks in myself as if in the drawers of a linen cupboard.

In the evening I touched Severin's fingertips underneath the sheets of newspaper in which I was wrapping the crockery. He turned his head aside towards Marianne's empty chair. Then he put my fingers into his mouth. He bit into my nails till it hurt.

I took the next day off. Took the train home. From the station I went to the cemetery. When I was a child I'd asked my mother what it would be like to walk into a mountain, right through it, not across a pass.

'That won't work,' she'd answered.

Falling asleep, I imagined the interior of a rock. I tried to think of sounds nobody had ever heard before. And I smelled the colour of the stone, a colour onto which white snow was falling.

It was cold. I could tell from the breath of a woman in black who passed me by. I followed her quickly, trying to walk in her footsteps. At the cemetery gate we separated. She got on a bus that was just arriving, and I entered the café next to the cemetery flower shop. A small table at the window was just being vacated, and I sat down.

The people opposite were having lunch. They were all dressed in dark colours. Only a little girl was wearing light blue dungarees with penguins printed on them. She was sucking on her bottle and looked over to me. I smiled to her and a man with a black tie smiled back. The girl came to my table. She put her bottle in front of me. The man with the black tie followed her and said 'Hello'. He took the girl on his arm and carried her back to her family.

I asked the waitress where the phone was. When I dialled Severin's number, Marianne answered. I hung up quickly.

At my table sat the man with the black tie. I could see him through the glass partition of the phone.

'I'm sorry if I've disturbed you...!' he said when I took my seat next to him. But I shook my head.

'It was only a distant relative, an uncle of my mother's,' he apologised.

'I'll move house, too,' I said. 'Do you know a flat or a room?'

While he was still trying to think of one, I paid and we left the café together. On the pavement he pulled the black tie off his neck and said: 'We'd best buy

the local paper. As far as the flat's concerned, I mean.'

Then he put the tie into his coat pocket and put on a turquoise shawl.

'Can we go to your place?' I asked. 'I'm cold.'

'I've got a paper at home, that's true,' he answered.

There were fruit crates all over his kitchen where he kept crockery and food. Dark grey letters on one of them spelled 'Greece'. He took the newspaper from the letterbox. I underlined some flats with a blue biro. He took two teacups from one of the fruit crates and handed me one of them.

'Ever been to Greece?' I asked him.

'No,' he put the water-filled kettle onto the cooker. When he unbuttoned his jacket, the lid fell from the kettle, hot water sizzled onto the plate. I thought of mother's long scar that reached from her chest below her navel.

'We must cut open the blouse at the back!' my sister had said. 'It's too small for her.'

It was mother's favourite blouse. She'd only worn it on special days. Once she'd singed the collar with the iron. From then on, she put a small paste brooch over the spot. We couldn't find in it her jewellery box in the bedroom. My sister put mother back on her bed and got a pair of scissors from the kitchen. Mother lay there wearing nothing but her pants. Her breasts were lying next to her like small cushions. It was the first time I saw her without clothes. I turned around because she certainly would have minded. While I stood at the window, my sister cut open the fabric. I had used to pick mother up from the hairdresser's frequently. I closed my eyes and smelled her backcombed hair, and there was the smell of her backcombed hair. When she had the blouse on I saw the burnt spot. I couldn't think of anything to cover it. A man came out of the neighbouring house. He stopped at the door and called to a woman at the window. But I couldn't hear anything through the glass pane.

'Ever been to Greece?' asked the man in front of the fruit crates.

'No, don't,' I replied because he put his hands on my back. I took them and pressed them against my breasts and my belly. Then I closed my eyes and imagined warm sounds inside the stone.

Contemporary British Poetry

Tim Allen

Molten Runnels:
A look at the working personality of Andrew Duncan

Where the hell did Andrew Duncan come from? Through the various stylistic landscapes of British poetry through the 80's and 90's, each *scape* defined as much by its degree-distance from another as any topographical difference, Duncan shoots around like some crazy electronic ball, a micro black hole eating up the greens – the landscapes disappear to be replaced by an occident without an America.

The simple answer is that Andrew Duncan came from Punk. Here was someone who understood the emotive sociology of languages – grin like a fool and you won't be fooled (again) – the best defence is attack – the best method-ology to adopt to block from consciousness the looming presence (both creative and critical) of the scarecrows was to use them as tinder. While the scarecrows, whether erected by Young Farmer Mainstream or ageing Uncle British Poetry Revival, go up in smoke, the birds land. But this is a fantasy. The only thing that burns is paper and the words that disappear with it can be reborn somewhere else – printing technology killed the song-and-dance-man's bangled star but information technology has given that old jester another chance. A New Gen. jester knows how to flatter the corporate kings and New Labour Barons with one face while the Janus spouts crap about class and 'streets' but Duncan was having none of it. While less intelligent post-punks like Mark Robinson were ripe to be taken in by that nonsense, and accuse Andrew Duncan of 'lacking humour' into the bargain, our man himself was busy turning the magazine *Angel Exhaust* (already an iconic vehicle for the anti-mainstream) from an in-house journal for the *late* British avant garde into an unpredictable hot-house where those same late British avant poets shared a font with those who were too wild or just too damn good for the New Gen. 'rebels' to stomach – the John James phenomenon all over again but this time under many different names as the roll-call of *Angel Exhaust* contributors rattles around in the small press hollows of recent history. And look at what was happening in the AE reviews. No longer were they there for the *avants* to coddle and comfort each other; suddenly the raw intelligence was turned on the shibboleths in an attempt to jolt the uncles of the British Poetry Revival into the fact that what ever had been revived was now sleeping again – maybe dead as far as mainstream propaganda was concerned, and these days propaganda is not to be dismissed. Hadn't these people read anything about 'power' and 'postmodernism'? Test: question the shibboleths and icons and if this causes you to become a pariah then you know the test has worked and that something is seriously wrong. When loyalty to the

cause is more important than trying to break down walls then what is the point of being involved in criticism? The rebels who felt secure in their rebellion were confronted in Andrew Duncan by someone who felt unsafe in his rebel status and who wanted to find out exactly why that should be. British poetry is up for grabs, let's go back into history and grab some, while all the time moving, moving sidelong, moving forward? And look what happens when you grab a handful – it's attached to Europe: the sea falls away to reveal sticky tendrils of sediment.

Andrew Duncan the poet is not so different to the critic. The same restlessness vies with the same surety, though both are projections. The same blistering intelligence vies with the same sonic sensibility though in the poems these curl inward while in the critical writing they curl outward. The same focussed recklessness vies with the same considered political twist, but in the poems this makes for an amazing bubble-view of Duncan's flat rhizoid world. Only frighteningly good poetry could provide such a bubble view. Duncan's acknowledgement of Deleuze and Guattari's input and insight is not something he shouts about but the *mesh* of his poems, their superb narration of an insider's pragmatic project is certainly a matter of SNAP. In the theatre of theory Duncan is the one concentrating on the music as it bounces off the walls.

By insider above I mean the opposite of romantic outsider. I remember when I first encountered Duncan's poetry properly (as opposed to isolated magazine appearances) in *10 British Poets* (Spectacular Diseases 1993) and I was struck by the way the writing was looking out at me. I was witnessing a poetry that made no bones of the fact that it never needed me as a witness. It was real – something like a 'real history'. While the work of the majority of contributors to that anthology was changed by my observational presence, akin to a time traveller's experience that changed the course of the material by the very fact of being there, Duncan's poetry was a lot more aimed, reading it was like being pierced by hundreds of arrows.

Yet the quantum relationship between work and reader, while obvious in so much avant-garde work, is not absent in Duncan, if anything it is all the more pressing. When compared with more typical 'innovative' poets (by which I mean the average reader's idea of such a poet) his poems are relatively conventional. Their form rarely varies from free verse where the line breaks are either predictable syntactic moments or come early to denote emphasis. There is a directness, an unfussy attention to writing what is on his mind that has no time for linguistic tricks. The play, the reflexivity, comes in the thoughts themselves and he has honed his 'straight' method to transfer their information with the least possible interference of aesthetic concern – no embroidery, no white noise, but no minimalism either, high access language. No overt formal self-consciousness or exploratory (experimental) journeys into possible ways of

saying the same thing either. No tangents. Why would a poetry which is (literally) made of tangents have need of a tangential form? It wouldn't! Duncan's thought is tangential from the off. His poetry is a channel becoming one with that thought as the thoughts dry and form new channels the way molten lava cools and hardens as a runnel for further molten rock. New hot thought is given its runnel by the cooled old thought so the walls (the poem) are the same material as that running between them (thought) but at a different point in its temperature cycle...

No wonder he picked up on D&G. Duncan looked around and discovered that he was inside processes as much as he was inside his factory, he was inside what he calls 'the bureaucracy of the unconscious' as much as he was inside economic decisions made by politicians. No outsider this, let alone 'romantic'. The political/romantic urge present in his early work (*The Threads of Iron*, famously commented upon by Prynne back in '82: the first half published as *Cut Memories and False Commands* by Reality Street in '91 and the second half published this year by Shearsman as *Switching and Main Exchange*) was already compromised by awful knowledge and breaks down in poems under a welter of astonishing surrealism that destroys the 'voice' through imagination in order to shift the ground, swivel focus, change reality by questioning it until it spills its beans. It is those beans, rattling around in the pod of history, that form the rich array of 'things' that parade through his material. This is where his work is quantum in a deep way that has next-to-nothing to do with surface form and effect but everything to do with observation (imagination in other words) of the historical dramas asleep in their dream of *issues*. And the scene of these encounters can be anywhere where his train of thought takes him. He gets off the train; he walks around, history changes as he opens his mouth to speak. The work is quantum before it even gets to us, that is why it is different, why it is unique.

Appreciation of what Duncan was doing came early from Prynne, whose opinion of the poems was very high; all the more astonishing when you consider how young Duncan was when he wrote those poems. The other side of the coin however was complete indifference on behalf of the mainstream editors and publishers. No surprise there though I remember a conversation back in the early 90's where I still expressed shock at his exclusion by those who were supposedly promoting 'political poetry'. Duncan labelled his own poetry 'socialist realism' and this was not entirely tongue-in-cheek. However, the curve of appreciation expressed by the left-field community began to wane when Duncan's critical work came to the fore. It is, after all, both easier and more pleasurable to write about someone's opinions than it is their poetry. The spotlight thrown on his prose has tended to leave the poems in the shade and there are few critical commentaries on his poetry (one of the few of any length, by Michael Haslam [*Angel Exhaust* 12], was quite impenetrable). Even in

Conductors of Chaos where others had their selections prefaced by dollops of illuminating adulation, Duncan makes do with a minimal biog comprising of a few publication titles and dates. Further, to what extend some individuals' reading (or merely consideration) of his work has been influenced by their disagreement with his forcefully expressed opinions in the pages of *Angel Exhaust* is an open question but it is no secret that as a critic he courts no favours. What for others might have sounded like typical small press bravado, such as his saying on the back of AE, "we contradict what we said last time" etc., was in fact true. People are so obsessed with having fixed positions that when faced with a fluid mind they react negatively. There are individuals who have spouted about the value of post-modern indeterminacy in one article who have slated Duncan in another for failing to toe some ideological line or for being rude (Andrew would call it being realistic) about a revered avant garde figure or tenet. And none of these critics of the critic have attempted to engage with the same range that Duncan considers necessary. While others have attempted to respond to the things happening in poetry beyond their immediate interests with a predictable sound bite or brush off Duncan has always dived in headfirst and come up with amazing pearls of insight – the man is an impulsive 'writer'. It is always chancy, and yes, sometimes after much strenuous work with the knife we find that a shell appears empty, but this is rare. It is not generally in Duncan's conclusions where we find the pearls of course, the pearls come along the way, tucked within the folds of his thought development. He rarely makes an attempt to shake the folds out in a conclusion for if he did we would witness the pearls scattering and sparkling onto the floor. It's just not his method; it would entail a degree of vertical closure at odds with the rhizoid adventure. I had a conversation with him once where it emerged that the need for this was down to raw necessity, the practicality of jogging people out of their sleep by saying something you know they are not going to agree with but saying it as though you mean it because you mean it. In this way his critical work resembles his poetry to a degree unusual in the average poet/critic, for whom the demands of the different mediums are clear-cut. I pictured this at the time (much as I pictured my own critical activity) more akin to a dialectic process, but it is not the case because the lack of teleology in Duncan is itself an expression of a concern with the 'human'. This becomes glaringly obvious when one looks at his poems as much as it does when his criticism focuses on what he considers the abjection of the human, especially when such abjection is rooted out by his analysis to be something linked with fashion or ideology. It is not that I always agree with Duncan on such matters, I certainly don't, but that is hardly the point. He has the right to express his opinion and I think the poetry world is a richer place for it. While for example I might agree with some of Adrian Clarke's 'response' to Duncan's attack on Writers Forum ('The Material Practise of Bad Writing') in AE 9&10 I nonetheless feel what Duncan said needed to be said by someone other than of whom they could say, 'oh but he would say that wouldn't he'. Duncan is not a polemicist. He is a stirrer of

gigantic proportions, an agent provocateur for the human and the honest doing his dirty work in the grand empire of the ignorant and stupid that passes for the British poetry scene.

A collection of his critical writing is expected out soon. It will be interesting to see what kind of response it gets from those who find in it succinct deconstructions of their sworn enemies in equal measure with pointed criticism of themselves. And I hope Duncan's wonderful appreciations of individual poets are there too, another area which tends to get forgotten when the focus is upon the friction and fractional. His writings about Tom Raworth and Maggie O'Sullivan, just to take two examples, are important explorations that can 'explain' (by which I mean 'put into words') our responsive feeling to their marvellous poetry. Duncan is a brilliant reader and I for one don't mind sharing whatever he's got to give on these matters. Talking is good. We're not kids any more so let's stop being so damn precious. Hey, this is what I think, what do you think? Ah, yes, but hold on.......

But how? How to hold on? The world has already turned and the centrifugal force stretches our thoughts until what we read yesterday comes around today stained into helium squeak. It's in Duncan's poetry where this 'holding' really comes to life, where, as Prynne said, it holds "its place in the altogether fraught intersections of history and personality." The instrument of holding is the poem, the organisation of language to maximise, as Andrew would probably say, the flow of information. This information is everything (which means *this information is everything*). It is not a recording of information, but, as I said above, a channelling. Beauty is an aspect of this, beauty as mental pleasure. Channelling is pleasurable, sensational. Duncan's poems make information 'sexy'. They attract. His latest work, collected in *Pauper Estate* (Shearsman 2000), is full of these attractions, these tracks made by the desiring machine (why not? To talk about such things without using metaphors would entail philosophy) that is the 'fraught intersection' between the plateaux of history and his personality. Duncan actually says of his old poems that they now have to exist without a personality, which is his way of saying that they have nothing to do with him anymore yet undeniably exist. How long I wonder before a poem loses its (his) personality. Is this a general truth or a particular? This is amusing as I actually find more that connects the early and late work than what connects either of them to the mass of in-between work, such as *Alien Skies* (Equipage '93). And, ironically, the connection is 'personality'. There are elements of the personal that come to the surface in both books to a surprising degree. The emotion is pressing and real and if there is a difference between the early and late Duncan then it seems to be only a matter of relative intervention and control, more marked in the material of *Pauper Estate* – and the control is very much to do with 'attraction'. Instead of spiralling down into cul de sacs of the self the 'control' veers him away to other horizons – the desiring machine is

now being steered. There is an abundance of such works in *Pauper Estate*, 21 titles (including one called 'Virtual Machines') that demonstrate a mastery of his material that outshines his previous best. If we needed an example of what could possibly be produced by a human post-structuralist poetics, then this is it. These poems could very well be Duncan at the height of his powers, though I suspect there is more to come.

A different article would have brought back-up examples from his poems to accompany this probing but if you go to the material you can sample and quote to your heart's content. Another, and longer, article might also have expanded on some of the issues raised above, both in connection with the mechanics of Duncan's poetry itself and the wider scene. Yet with Duncan both could well turn out to be endless. Nevertheless I would have liked to talk more about particular issues: the fact that Duncan is rarely concerned with American poetry (in comparison to most others from the innovative merry-go-round), his problems with both the concrete and the gestural in avant garde art, his translations from various languages and down-right scholarship, his fascination with Russia, the curve of his politics and the fact that he is that rare thing - a committed commentator upon the alternative poetries who is not ensconced in academia, a condition I share with him.

I am going to round up though by taking issue with James Keery's blurb (from *PN Review*) that sits beneath mine on the back of *Pauper Estate*. He says that the origin of the power of Duncan's poetry is "in an extreme case of alienation" – what a convenient evasion, what a cop-out. The only things that Duncan could possibly be alienated from are stupidity, evil and bad poetry; and then it's only if we know what we mean by 'alienated', let alone 'extremely' alienated. The very concept of alienation, whether Marxist or psychoanalytical, is notoriously metaphorical. Duncan's collection *Alien Skies*, which I presume the blurb is referring to, is not a metaphor for a metaphor; if it was then the resulting tedium would be most unattractive. This abstract use of the word alienation, taking it out of the real world of local particulars and placing it in some kind of floating pasteboard while it waits to be given value or valuelessness is a depoliticising project that completely misreads Duncan's output. The 'origin' of Duncan's power can no more be located in any alienation than it can be located in his post-punk wish to, as I put it, "engage with the power-structures of information by bringing into being a series of virtual scenarios that synthesise giddy desire (for Cloud 9 beauty and peace) with a programme of action-man analytics." Origins of the nature of any creative work are multiple and the rhetorical sifting out of one at the expense of another is no more than journalistic licence. It is a reductionism which takes us in the wrong direction and while it might suit a certain type of 'modular' conventional modern English poetry it is completely unsuitable for an expansive poetry such as Duncan's which at every turn engages with desire. The only way in which Keery's terms

could have validity is if alienation equalled self-knowledge, but then it would imply that those who wrote poetry in an unalienated state had no self-knowledge. Ummm? I remember when I was existentially locked in a work situation that I loathed to the point of a breakdown I could inspect the interstices of the minute people/system interactions in an almost trance-like manner; the components of my colleagues' reality building produced something similar to solid blocks of negotiated experience and I used to daydream of a poetry that could capture that – I was aware that it was the only art-form that could possibly do it. I couldn't do it myself because it was too painful but when I first read Duncan I recognised it immediately. So maybe Keery is saying the right thing but with the wrong words, after all. I began this article by asking where Duncan came from because there is no doubt that he is a black sheep. In answering myself with the word 'punk' I am pointing to something shared by the personality and modern history, or even something shared between the personality and society itself that in Duncan's poetry unravels: I see the image of a cuddly woollen toy helter-skeltering down the lava runnel.

© Tim Allen 2000-04-13

Switching and Main Exchange and *Pauper Estate* are published by
Shearsman Books, Lark Rise, Fore St., Kentisbeare, Cullompton, Devon EX15 2AD and cost £6.50 each.
Skeleton Looking at Chinese Pictures is published by Waterloo Press, 51 Waterloo Street, Hove, BN3 1AH; 88pp, £7.
Also available from Oasis Books, 12 Stevenage Rd., London SW6 6ES
& Peter Riley (Books) 27 Sturton St., Cambridge CB1 2QG.

Andrew Duncan

Some Chinese characters in my hand

Rocks strove to rear and form a mind,
The mind strives endlessly to form a rock.
By smears by swipes
By prayer and philosophy
By horsehair led over Soochow paper
By calligraphy and effacements.
Minerals yield fine inks and stains,
Are content to be led by any dunce or scholar.

Flawed childlike drafts never drawn to an end,
You witness my laziness and grasping:
Seven years ago I practised like any Bao-Yu.
Apes near the Academician's retreat
Jab and smear with juices on a piece of bark!

Ink
Smeared on a fine roll recalls
A journey up a river in the South,
The rocks are not blotchy or too real.
Unrolling
The journey makes me calm in my desire.
Images
Pushing at the membranes in the head
Attenuate the grips of reason,
Affirm the flesh and cleanse the blood.
On the journey, everything passes by us
And the self is scoured clean of externals.
Desire is spent and yet the eyes see ever on and on.

I stepped out of my language and my soul felt cold.
I am a Northern European,
That continent made me feel homesick.
Oh dynasties, oh tones, oh characters! appetite
Made me ill, and my coarseness
Betrayed me in every ideogram,
Hairy and illiterate-no Zhuang Dze I.
In the ruinous temple there's a bell in the morning silence,
Dreamless, the spotless gibbon cries its grief by night.

In the Realm of the Great Within
A hammer taps the gong of the old smith:
Bronze sound vibrating in the air
Thrills powder on a plaque into concentric rings:
The Sage on the mountain out in the wilderness
Acquires Dao and sets the State in order.
His pure thoughts align fundamental energies.
Performing auspicious actions, he
Shakes the Time of men into its pattern.
He makes fires of pure fuels,
And nurtures flowers upon the sated ash.
Through 5 ashes things return to their first state,
A wheel of fires links wood to man to metal;
The flame must weary and devour itself and, dying,
Restore the order which it seemed to break.
The ash of earth is the sharp and slender metal,
The huffing of wicked men clears the air before the Sage.

Rejoice, unsated eyes. Admire, barbarian.
The thousands of vain desires
Taunt me from this mass of papers
Like my own voice hoarse in madness.
The immoderate desire caused ill-health for some years.
The thousands of still free objects
Like wild game in some Great Forest
Attract the journeys of still latter days.

I draw a line a thousand times
Growing finer as I approximate the quiet Masters.
Flickering in slow light movements
I step into the picture's hills
To be at one with the wave that forms the plants
And smooth the rough heats behind my brow.

Furs and Masks

What shall I wear? the cold grey
Stagnance of the mirror barely ripples, shapes
Bloat and die, the day is coming.
What shall I wear? I grind my teeth,
And my clothes tear like an image in splashed water.
The broken foil of my razor rends my skin,

Piles of black shirts obstruct my bed.
The wings of dead textual figures litter
The floor like butterflies caught by snow.

Vexed, I visit the monkey-house.
Gibbons, dextrous as art students, fight and leap,
Like water boiling in a pan. Like swallows they shoot and tumble,
Not swooping on gnats, but on each other.
Ideas for them are bodies twirling in the air,
Shooting up and down the levels of the mother-tree,
Evolving in the three planes. They are
Halfway to heaven, the tranquil canopy
Approached by leafy loggias and tapered sappy columns.
At dawn
The cry of the flawless white tumblers
Hails the sumptuous mango of the sun.
Thoughts
Are glides and somersaults withdrawn and urban.
Could it be true
We have slowed down since we fell to earth?
In thought-forests my white saltimbanques
Simulate and shapeshift fast as flame.

I solved my style problem. In the café-studio
I had a transplant of gibbon-fur—
A tape of Javanese music plays, the Monkey Dance,
A surgeon, a snipper, and a Dayak shaman
Peer at my body, my old skin peels off—
A film of dark hair,
Like Guinness sprayed on a centimetre thick,
On the fresh vellum a tedious novel is written,
The nonsense I pour out whenever anyone touches my skin,
Old images shake out from its pores
Like a fur coat lost in the afternoon,
With love-notes in its pockets, perfume in its fleece.
Droplets of blood and a smell of cognac cling to my slough.

The archipelagos of venules and nerve-ends
Tie one by one into the fine white pelt.
The Dayak talks to me about my love problems.
A wrap white rich and even, fleecy as cream,
Caressing and entire, drapes my shape.
It was as if I was dreaming with my hair,
Not with my brain as usual,

Because the fur strikes up with all my moods:
When I'm happy, it is silky and sleek;
When I'm sad, the fur is grey and lank,
When I'm afraid, it bottles, ravelling
In shaking snakes, frayed and sparking.
When I fall in love, pictures emerge in the pile,
Rich scents waft out of the dermic vials.
Beautiful thoughts leave a wake of beautiful fur;
It softens the impingings, lags the ego.

One hundred people in a short-let Council squat
Drink, gesture, and throw shapes on the slanting walls.
The roof is leaky, huge masts stay up the front face.
I imbibe the specifics of the atmosphere.
The throng of stylistic pirates and parasites,
Covered in blue haze, decked in disguises,
Prate and flaunt in an aesthetic seethe.
Young bankers vomit out of windows.
Yes, these are my friends. O exile! dwelling of a poet!
No longer twisted by a mute anguish,
Nor scowling darkly in a corner, I fling myself
Across the room, I dance on my hands
And mime the ideas of Starobinski.
I imitate the cultured people
And throw crisps at the rest.
My fur swishes with feints and devices.

At four a.m.
In my street
The smooth white cylinders of the Brick Lane Brewery
And the precious façade of gridded mirror-glass
Are the primps of some fanciful architect,
A drunken building in the bloom of unsteady Night.
I spit out stars like shards of glass.
My fur is deep and black and glossy...

Stubble fires

stubble smoke
above morning mist
above ground frost

the huge straw lion of summer
disperses in puffs and snorts
the fairground is empty but for litter

the layers of hot and cold contend
the softened frost slides into the earth
the morning pours down over us

Butterflies woken in winter

Sleep's fruit is broached and musty.
As if a star in the Christmas sky sent a
Call across the deserts of sable dust,
The pin-head node of wakefulness
Shakes out the wings of Spring; the red
Double masks spin around the room.

Two shreds of Chinese lacquer turn around a toy sun.
Unnatural heat stokes a mortal revel,
A drug to tide away the heartless Winter.
Stars are silent,
The green orchards of Spring are locked up.

The white metallurgist shears his crystal sheets.
Flakes from that chill matrix in the high skies,
The migration of birds stamped from white sparks,
Like drops of light sifted through the lattice of heaven,
On hexal wings descend to fleece the dying garden.

The petals of a metallic tree tend fruit.
The fleece of starlight swaddles
The lying-place of a low nativity:
The fibres' stir and swelter in the black bed.

These ashes of the autumn and its stubble fires
Are not the apple-blossom you can stop on, moths:
Slashes in the textile, glints of a deep ground,
You are like paper burnt for the dead.

The June Sun cast as the absent lover

The embrace of the sun strips me and lays me out,
The warm clasp sliding across my skin
Is not corporeal and not affectionate.
Reckless and remote,
A shock of gold unshackles my limbs.
Nothing is so warm except blood.

I know your blood is strong, o sun, it fattens
A million grapes and wells upon the tendril
And gleams red when it is spilt; it rears like a beast
In the glass enclosure; its Syrahs and Tokays,
Its muscats and monemvasias,
Its tears and hazes,
Its flocs and drowses,
Irrigate your body.
I drink your cognac, o sun, I
Drink your Franconian wine in lacquer bowls, I
Drink your Lombard blossoms in a fragrant grove,
I replace my bleak blood with yours.
Your limbs are all of grapes, my sun;
Your skin is the sea flashing in the shallows.
I drink your summers, spirits, sugars;
I pass out in your milk of splendour.

Up there the Fall is still happening, the
Fragments of Paradise fall incessantly to the ground,
The wounded darkness loosens its clench,
Eden's unnamed florescence thrives for a threemonth.
Dark lines crackle your ingot, I see
Your face shaped, my love; I see your smile.
I know you for a second. Who are you?
Your compassion turns up my face where I live
In the sad darks.
Your beauty drops my eyes, your beauty
May I not sustain. Am I not pious?
Do I not wait for you? The berry
Is white unripened in the late season,
And I waited in vain for the sun.

You cause the skin to cry out loud, you repeal
The blindness of the limbs, they form images

In bright mass on their lolling pulp.
I lie here in the grass and listen
To the shapes stirring written across my body.

In the evening is repentance, the white
Petals of regret fall from the cooling sky,
The images of the day drift as memories into the North;
In the Morning
Is labour, the back bent in the harness,
The iron across the forge; the straight light
Envelops the curved edges of machines like a Zeiss lens,
There is neither memory nor fatigue.
Those are good hours.
Noon is the hour of love,
It beats like a bell in the heavens;
Noon is the shaft of love, the star flares
Cracking open on the blue hull of steel,
The zenith and arrogance of the day,
Its hungers, its flanks of meat, its gold cuirass
Strapping gold limbs, its animals lowering
Their heads to drink; its
Wet blazes trickling out over the grass, the weight
Of mid-day pressing me down, softening my limbs.

I ripen myself in the torrent of golden drops, ropes
Of flax and linen hailing in motes and silence.
The sunshine is swallows ripened on a tree,
And the swallows are sunlight fledged and fleeced,
Cutting the fabric of the fine beamness.

I lucify myself with immensity and
Drench myself in density and
Glaze myself with gaudy gold and
Fleece myself with blazes of stellar velocity.

Poems from *Skeleton Looking at Chinese Pictures*, published by Waterloo Press.

Jean Symons

In January

What foreignness with their white slit eyes
Perpendicular and no pupils. They thrust up through mould
Already with lozenge eyes. They are like bread mould
Large. Thin, they are populous.
In the dell market-towns and villages, road lines...
I see more and more as I sit.
They will be a fine sight in two weeks' time. I like them now,
Alien, secret.

Rain Said

Nothing to enjoy it, it may shift some spit
Tempers bloom with umbrellas, this rain
Increases our bulk we barge blinkered,
Bus lights, the glistening slips.

Disappointed me bathing, rain, with wind
Over the sea advancing and the rain said

Never mind, never mind, never mind, it flowed over my scalp
And the rain said, *Never mind.*

Steve Spence

"& then the fringe minister replied in kind"

an outsider's point of view,
true, it was an enlarged frame,
shame about the curtain rails,
sails away leaving a trellis in wake
fake, the bone shivers marmalade, aubade, sunshade, white teeth & nails
pales into significant partition,
tuition & sales 80's merchandise peace
piece of cake, thus spake carruthers,
land-lubbers mark their ground in spleen,
clean up while yr awake, hold back,
crack a few eggs to revolve the world,
curled up together, never look ahead
abed as donne's sunne charts its course,
bourse, gaugin's career took off in paint
feint an angler or a fencer state of art,
impart a known world knowledge for infancy,
mendacity, alacrity, shaken not stirred,
turd in aspic entropic deviant howl,
tall order, fallen idol, bouncy bouncy heart,
tart in the kitchen, meat pie in the oven
coven, if the bombing doesn't stop

all those famous scientologists rolling in lucre

the most beautiful sound in the world
 slap of wave on cricket bat pagan curl

those oh so blue remembered wortleberries
 lines of friction mostly texts in the gloaming
 circle the square too much hard reality bites
 the red float bob bob disappeared tight lines

almost wrote itself the lady in lakeland unique
 satchmo zinging trust rick the dealer
 search for peace crisis tumbling pickets progress
 merry dancers man the barricades don't shoot

an endless trickle of trivia song of the morning
 believe your mother the homeless are coming
 second night away from bomb expose a tale
 running out of lime juice strike the hot iron.

Martin Jack

Keep Refrigerated

Mine is best in a cooler.
Where do you keep yours?

It is hazardous material when overheated.
It drags like a gallstone through your chest,
And hangs heavy with knotted twine.

Better to drift into numbness,
Unbalance the cares,
And live each day as a ghost, pale and waxen,
Barely alive with stuttered words
And indecisive dice in your hand:

A kiss never shared by your San Andreas face,
Cracked by the freezing temperature gauge.

New England Glass

New England snow cuts like glass.
She glides on the silver-studded platform,
Ballroom dancing in fabric-conditioned warmth;
The conifers like curtains over the parade.

A little pick-me-up for the childlike sense
Captured in slicing skidmarks.
Pratfalls to the deck, the unbalanced struggle
With the icicle works peeling off
In knee-skinned flecks.

Hello, hello.
We meet in a tumble,
Hand-cuffed in a twosome.
Capture my insecurities in your fur-lined glove,
And maybe we can meet later for tea
Under New England glass,
Leaving our skates behind on the dash.

Helen Buckingham

Animal Nexus

The dog is howling
He is coming to fetch the rent.

I sense his approach:
drab coat and grubby feet;
up the stairs, barking,
wagging his bigotry -
"Night-birds with ragged nests,
preying on Benefits!"

I crow through my bigotry:
post-date another cheque.
(Where would we be without demons
to pay the rent?)

The Caretaker

It's pride's determination not to fall
that keeps me locked here in my lofty cell,
rewiring and recounting each rough call
that drove my CV to this attic hell -
to spend my small hours ear-clamped to their floor,
recoiling as they conga through the night,
each seismic cosh delivered from the core
contrived to crush me - try hard as I might
to keep my office mausoleum Cool
in case some Act of Satan should arise -
the locking out of Jekyll's jilted ghoul,
or siren's song to bar-stool enterprise

One day they'll find out what it means to freeze
upon the hook of heaven's numbered keys.

Birthday Wish

JD empty.
Roaches in the ashtray.

A few last crumbs stuck to the cooling tray.

Forget the icing
sugar.

Just return.

Andrew Duncan

Contemporary British Poetry

Contemporary British Poetry: Essays in Theory and Criticism,
ed. James Acheson and Romana Huk (SUNY Press, 1996,
ISBN 07914 27676; £22; 414pp + index)

Poetry in the British isles: non-metropolitan perspectives
ed. Hans-Werner Ludwig and Lothar Fietz (University of Wales Press,
October 1995, ISBN 07083 12667, 310 pp. + index)

Reading these two volumes on a neglected era of British poetry is like having
the floor of the warehouse collapse above you and bales of exotic material come
cascading around your ears. Out of roughly 80 poets whom I consider signif-
icant (!), *Contemporary British Poetry* manages sketches of 14; which, in this
exceptionally rich and diffracted era, is a new high. The collections are far in
advance of anything which preceded them; anyone who does not read them
may find their views becoming out of date. They converge to exhibit a new
synthesis, which emerged from the subdivision or subletting of counter-cultural
hopes in their decline around 1974.

The Acheson-Huk collection offers chapters on the anti-modernism of Donald
Davie; Roy Fisher; JH Prynne, Veronica Forrest-Thomson, and Andrew
Crozier; Poetry and the Women's Movement (roughly 1970-79); Ian Hamilton
Finlay; Gunn and Hughes; Jon Silkin, Geoffrey Hill, and Tony Harrison;
Geoffrey Hill; Carol Ann Duffy; an attack on the introduction to an anthology
by Carol Rumens; Black men's, and then Black women's, poetry; Scottish
poetry (in fact Douglas Dunn, Liz Lochhead, and Tom Leonard); Wales and
"the cultural politics of identity" (in fact Gillian Clarke, Robert Minhinnick,
and Jeremy Hooker). So if you're English, a man, and began publishing after
1968, you don't get a look in; the collection is thirty years out of date for that
sector, although this is still ten years better than rival treatments. The
diffraction grating breaking of the literary space into spectral components
answers to the market and avoids the charge of patronage, as each writer
identifies with their subjects; but prompts the reader to get precious and reason
that their own subjectivity is slighted, in the collection's own terms, by the
mismatch with every essayist. It also offers the possibility of temporarily and
blissfully surrendering one's self-possession to try on other clothes: *Nice to see
you, wouldn't want to be you;* if the vertices of the Gestalt are faithfully
dissected and laid out, as behavable elements in the essays; the function which
the words of poems always carry out in relation to an experience.

The cover of *CBP* claims the participation of Eric Homberger, who features nowhere within the covers; he is a mere verbal icon or come-on, flashing us back to his classic *Art of the Real*. This is otherwise a nonpareil collection of statements about out-groups from within. The prospect is enticing: a narrative about British poetry which takes the remote and obscure as its vantage point, so that every fact, every poet, is new and original. The spatial periphery stands in for the unknown as the temporal periphery, liminal between the unknowable and the worn-out, the alluring and imaginable future after the overset of the forces, readily identified with a centre and common sense opinion, which keep things as they are. Identification, sorting out the problem of observer-observed interaction, is the commercial advantage, and so the problem. You cannot say to someone, *You cannot understand me,* and also buy my book. The poets often shorten social distance from their subjects in the same way; less self-narration than communalism. Belonging texts store a world horizon of someone who lives in Cardiff (for example), whose recognition patterns relate to Cardiff, who expects always to be in Cardiff, who grows warm when the sun shines in Cardiff, who has a great stock of memories and projections about Cardiff, offering a *there* for the reader to soak into. Afterwards, you can regain detachment and overview, but still you have been there. The profit urge is to be swallowed by the pride of belonging to a community; decisions are to be taken by local people steeped in short-distance knowledge, globalisation is to be counteracted by the concertment of parishes. The consciousness of the oppressed is false because all the public information pleads for the masters, they lack self-esteem, are excluded from sites where information is shared, their fellows hold them in low esteem, and so their poetry is poorly informed. Is the thesis being controverted. Belonging poets are not what W. Watson described as spiralists, i.e. people who move horizontally around the country to advance vertically in their careers; they are spatially bound, like parish priests, to their subjects, they relate face to face and laugh at books and ideas.

I am profoundly uneasy about the handling of the formerly excluded social groups, the choice of which poets to describe and the quality of the discussion of them. The quality of the writing about the male poets of the fifties (Hughes, Gunn, Hill) is far higher; as if second-rate nations, with no warships, no States, and no school syllabus, have to make do with half-awake literary criticism, a flow of warm indifference. This account of the period 1968-96 is unlikely to last; although the vision of the period 1950-68, roughly, seems very robust. Innovative women's poetry since 1980 is, with apologies, not treated.

Edward Larissy writes about three poets associated with Ferry Press in the late sixties and early seventies, and quotes a 1969 poem by JH Prynne:

 See him recall the day by moral trace, a squint

to cross-fire sewing of hurt at top left; the
bruise is glossed by 'nothing much' but drains
to deep excitement. His recall is false but the charge
is still there in neural space, pearly blue with a
touch of crimson.

commenting that "It is to the practice of Prynne and Crozier that contemporary poets will turn if they wish to seek models capable of encompassing more diverse areas of thought and experience than can be treated in the modes that have prevailed until recently with British publishers and reviews. (...) The results are as rich, complex, and as powerfully original as any poetry written in the English-speaking world in this century."

One way of validating deconstruction is simply to hide the reality outside the text. Claire Buck writes on poetry and the Women's Movement, retrieving the behaviour of a society existing both outside and inside the poems, which exist in a language which expresses parts of a semantic matrix which is learnt and produced inside situations; of disagreement, reflexive modification, inconsistency, and rapid change of a behavioural code existing only in 58 million defective copies; of dialogue generating symbolic operators which transcend and precede and organise poetry: the poem is perhaps closer to the collective composition than would appear. Buck catches in words a shifting set of hopes:

the status of the personal is a touchstone of authenticity because 'we' cannot rely
on existing ideologies as they are all products of male supremacist culture.' (...) Every
kind of day-to-day experience, and women's feelings about the experiences, are
included and explored in the poems: work, friendships with women, domesticity
and family relationships, abortion, childbirth, and sexual relations(.),

although she does less well at linking her chosen demonstration of raising texts (the bad anthology *One Foot on the Mountain*) with her chosen good poets— Riley, Mulford, Fell—whose work is not in that anthology and is less politically hurrah. Their work is excluded from most women's anthologies because of its withdrawal from the *more gratification, more me* project:

the more effectively the poems disempower the 'self', the less they have an obligation
to the 'law of legibility'. Thus, Riley's verse is exemplary of how feminism can use
avant-garde poetry to investigate the effect of ideologies of gender and the self within
a poetics and a politics of representation. But the result is of necessity a 'difficult'
poetry... (T)hese demands, and the nature of their work's critique of experience, have
also left Riley and Mulford to an already marginal feminist poetics.

Not only the adoption of critical sociology and phenomenology, but also the socialism of all three poets, have been interpreted as reducing gratification, and so as old-fashioned and even authoritarian. (None of them is difficult or avant garde.) The alliance across this gap is precious, asks for the forfeiting of

principles whose assertion forfeits the chance of everyday effectiveness, is a mere notion, and a thing to treasure. The modern poem is a temporary agreement between writer and reader about how the world is, and about what our wishes currently are; as the poem fulfils and also changes the latter, they and it become temporarily the most significant element of the former. Any social situation is, it may be, structured by such unstable agreements.

Struggles have continued, elsewhere within the Left, between jolly clapalong Pop poetry, like Adrian Mitchell's, derivative of hymn form and of the Christian youth club, and intelligent critical poetry. Scotland and Wales failed, unlike England, to develop a new and formally modern poetry during the euphoria of the sixties and early seventies, as nationalism and folkism crowded out Parisian philosophy and the Counter-Culture; in England, the institutionally dominant empirical and moralised verse traditions were swept up in the later seventies by a hateful backlash against the new politicised formal innovation, which has produced, underground, almost all the modern poetry worth reading. Neither volume registers the best Scottish poets born after 1925; but their largesse fills so many other gaps.

It is comical to find Anthony Easthope at one end of *CBP* denouncing the transcendental ego, the empirical self, and conservatism, while at the other end we find extended praise of poets, from "underprivileged" groups, wallowing in exactly those sloughs and being called post-modern because they are mending the holes punched in the self-maintaining ego by modernity. The marketing problem of rebadging culturally conservative and nationalist writers from the minorities with the designer labels post-modern and post-Structuralist is handled by a number of writers here with the scrupulousness and self-denial of a Japanese manufacturer filling out an application for EU subsidies; the kind of contortion involved will probably characterize, as a Gadarene fit, a whole brief era. For Linden Peach, the reterritorialisation of Welsh belonging poets is post-modern, because it comes after, and so is post, deterritorialisation, which is post-modern. Poets who write in clichés are said to be incorporating popular forms into their work in a knowing way: more unoriginality is more self-consciousness.

It's time we listened to naebody but oorsels, TS Law (Fife) said around 1983; words wasted on poets. The more poetry rejects the traditional means of literature, the more literary it is; the more aware of its relation to other poetry, and to failure, it is, the more differentiated and refined it becomes; poetry close to conversation and jokes is conservative, narrowly repetitive, and not fit to print. By abandoning the claim to a shared ownership of the means of production, so as to take part in a political-semantic system where we have no part in those means, we are released into a shared acoustic space where every cubic inch is a gobbet of vocal contention by turgid-pressure groups who forthrightly assert

the denial of each other's claims: We must throw our own fish-guts to our own sea-mews. The claim not to be understood writes off and down any attempt to represent society, even to yourself. In the ashes of the razed building, poets can either search for new glimpses of the mind experimentally and cumulatively, or renounce writing anything introspective, subtle, or original; as Clarke, Harrison, and Duffy have done. The bridge between the phenomenological self-awareness of a Denise Riley and an Easthope, and the communitarian single-issue pressure groups, is composed of friendship and false words. The policy weakness of (post) Leftist leaders like Clinton and Blair may not be down to character but to the mutual distrust of their conditional supporters. Because there is no principle they can safely offer, they fall back on looks and person-ality: precisely this is the object of dissection of modern-style poetry, and the source of dissensions of taste. Or, we can describe poetry as a mature product because it is small batch, high end, low kilogram design-heavy, near-zero turnaround, highly customised into a spectral market.

The declared intent of Huk and Acheson, to arouse new interest in America in British poetry, may hang fire, because British poets of 1966 really are thirty years behind American poets of 1996, and fifth-rate British women poets really aren't quite as good as first-rate American ones. Both books exclude the little magazine, as a source of information, almost entirely, yet are decorated with sneers about the academic world; the connoisseur who does not wish to face the frustration and misdirection of the little magazine data glut can pick up recent history in the anthologies the *new british poetry, Floating Capital, Dream State, Contraflow on the Super-Highway, However Introduced to the Soles, Out of Everywhere,* and *Conductors of Chaos.*

Fietz and Ludwig's book seems more indebted to EU regional policy, and offers a scattery fun polemic by Christopher Harvie; essays on the history of the out place; a chapter on Poetry and Place; surveys of contemporary Welsh poetry in Welsh (1950-90), Welsh poetry in English (roughly 1979-94), Scottish Gaelic poetry (1945-90), and Irish Gaelic poetry (roughly since 1945); poetry and place in Irish poetry in English since about 1930; and essays on George Mackay Brown, Waldo Williams, Charles Tomlinson, Tony Harrison, Gillian Clarke. The Second (Anglo-Welsh) Flowering is omitted here, as the subject of wonderful books by Tony Conran and Jeremy Hooker. Ludwig and Fietz offer the germs of a solution to the underdevelopment of literary thought in Scotland and Wales. Except for a startlingly weak handling of Tony Harrison as the laureate of Leeds, they fall down on England: are we to presume that the whole of England is a metropolitan area? This enables all concerned to sidestep the strong stylistic resemblances between Scottish and the Welsh poetry and the English equivalent, so that if far-flung poets stand out from the Oxford and London *Hofsprache* of the present day, it is because they belong with English poetry of much older generations (for example the hymn writers, the Georgian,

New Romantics, Movement, and Pop), which thrive yet in the English regions.

Gareth Alban Davies' article on poetry in Welsh describes its social milieu, for example observing how eisteddfodic poets

> traditionally, were ministers of religion (...) The decline of organized religion means that (...) the eisteddfodic poet (...) has migrated to (...) teaching, the law, or radio and television. In other cases, however, he remains the rural shopkeeper, or farmer, or craftsman.

The fight for survival has promoted real awareness in the cymrophone literary community.

Swollen with spatial information, both volumes are weak on stylistic analysis, typification, source analysis, topic analysis, intellectual milieu, periodisation, classification, isolation of distinctive features; the prose, instead, claims alliances for favoured poets through common ancestors and positions. Accurate philology might cause these relations to wisp away and vanish. The face hidden behind all this careful misdirection is the common Protestant culture shaping the formal speech of all three countries, replete with evolved forms on all scales which are ancestors of modern notions of autobiography, genres, codes of sympathy, imagery, and phraseology. The staples of Anglo-Welsh, Welsh, Gaelic, and Scottish poetry of the last forty years correspond closely to the solutions, combining Christianity, close reading, personal witness, and a taste for the Metaphysicals, worked out in England and America during the 1950s. As the imagined community is the parish, so the individual life is written as a curve towards atonement, a line away from the self signalled by irony, restraint, shunning of rhetoric, careful listing of details, and scrupulousness of style, looking outwards with pastoral benevolence; the traditional is admired because communal. This art-game has its combinatory potentials, but the bad faith, signalled by the contortions of Linden Peach and K.E. Smith here, of many of the principals in owning up to it, points to a lack of consciousness and conviction, affecting the quality of aesthetic decisions. The poets who get most attention, across the two volumes, are Gillian Clarke, Carol Ann Duffy, and Tony Harrison. Advocacy of the sociologically weak is ungrudgingly extended to the artistically weak.

> The washing machine drones
> in the distance. From time to time
> as it falls silent I fill baskets
> with damp clothes and carry them
> into the garden, hang them out,
> stand back, take pleasure counting
> and listing what I have done.

— as Clarke is quoted, on p.379 of *CBP*, allegedly as an example of up to date

British poetry. One would have thought that the jumping-off point for modern poetry was the Counter Culture, and that the theory underlying the play with identity was the Left conceptions of alienation and anti-capitalism; neither the Counter Culture nor the Left come on stage here, unless in the sublet forms of feminism and (modified) Black awareness. The eclipse from tribal memory of the Movement Poet cum academic seems likely to be followed by the eclipse of the socialist poet cum white man, apparently unwished-for. The imperative to help the weak (no notion is offered of Jewish poets, because they are assumed to be middle class) points towards the Welfare State, but in a non-transformatory, self-effacing, receptive benignity which is only a few inches away from the hated 1950s predecessors.

The subverted centre here is the Movement, written off, as seems likely to be the final word, in both books; good at institutional and media warfare, accumulating enemies. They were bad poets, not bad people: the effacing of stylistics, in favour of personality and background, means ironically that the Movement's legitimate legacy, in the flattened and colloquial style of Gillian Clarke, Douglas Dunn, and John Davies, for example, goes unnoticed. Easthope's attack on Donald Davie is accurate and well put, but the Movement's grand fogey-ogre may have been perfectly right in his descriptions of the abiding mainstream of all-British poetry, in 1996 as in 1956. If you felt hungry after Enright, Amis, and Conquest, you're going to be starving after Clarke, Harrison, and Duffy.

Fiction

Jane Fell

Christmas Past - Caring

The sun rising late that bleak winter mourning keening thin-ill-wind whipping up ill feeling, (together with resentment, and jealousy - all together again - uncomfortable with each other, with what they felt about each other - unhealthy) proving fatal. No warmth, no love lost between them; no contagious laughter to save the day wearing on. Disturbed, black-garbed, rattled - snake, baby, death - not necessarily in that order - of the day: silent hatred. Distant family huddled in the cold; gathered in a tight umbilical knot - thick as thieves. Crowded at the open grave - like bloody vultures. Their dead willing them to be there in the flesh - maybe secret hoard - lest ignored towards end of all and be.

Picturesque parish church - surrounding village outgrowing it - spreading. Country memory lanes bulldozed and widened. People forgetting their roots: the yews in the graveyard - and the corpses buried there; strangers.

The snow falling in the hole as they stood and froze - with blood running in family cold flesh. The knot of mourners - in this bleak space - in their finest black; while just outside, the real world was decked out for Christmas. The red town strung-out - (with bright fairy -as opposed to angel - lights, bare trees glittering with childhood vibrant, strong colour made glamorous) - like at least one of the mourners, ropy.

Ancient graveyard; the last of the very old mourners were dying away - churchyard too crowded to be buried with their beloved dead. The cemetery filled to capacity (to depress) with corpses: maybe room for one or two more. As it was, ancient dead would soon have no one left to tend the graves - or dance attendance on them. (This late, great corpse having bought a burial plot for himself - years before: morbid or what?}

The mourners having thrown dirt on the coffin, turned their backs on it and went. The snow falling heavy, filling in the hole as the earth was shovelled back by two lazy sextants, taking five - man alive - getting a little high (having had covert drags on happiness - in the sidelines) - slipping gold rings off cold dead fingers, and onto own.

Late afternoon when the funeral coming to an end, eventually - growing dark. Night drawing in with smoke. A bit nippy, the diggers nipped into the vestry for a nip of whisky, or brandy (anything but bloody wine!). Liquid fire in (pot) bellies spreading - inside. The church hollow, high and wide, and echoing - not so forbidding when warm glow inside. No candles lit. Would be some when drunken stragglers staggered in, on Christmas Eve. Expecting no big turn out - in the cold. Diggers downing their pick and shovel, or whatever the fuck tools

they used, and downed the demon booze. While outside noisy nippers threw snowballs at the ancient, leaning headstones that were like huge and crooked loose teeth - and played Hide and Seek around, and over graves.

Not many flowers or prayers brought to those who died, more than one lifetime back. The cemetery somewhere for kids to play, as night approached. In a built up area, not many places for their games in crunchy, squeaky clean, white snow - virgin on the graves - to sink knee deep in: salt in the outside world keeping snow away. And later, when it was dark, those slightly older kids, gathered to smoke and swill cans of lager, slouched against mossy grave-stones that were covered in graffiti, striking matches on them. A good spooky, creepy place to copulate in black silence penetrated with (ghoulish) laughter.

Coming down to earth, the diggers shovelled it in, half-hearted, apathetic: job not finished off. They threw wreathes left behind by the mourners - on to the molehill making to be buried by white grief. Then the diggers went home, and scrubbed their dirty (someone's got to do it) deed off.

Christmas Eve. Full of beer and cheer, merry on sherry and high spirits, fair-weather Christians going to church to top up on cheap sentiment and wine, and song - and even women coming at end of day, all said and done. Milder tonight, thaw setting in. Nostalgia and romance in the air, everything turning slushy. Vicar floating up and down before bleary, glazed eyes - up and down in his seaworthy pulpit; more like a cockpit to some. Sacrament the taste of things to come.

Afterwards in the cemetery young revellers, cracking open and entering into high Christmas spirits. They formed a 'Conga' line and wove in and out of the graves, as bells rang out merrily on high, they danced and sang each to a different tune. Having a ball in the snow - lying in it in a hell of a state with chance of a snog and a fondle being discovered. A delicious shivering thrill. Stopped when the little, fat flat-capped verger put them to rout: all except plain Jane, on her first night out for ages - her spouse at home drunk himself, out cold and dreaming her nightmare.

She lay where she fell, on a blanket of snow on a grave - misgivings to be alone with her thoughts, and cold. Her aching head, and maybe whoever's corpse she lay face down on - spinning. Coming around cold stone sober - thawing down and out - neck stiff, clothes wet and clinging; her teeth chattering.

What she thought were giant, grotesque, hunchbacked snowmen now revealed, as snow dripped, were masonry undercover stone (avenging) angels putting wrong to right. Making sure the dead stayed that way. And she shuddered, fear creeping up on her - spine tingling, and needing to pee. Hot, hissing yellow torrent that unlike men she could not write her name in the snow melting.

As she squatted she fell against a statue meeting no resistance - giving in, just like that, enveloping her (with icy horror). Falling into the lap of something -

compared to stone - soft, that was no angel.

She jumped up - sudden flash of cold pain in her head, behind her eyes; and she spun round and shrieked. The figure inside the snowman - as she brushed (not braved, but compelled to do so) with numb fingers the Christmas white away, was a man all right; but it was not all right - it was a bloodless sack of loose bones slumped against a gravestone. It flopped over at her feet. She heaved it off with her foot, then raised it to slump again against the stone. A limp perished monstrosity, with only half a face, grey and drawn and painted - colours running. Accident leaving it with one arm hanging out of socket, and only one eye in, another crusted with snow. Nose, one big hole. Flesh beginning to rot as it thawed - dislocated the jaw - face gaping. Where the fuck was she - beyond (caring) the grave?

The corpse before her - beginning to hum to the tune of the bells in her head that Christmas morning - waiting to escort her to merry Hell. 'What the Hell!' she said, sitting beside the corpse, letting it lean on her heavily, taking the mistletoe out of her pocket, holding it (everything his fault) over his head, and kissing the slack lack of mouth and almost smiling, as she said,

'HAPPY CHRISTMAS DAD!'

Kay Early

The Frog

The girl stared with loathing at the frog. It stared back. The repulsive shiny green body sat on a flat stone edging the well. Her mother let go of the child's hand, bending to fill the aluminium bucket. The well sometimes filled so that water spilled over into the garden. The small pale face peered over her mother's shoulder at the dark depths. What if tadpoles were scooped up and her mother didn't notice. What if *she* didn't notice them in her glass and swallowed one; a frog would grow inside her. Horror stemmed further images. She felt sick. Suddenly the frog leapt straight into the undergrowth. A few blades of grass shook, stood still.

She watched as the woman stood up, taking the weight of the filled bucket in one hand and stretching the other arm to balance herself. They walked back along the flagged path, the child marvelling at the shine on her mother's hair - the golden curls flecked here and there with grey. She longed for hair like her mother's. Her own hung straight and dark covering her ears. A pale hand strayed often to the wide pink ribbon holding the fine strands in place. Sometimes the ribbon would slip off, sometimes it got lost. Now and again her mother would plait the fine hair with strips of rag. These torturous episodes left her with an unnatural frizz which stuck out at different angles.

The long grass waved in a light wind. Since being stung by nettles she didn't like to play there. Tiny hot pokers raging at her bare legs had sent her running to the kitchen. Her mother had carried her hurriedly through the garden. "Show me where the nettles are."

Clinging to the woman's neck sobbing, she'd pointed to the grass, the flattened patch where she'd fallen displaying dark clumps of nettles. Picking a handful of large leaves her mother had rubbed them into the reddened skin. "If you ever get stung again, look for the leaves and rub them well in." The pain had subsided after a while.

Shouts in the distance. Her older brother and his friends; trying to catch fish with bare hands. The river kept them there for hours. She was too young to join in - three years difference a lifetime when you're four. Anyway, they teased cats and killed things.

The wind cried in the night; no moon, no pale light to shine through curtains. Burying her head under stifling blankets, the girl thought about the frog. It must be asleep. Did it sleep in or out of the well? She could see its' beady eyes watching from under the water.

Morning brought rain. The child played with her rag doll; a Christmas present from her aunt. The brother was out, his boisterous gang calling for him early.

She'd stood at the window watching them push and shove each other, darting under the archway to the garden.

The rain had stopped. She loved the smells after rain, weaving around her, drifting up her nostrils, almost tickling. The green smell settled at the back of her throat. Accompanying her mother to the well she watched drops of rain fall from the forget-me-nots alongside the path. The clear soprano; high notes floating through trees, disappearing over the stone wall. Her mother didn't sound like the lady singers on the radio. Sometimes they wobbled, especially on the high bits. Mother's voice never wobbled.

Often the young widow had told her daughter how, when she was a girl, barefoot and full of the business of having fun, the priest on his weekly round of the school would send for her. Standing before her audience of two - headmistress and priest - she'd had a fit of giggles when asked to sing. The town's only music teacher had offered to train her voice free. She'd refused. "But why?", the girl had asked. Her mother had laughed. "I'd have missed playing with my friends." The child didn't fully understand what was meant by 'a trained voice'. Sometimes she'd get the feeling her mother wasn't with her when she told the story - like having someone beside you but feeling you were on your own.

Dancing down the path in front of the woman, listening to the clank of the bucket handle the girl suddenly stood still. Something lay by the well. She crept forward. The frog, motionless - dead. She felt a great surge of relief; it wouldn't jump at her anymore. Her mother's voice behind her.

'Those boys, how many times have I told them to leave things alone. Out of the way child.'

The girl stood back. The woman picked up the frog and flung it deep into the bushes, its stiffened legs silhouetted against the dark green foliage. The child felt a faint stirring in her chest, almost like pain, and then it was gone.

David Kendall

Screaming

'Your room needs tidying.'

On the dark roof space of Gotham City the Joker's trap sprang open. The fist-in-a-box caught the Batman just below the ribs. He clutched for something to break his fall.

'Are you listening to me?'

The whine of the hoover vibrated in my ears. I swung my feet on to the sofa to escape its slurping sweep of the carpet.

'Don't put your feet on there.'

I held my feet in the air while the Batman clung to a section of iron guttering. A crimson smile splitting his powdered face, the Joker aimed his giggle gun. The guttering began to give way.

Clickerty-click. Anna's hair pins scratched up the hoover's throat.

'You could do it now. You aren't doing anything.' Mum jabbed the hoover to a slow stop with her toe.

The Batman writhed in agony his muscular body about to rip open with laughter.

'Do what?'

'Your room. There's comics all over the floor.'

Where was Robin? He'd been there at the beginning. Was he waiting out of shot, biding his time? Or had the Joker's psychosis-candy finally taken hold? The guttering collapsed and the Batman dropped to a ledge. Two pages left.

'You won't be able to get in your bed tonight, there's that much junk.'

Slowly, chewing his lips to hold the laughter in check the Batman got to his feet. The Joker watched in astonishment as his enemy flung himself into the air. Landing on the roof he walked towards the now worried Joker.

'Will you stop reading that rubbish, and listen to me?'

With one page to go the comic was snatched away, leaving two tiny half circles between my fingers and thumbs.

'Don't glare at me like that. You shouldn't have held on.'

'I was reading it.' The pitch of my voice strove to rise, I smothered it with an imaginary duvet. Emotional extremes were a sign.

'You don't call that reading.' The pages fluttered harshly as she dropped the comic behind Dad's armchair. 'Robinson Crusoe's on the telly. Why don't you watch that?'

'Seen it. Loads of times.' Crusoe and his ex-cannibal, Friday, skinning goats and talking about religion. And it was in black and white.

'Well, go and tidy your room before your Dad comes in for his dinner. We

didn't move here just so you could mess things up.'

I knew why we'd moved out of York. For Mark. Dad wouldn't look in my room. He hadn't since we'd arrived six months ago. Before that I'd shared a room with Mark. Dad had often come into that room to talk to us when we had nightmares. Mum said Mrs Hawkins next door was always complaining about the noise. I'd kept the scream buried deep since we moved. Now, it was the Wilsons next door. Mr Wilson was the milkman, and sometimes the drone of his cart would wake me in the early morning. It wasn't right, Robin not being there: he was always by the Batman's side. perhaps he had arrived on that final page.

With the bedroom tightly closed I sorted my comic collection in chronological and then alphabetical order. Downstairs I could hear Dad sharpening his carving knife to the wet slap-slap of Mum mashing potato. Anna tapped on my door. 'Dinner's ready.'

Now she was the eldest she always had to be first, the one in control: the pretend grownup. Placing the last crisp edged pile by the bed, I followed Anna downstairs. We both ignored the open door of Mark's bedroom. Even though I didn't look, the large poster of Siouxsie Sioux slipped into my head. Mark had thought she was gorgeous. She seemed a bit odd to me. Too much black.

'I hope it's tidier in there now.' Mum sieved peas over the carrots already on my plate.

'It is.' I wished I had something to read but last week's no-reading-at-the-table ban was still in force. With my fork I sorted the peas and carrots into separate piles.

'Nice piece of mutton this, dear.' Dad cut the string tied around the bone of the joint, 'Tender.'

And greasy. Mutton was always greasy, that was how I knew it from lamb. Age made them taste different even though they came from the same animal. I liked the dark well-cooked meat close to the bone.

Dad smiled. 'This for you?' The knife slid through without pause.
I nodded. The meat was deposited next to the dollop of milk-white potato. There was just the right amount of gap between them.

'Don't you have homework to do?' Mum collected the empty plates into a pile, squeaky-scraping the leftovers for the birds. She liked living in the countryside; said the air was good for us.

'No.' Fixing on Anna, I dared her to contradict me.

'Would you like to give me a hand in the garden then?' Dad asked, his fingers tapping out a Morse plea for cigarettes. He was only allowed to smoke in the garden.

Anna's eyes lit with laughter. I kicked her under the table.

'I have to -' The phone brought me time to think up an excuse.

'Is that for you?' Dad grinned at a now blushing Anna. 'Wouldn't be that Justin would it?'

'Give over, Dad.' Anna returned my kick. 'Could be for any of us.'

'Daniel. It's for you.' Mum called from the hallway.

'Who wants to talk to you?' Anna next kick missed.

'How would I know?' Smiling I pushed back my chair.

Mum handed the receiver. 'It's James. And lift your chair next time. You'll mark the carpet.'

Wednesday's child is full of woe. Thursday's child has far to go. Had any of us been born on those days? Don't listen to them, Mark had said. They'll try and boss you around but don't let them.

'Jim?' I kept my voice low and listened hard. 'What's up, mate?'

Earthy laughter exploded in my ear, 'None of your business. What you doing this aft?'

Mum and Dad were too close to risk a 'fuck all'.

'Nothing. You?' I listened to the spaces between his words.

'Going out. You wanna come?'

I could hear other voices in the buzzing background; shrill laughter and the banging of heavy boots.

'Your parents out?'

'Gone to ASDA.'

'Lucky you. Where are you going?'

Behind Jim someone yelled, 'We're off Paki-bashing.' More laughter.

'That Geoff?'

'Yeah,' Jim's voice dropped a level. 'Him and Solly just came round.'

'I'll be there in a half hour.'

'Okay, Danny. See you then.'

After Jim had hung up, I kept the receiver pressed tight against my ear, waiting. Nothing. No voices. No voices.

'Are you going out then?' Mum knifed her way through the rhubarb crumble.

'Yeah.'

'Have your pudding first.'

'I've got to get ready.'

'But it's your favourite.' She whined, flopping sections of crumble into waiting dishes.

Not my favourite: his. She'd put too many plates out again as well.

'So where are you off to?' Dad called as I took to the stairs. I could feel the matey-snare in his question.

'Nowhere.'

'Nice place,' he laughed. 'How do you know where to go?'

'I'm off round to Jim's.' Taking the last three steps in one painful stride, I escaped.

My main problem was which T-shirt to wear: Guns 'n' Roses or Metallica. Both were covered with violent colour. I chose Guns 'n' Roses. Geoff had a Metallica T-shirt. He'd gone to see them in London. No point in giving him an opportunity to boast.

Paki-bashing. But there wasn't anybody like that in the village. Mum liked that.

'Too many of them about now,' she used to say when we lived in York. At school there was Sarah and Alexander Matiasz but they were as much French as black; more really, with their heavy accents and flash clothes. There were a few Asian kids in the year below but they got on different buses to us. I was more bothered about how Geoff had been niggling at me the last few days. Nothing specific, it just seemed it was always me he was having a go at. He could be such a wanker. He reckoned he'd got off with Jayne Bryce the other week, at her house. Said he'd put his finger up her, and then licked it. Neither Jim or I were sure whether to believe him. All we'd seen was Jayne mouth 'piss off' to him when he'd thrown darts at the back of her head in Physics.

'She's a real blonde,' Geoff had said with the air of someone imparting vital information but I'd never thought she wasn't. Bleached blondes were different: Anna's brown eyebrows cried out against the orange thatch above. Mum approved of this change but not of my own attempts to darken.

Dabbing at my fringe I tried to shock it in to life. The result looked confused rather than upright. Hair spray might help. I could hear Anna thumping about to old Bowie in the bedroom opposite.

'What do you want? What have you done to your hair?' She tried to touch it but I pulled back.

'Can I borrow some hairspray?' Facing each other we managed to avoid looking left down the passage.

'Thought you were going out?'

'I am. In a minute. Can I then?'

'I want it back before you go. And don't use loads.'

Retreating back into her room she plucked a tall cylinder from the cluttered dressing table. Some of the items were hers, others were donations from Mum. All I'd been given was an old electric razor of Dad's. Interesting but pointless.

I sprayed carefully in front of the mirror, holding my breath until it hurt. The result was wet and sticky but definitely spikey. A card fell from its blu-tacked place on the mirror's edge. Happy Thirteenth. I left it on the floor. I was late, and still had to bike over to Jim's.

'Oi. Where's my spray?' Anna grabbed for my elbow.

'In my room,' I called, using the banisters to take the stairs four at a time.

Mum was safely stacking plates in the kitchen, only Dad to walk by. Slipping on my denim I sauntered past.

'Aren't you going to be late?' he asked flipping the cigarette packet over. 'And what's the matter with your hair?'

'Nothing. I like it like this,' I said softly.

'Like what?' The noise of the plates stopped.

Holding Dad's gaze I tried to elicit some male solidarity.

'Off you go then,' he muttered. 'I'd better make a start on that garden, or your mother will be after me.'

We both eyed the door into the kitchen.

'She'll settle down again soon. There's been a lot of upset lately.'

What must it be like when they were on their own? When there was no one to organise.

'Yeah.'

Did he really think I didn't know what was going on?

Closing the door behind me, I grabbed the bike and pedalled like mad all the way to Jim's house. Unlike us, stuck in the middle, Jim's parents lived outside the village near the riding school. Dropping the bike on the gravel I glanced in a window. Despite the drips of sweat my hair was still upright: sort of.

The door opened. 'Come on. My folks will be back in a minute.' Jim pushed me out of the doorway followed by Geoff and Solly.

'So where are we going?' I eyed the beer cans in Geoff and Solly's hands.

'Told you before, dick-brain.' Geoff slurped noisily from his can then wiped the creamy foam from his face. He was wearing his Metallica T-shirt. 'Paki-bashing. You still like them?'

'Who?' Fear crept up my legs.

'Them, shit-for-brains.' Geoff stabbed at my own T-shirt.

'They're okay.'

'Haven't seen them though, have you?'

'Only because they didn't play here this year.'

'Proves they're no good. All the good bands play England.'

Jim passed me a can and a look of sympathy. 'Come on, I don't want to be stood here when my parents get back.'

The fear shrank away but I thought the ghost of a whisper hinted in my ear.

'If you know where to look,' Geoff was tapping his thin nose. 'I can smell 'em.'

Solly giggled. He giggled high, like a girl. I didn't much like Solly. He was too much Geoff's monkey. At least Geoff could be funny sometimes. Jim was my only real friend. The other two came along with us because we were all the same age. We'd met at the bus stop waiting for the school bus. Jim and I had hit it off straight away. Geoff's Dad ran The Bull And Boar which made him handy for beers. Most of the time it was just mouth with him anyway.

'We're going to the river.' Jim took the can back and followed Geoff and Solly down the drive. We took the short cut over the fields. The river was a good place to hang out. On a Saturday afternoon there'd be parents pushing whimpering babies, and grey faced old people getting in our way but we could always find a space to ourselves.

'We can get ice-cream,' I said. On warm days there would be a refrigerated barrow on the patch of grass where you could feed the ducks.

'We can get pissed,' sang Geoff, stalking down the muddy path on short black wrapped legs, the sunlight flaring on his spot-bleached denim to form a misshapen skull. Mum had thrown a right fit when she'd found me in the bathroom dousing my own jacket with Domestos.

The first of the cans were empty and thrown when we reached the bridge spanning the river. Solly produced two more, and we cracked them open as we walked through the parked cars. Now I wished I'd come on my own. My head was swimming with the sun, and I wanted them all to go away. It would be peaceful here if they'd go. Leave me to watch the water plunge over the weir: the fishermen crouched like Barboured gnomes.

'Down here,' shouted Geoff, waving us to the river bank, and away from the toddlers and picnickers. Here the grass was untouched, pushing up through smooth stones from the river.

Squatting on our jackets, we popped the last of the cans, laughing as the warm liquid spewed over our legs as we frantically clamped our mouths around the rims. We spent the next hour or so fooling around, and listening to Geoff go on about some movie he'd sneaked into.

'Blew them away. Fucking brilliant it was. He just stood there with this great fuck-off machine gun and wiped them out.'

The sun was too bright, squinting my eyes. My head was heavy and tight.

'He had this knife too. And when he ran out of bullets he hacked then up with his knife.'

'It was just a film, Geoff,' Jim passed me a slurp of the remaining beer. I shook my head.

'I know that, but if you know what you're doing you can do a lot of damage with a knife. Look,' he commanded.

'Shit. Is that legal?' Solly was positively drooling as Geoff showed us his clasp knife.

Geoff snorted like his nose was a drain. 'Course it isn't.' He tucked the knife away from view and looked over at me. 'Go get us some ice-creams, Danny-boy.' From another pocket he pulled a handful of change. We searched our own pockets and I pooled the money in my hands. The walk would clear my head. Solly hadn't given me enough but I couldn't be bothered to argue. 'You all want flakes with them?'

'Yeah, and hurry up.'

Shading his eyes Jim asked whether I wanted any help.

'No, I'll manage.'

Scrambling up the bank, the world lurched and spun to the laughter behind me.

'Piss off the lot of you.' Biting my lip I got the dizzied world under control. I

could do this.

'Four cones please.'

'Right.' The ice cream man's face was shiny jet above his white shirt. Grey fuzz drifted down from beneath his cap. There was no Man Friday bone necklace. 'Beaut of a day.'

'Yes.' Did Geoff know about this? Was this why he'd brought us here? I tried to remember if it had been his idea or Jim's.

'Haven't seen you here before,' I offered as he curled the vanilla swirls expertly up the cones.

'First week.' A chocolate flake was pushed into each ice cream.

I reached up to take the cones then froze at his next words.

'Not many of us darkies round here. Is that what you're thinking?'

Crusoe watched huddled figures eating around the fire, his stomach churning at what they held to their mouths.

'No. I wasn't thinking that.'

Geoff had a knife. A fucking big knife. What was he going to do with it? The whispers crackled the corners of my mind. My fingers were wet. Cold. I had the cones in my hands and they were already beginning to melt.

The seller smiled as white as his ice cream.

'I've had a long time to get used to it.'

But I wasn't thinking about him anymore, just worrying how I was going to get the money out of my pockets without dropping the cones.

'Give them here.'

Gratefully I handed him back the cones, and clinked the money onto the side of the barrow. Taking back the cones I nodded my thanks.

'No problem.' His voice lowered, 'Take it easy on the beer in this heat. Know-what-I-mean?'

Again I nodded then shifted away as more customers approached. The cold taste dislodged some of the heaviness in my head, almost made me feel normal.

'So?' Geoff almost made me stop the cones with his shout. He snatched one for himself.

'So what?'

Moans of delight came from Jim and Solly as they discovered the cold release.

'The ice cream man.'

'What about him?' I concentrated on catching the creamy rivulets with my tongue.

'He's a fucking nigger, that's what.'

Jim and Solly stopped eating and looked at one another.

'So?' I shivered as the chill hit a loose filling.

Geoff kicked my foot. 'What did we come here for?'

'Ice cream and beer,' shouted Jim.

'Shut up.' Geoff snapped. 'I told you what we were coming here for.'

'We thought you were mouthing off as usual.' Had I really said that? I hadn't meant to say anything like that.

'You what?' Geoff's cone was melting through his fingers.

'Eat your bloody ice cream.' Jim tried to restore the peace while Solly sat and waited.

'No. I want to know what he means. Come on, Danny-boy, you got a soft spot for them?'

I carried on eating the cone hoping having my mouth busy would get me off answering.

Geoff let go of his cone and got to his feet. Solly made a grab for it. 'What did you do that for?'

'Shut up.'

Geoff stood over me his boot nudging mine. 'I want to know what this arsehole means.'

'He doesn't mean anything. Do you Danny?' Jim's eyes flashed frantic back down signals.

'That right, Danny-boy? You talking crap as usual?'

There was my exit. Admit I was wrong, take the abuse, and everything would settle down. Do what I was told. Geoff kicked my foot demanding an answer.

'Maybe there's nigger blood in Danny-boy. Maybe his Mam got friendly with the milkman.'

Mr Wilson brought our milk everyday. He wasn't black. Why was Geoff doing this?

'Maybe that's what was wrong with his brother. That's why they took him away.'

'Geoff,' Jim warned.

Would Jim help if it came to a fight? He was scared of Geoff. I'd never seen him fight anyone.

'It's true, isn't it?'

The three of us started at the enraged Geoff. Solly with wary anticipation, Jim with fear.

'They took his brother away. No one saw him. Bet he was black.' The knife appeared in Geoff's hand.

'Danny's white, Geoff.' Jim spoke the words carefully.

'So what? Happens doesn't it? And if he weren't black, what was wrong with him. Why was he taken away?' Geoff declared triumphantly.

Now I could see behind that smile. This was what he was really digging for.

'Come on, Danny. tell us what really happened then. Or,' he ran his finger along the blade. 'Say me brother's a nigger.'

'Piss off.'

'Say it.'

'Fuck you.'

'Say it.'

He was right above me. Trying to make me say a lie to find the truth.

'Say it.'

Trying to boss me about. Telling me what to do. Don't let them boss you about.

'Oh shit,' Jim rushed towards me. I waved him back, blood streaming from my left arm

'You idiot,' Geoff looked in horror at the knife in his hand. 'He came straight at me. I didn't do anything did I?'

Solly didn't move. Just sat there watching the blood drip onto the grass.

'Tie this around your arm,' Jim handed me his T-shirt.

'I didn't mean to do this.' Geoff was almost crying. 'My dad's going to kill me for this.'

'You shouldn't have tried to push me about.'

I didn't need Jim's bandage. The cut stung and I felt queasy when I looked at it but I could take that. Don't let them boss you about. Mark hadn't been strong enough. I took a step towards Geoff.

'You could tell them it was an accident, right?'

He was pathetic. I launched myself at him, and we went down together, the knife lost in the whirl of arms and legs. Solly and Jim's yells floated somewhere outside the mist that had settled behind my eyes. Geoff was whimpering and trying to curl away from me. I dropped down hard, stabbing my knees between his shoulder and collarbone. His nose felt hard, then soft, as I punched down. He tried to buck me off his chest. Tried to twist his face away but I dug my knees in deeper, grabbed his hair, and began jerking his head backwards and forwards. And the scream was there again, building in strength for the final ride, tearing itself from me.

'Get off him, you maniac.'

Black hands pulled me from the motionless Geoff. He wasn't telling anyone what to do now. Jim and Solly stared at me like I'd two heads.

'What the hell's the matter with you?'

The ice cream seller shook me but the scream just kept coming.

Music

Simon Jenner

Feasting with Pantheist's Iannis Xenakis in Conversation, 1997

The following was a scrappy transcript of a conversation between the late Iannis Xenakis (1922-2001), the French-naturalised Greek partisan, Corbusier-trained architect, and composer; and Huddersfield Music Department and Festival Director, Richard Steinitz. It took place on Saturday 29th November, 1997.

I

Surfeited with the electrified James Wood and his merry Babel of a choir, we began to hunger after ancient gods, their calm Olympian fury. We hurried off to the real Xenakis; this time the venue was sensibly if belatedly altered to the theatre. Why couldn't they predict such a torrent of interest in such a man?

In the flesh. He was being interviewed by Richard Steinitz. And interviewing was the problem, as the film (1990) which I'd seen here five years ago made clear: he never responds directly or immediately to stimuli or questions. We got nothing much more than civility that way; steely obliquity prised the jewelled in-jokes. Still, Steinitz got in a few stings. 'People here might be startled to hear you're the only composer I know of who's shot people.' Germans in the war and possibly a few occupying British bolstering the right, before being shot himself in the face and smuggled out after an operation, everyone in his communist cell killed by Nazis or the ascendant Right. 'Ah. We were betrayed.' He meant partly by the British.

Xenakis's mother had introduced music to him - as often happened in upper-middle class homes such as his in those days - as a very fine amateur pianist. But she died when Xenakis was six. His father introduced him to Beethoven. His training, interrupted by the war when he'd fought in communist partisan cells and been severely wounded, was as architect/engineer. As everyone else in his own cell had been killed, he felt great survivor's guilt, as we discovered in the film later. His schooling had been so English that his feeling for the betrayal of the British in 1945-6 was acute and seismic. Smuggled out of Greece to Paris he studied and went to Le Corbusier who saw his engineering/architectural skills and as Xenakis said 'listened.' Le Corbusier was open minded and a great man. He'd been at class again in Greece 'not so intelligent' but after a spell in Louisiana for 4-5 years he lived in Paris and worked with Le Corbusier till c. 1959.

Steinitz was quite adamant he'd caught one of the few killer composers - one might add Alberic Magnard (1865-1914) before he was shot himself by Germans he opened fire on in 1914, killing two. 'But I liked music' said Xenakis, which explained, one imagines, everything. It was Le Corbusier who suggested study with Messiaen. 'I didn't understand harmony... Messiaen looked at some of my early pieces and accepted me without any exams. His analysis was of the largest concept imaginable, and my time with him lasted 2-3 years in the 50s. He made no recommendations or pushes, that is why I liked him. It was difficult to get performed.' 'It's still difficult' chimed in Steinitz. 'My first break was in small venues - a German conductor - not Scherchen - championed me. *Metastasius*. The older audience were horrified, the younger asked for autographs...' 'Was it like drawings for architect's paper?' asked Steinitz. 'Not so...' Steinitz asked: 'There was much in the motion of glissandi that could be taken for some of that... but when you took the drawings and designed the Philips Building 1956-8. It was difficult, now easier one imagines - they were happy with it?' 'I was with them who built it.' Steinitz added: 'Your drawings are artistic.' 'I'm sorry!!!!' {roars of laughter}. Xenakis continued. 'They were very good engineers - from Belgium, music lines - I think many disciplines important for a poet...'

'Flow patterns are more important for me than notes... that's easy save for the strings. If notes are needed, you could pick out points on a curve. {Flow chart poetics}. Computer drawing up to a point, simple for children - if only they could programme!! But it's also to do with *energy* and *density*. An inner almost abstract quality is important.' Steinitz: 'Maths in your earlier works generated precise qualities?' Xenakis: 'Well, straight lines, curves... it gets more complex...'

Steinitz moved on to the visual arts, as Xenakis possessed many art works. 'No, not so much, more an architect - I've not liked art so much, even now.' 'Well' Steinitz slightly stymied, 'what about fractals?' 'Mandelblum's idea really, I'm not interested in *fractals* so much, or *polytopes*. Studied with no reference to *visual* or *audio*.'

'About *Persepholis,* lasers become - only straight... light in nature, I was restricted only by the number of lasers.' Steinitz: 'Literature?' 'No - that's my wife's problem.' Steinitz added for us that she was a writer. 'Not translated, though distinguished.'

Steinitz turned with some relief to the conductor Charles Bornstein. He'd encountered Xenakis's music in 1964 in Buffalo. There was a lot of laughter at that - people wondering how a Buffalo audience (bred on Dylan Thomas readings) might react. Well, with laughter. It was the violins and knuckle-knocking the wood nearly out of the halls. By the middle, 12 minutes in, they

were no longer laughing - unlike works of Cage. Xenakis had won his point. Then Takishaki had performed in the 1970s *Eonta* and *Herma*. Bornstein waited to expand, not having to wait for the one drummer who could perform a Xenakis piece but find something transferable, that could be played. He thus learnt all Xenakis. He feels Xenakis is as important as Stravinsky was in the early 20th century (well he would, having taken all that trouble). Xenakis didn't change (nothing against those who did, and rediscovered harmony - er like co-festivalee Lou Harrison?). Discovering deep feeling. Applause. Xenakis asked: 'Is this being recorded?' Gales of scurling laughter.

Xenakis: 'You laugh in the right sense. Don't mind laughter here.' Steinitz: 'Oddly I wanted to laugh in *Cendrées,* strangely, a work I deeply love, I was surprised at wanting to, and didn't dare as you were in front of me! But what I found most haunting was the French inscription in a work I wanted to put on since I heard it on an LP 15 years ago... I slightly disagree with Charles that Xenakis hasn't changed.' CB took this up 'No, clouds of notes, wholly inexpressive, but now are... the primitive {like Stravinsky/Picasso} are steps further back, pre-historic. Love of woman long before Rite... Xenakis with his hands gestured 'maybe' in the balance. 'We're free to believe what we want...' Steinitz added 'You've been simpler recently.' 'I'm sorry - I've pared down perhaps, age... in Glennie's piece *Omega,* a conviction, no meaning..'

Steinitz threw it open. Brian the Prof. of Architecture wondered if he's had his question answered but asked it anyway. 'Le Corbusier's modular system, Philips, Le Tourelle (cathedral), links in spatial terms {Architecture frozen music - in reverse}. 'Yes the golden section I inserted as something I always used. Le Corbusier liked this. Le Corbusier was reluctant to give me credit for Philips etc. That kind of problem. It was his domain.'

A student threw one on randomness, certainly one unlike Cage's though not wholly uninfluenced by him I imagine. 'Randomness can't be turned into a process with other principles. Giving voices..' Steinitz suggested a sense in sequences. An end but with surprises - he'd forgotten the end of *Cendrées* and couldn't recall it so it had been a surprise. Another asked if *Palimpsest* had been created more intuitively than calculated. And consonant. Xenakis said 'Yes, without calculation..' Someone added about a 10 voices piece on a perfect upper major 3rd and perfect 5ths - beginning of understanding of harmony... 'Recalling via sense of harmony.' Steinitz asked about Ehr... CB interposed 'A cluster, that's how his harmonising works - blocks of dominant and tonic - there are precedents in Beethoven.' And with that coming distractedly full circle to Xenakis's first musical experiences we ended.

The Xenakis film followed. Nauritta Mattosian made the film and taking Xenakis round to his old school and elsewhere. His British/French schooling - many masters were English - were lent a peculiar haunted innocence. Much of the knowledge, literature and otherwise, seemed tainted by later events. That this was an Edenic visit, unrecapturable, seemed plain. The Greek partisans whom Xenakis fought with against the Germans, were betrayed by British support of the right in 1946. This made his sudden quotation from Ariel's Song all the more haunting.

Later, a light was thrown unexpectedly from the poet and Wittgenstein scholar Charles Lind. He'd known Xenakis *et al* in 1974 (through a girlfriend now settled on Cyprus). He said Xenakis, Berio, Boulez had all been madly in love with Mattosian. Cathy Berberian, then still Berio's wife, Charles had found rather neurotic. They later divorced but I'm not sure where in the narrative Mattosian featured - probably symptomatic of many ways to end a marriage. Xenakis himself was speechless with passion. Had I known this I'd have watched more closely. As it was she drew a frail touching emotion, welling out of a far greater one, like a flower on cooled lava, with a hint things might erupt again. He recalled his school and classrooms, but didn't seem interested in the visceral physical details which as a scholar fascinated her. This said much about him and his music, points on the curve, not notes.

The film cleverly married natural detail from vibrant stars to dripping rocks and sunsets, to technical memories of his time with Le Corbusier. All this reminded me of something my father had heard in a Hans Keller talk in the 60s. 'Imagine a horror scenario...' He proceeded to play Schoenberg then Stockhausen. 'Not bad, was it?' My father thought it an excellent demonstration of the frame of reference of listening, And a reminder that Benjamin Frankel wrote the first British 12-tone film score *Curse of the Werewolf,* in 1960. The film, made in 1991 by Marc Kidel, also took advantage of the French critic who'd championed Xenakis against a particular brand of French intellectualism and emphasised intuitive feeling and response, that children uncorrupted by sophistication will find something extraordinary. This is a little messianic but one sees what he means. One extraordinary sequence on the critic's Super 8 showed Xenakis responding with intensity to his first 1974 trip to Greece and its landscape. Kidel died in 1990 as the film was being completed, and it's dedicated to him.

As for the subsequent concert, *Palimpsest* (1979) was a percussion watershed for Xenakis in its delicacy and intricacy. A dominant piano with toccata-like part assets a complex rhythmic pattern of great brilliance gradually 'overwritten' as the title implies in a slate that can be written over twice, by

other instruments - oboe, clarinet, bassoon, horn percussion and string quartet. The original material is obscured, and the piano ends by interjecting wanly and becoming a unison instrument. Rather mesmeric, lasting 11 minutes.

The Xenakis premiere rightly transposed to the second half, was the (one hoped not prophetic) piece, *Omega,* he'd apologised for in advance. He feels he's becoming more aphoristic, less disposed at 75 to write large-scale gestural pieces. It reminded me of one of the late pieces of Messiaen second-premiered here, *La Ville en Haut,* for Yvonne Loriod on piano with orchestra. She'd been to the left, Glennie to the right of the platform. But that was eight to Xenakis's two minutes, expressive of comparative lengths of the composers, about the same. Characteristic, not revelatory. A pity really that he'd not written something for Glennie when she'd begun her international career in '88, or shortly after. This is attractive but a stocking filler for her, and for us.

Thallein (1984) demanded on the other hand total attention, as one would expect. It's one thing to illustrate Xenakis on film with natural life clips as coloured explanation but the music always subordinates image, itself designed to illustrate only. 'The main theme which comes to dominate *Thallein* seems like a (Greek) folk melody torn out of one context and with total naturalness in another.' Steinitz's analogy seems precisely apt. *Thallein*'s meaning 'to sprout' shows how with subtle modulations interlacing harmonies can generate from an initial idea. The intensity and visceral impact were as usual in overwhelming evidence, in this wonderful concluding curtain call of the 20th Huddersfield Festival. Also in evidence is Xenakis's tendency to simplify and clarify his procedures as human virtuosity has gradually crept into his work as a constituent. Steinitz suggests the piece reflects an increasing intensification of Xenakis's human qualities, as a Greek patriot. It recalls Boulez in a very different way, becoming more French and instrumentally beautiful and less Darmstadtian, though he'd deny this vigorously. In a very much more sophisticated and important way than say architecture, it reflects the retreat or modification rather, of the great Internationalist sacred monsters into discovering their roots. Xenakis had at last made the Festival, as he'd not managed to in 1992. The applause for Xenakis, led on, was almost as overwhelming and visceral as his music.

Iannis Xenakis died on 4th March, 2001

Simon Jenner

Xenakis

Shooting Germans, then British...
As the world flipped film noir
with the white night flesh of Heinkels, arced
under the cheesewire searchlights of Athens
throbbing bass-notes lit against the stave
then green with suborning Cromwells -

Comrade Xenakis, architect
with a yen for music
fled with his face wound to Paris,
Cyclops eye sliced as a talisman
refusing cosmetic surgery, cradled betrayal -
British schooling -
the education of partisan warfare
and the fire-stepped harmony of Beethoven.

To Corbusier, perhaps: If architecture's frozen music
I'll unlock them both like a Russian spring.
Corbusier: 'Sacre du Printemps is Messiaen now.'
Messiaen set him in the key of dreams
and waived the slow motion shibboleth of exams.

No Teuton's tectonics.
No lit-note counterpoint but echoing curves.
His own Philips Building he swept
in volume and echo the *Persepholis*
that could be played inside
like a door banging on infinity.

No western accretions but a myth-stripped world
with names hacked in consonants
before corruption
Pleiades, Psappha, Kekrops -

The one-eyed man's no king of infinite space
yet reads in the monochrome countries of the blind
contours of algebra growling to it,
noise of Doppler, blue shift notation

sung lines bent with light
notes absorbed like gamma rays
a recurring *Palimpsest,* whose instruments
scribble over each other in scumbled colour.
No sly mineral return to organic pattern
all the retrograde motions of the skin.

No polytopes, or
the fascinating rhythms of new fractals
like Ligeti, or whiff of delicate Berlioz on Boulez.
He weathered only, like his grisaille buildings
as his face shadowed more overhang and dark.

Read the Odyssey, knew 'Who hurts you Cyclops?'
'No man hurts me.'

Being invalided out from harmony
melody glassed forever in a stare
he saw music like a sharded mirror
cut to the air's bone beyond mercury

rung in sphere metal, never to decay
not frail as the memory
of his butchered brother singing
his pianist mother dead before her notes cohered
for the avid six year old with both eyes staring.

And broke free of the consonance of suffering
for Iron Curtain dissident listeners -
Kundera - Czechs - Hungarians -
found tuned in, turned on to solid state
in long waved whistling at 2 am
its unjammed unwowed
interstellar percussion
crashed beyond 68's ring of cracked steel
numbly catchy martial brass as solder.

He'd trust no inner space seeing.
Analogies just breed up like slogans.
The mineral voice lies howling its cause
while the organic one wails at the stars.
The fractal microbiological
inscape of repeating
like Quaker Oats

to infinite decayed regression on a packet front.

But - like ether in the universe we used to believe
or string theories we now believe
like the meta emotion before the words
that live, like marimbas, in absolute pitch -
Pleiades, Psappha, Kekrops -

soar like the flow chart poetics of his curves
(music concrete renforcé?)
that cracked Brussels open in '58
when his World Fair Philips Building
swelled like a Brazil nut in white chocolate
vast with its bitter private joke.

Visiting the flaked amphitheatres of home
after his chrome denials of decades
he still recites *Ariel* as if at school -
Full fathom five
the innocence lies.
He lets the fine dust settle.
It might have sounded something like this.

With *Pi* for all the major intervals
cubing the root of living
scores in 3D hollow the brass silence
till it follows the sound of one eye -

frail as the memory of banished singing.

Simon Jenner

Boulez and Carter at Huddersfield, 2000

Yorkshire blasts 40 mph at you. You're back in the county of cutting-edge music, just like every other late November since 1978. Forget the advertising 'poetry capital of the North' for what most British people have no idea that Huddersfield's world-famous for. The Huddersfield Town Hall was not as full as it might be but the acoustics of *Sur Incises* with its three pianos, three harps and three marimbas need a kind of resonance not at St Paul's. We comfortably sat in the middle.

Pierre Boulez over the past - particularly past fifteen - years, has mellowed; thawed from the squeaky-clean, even infamous squeaky-door Darmstadt internationalism of the 1950s shared with his great contemporaries. It's tempting to see this in terms of personalities breaking in and out of it; though that's only the most obvious sequence, it's still attractive. The divergences perhaps began when Georg Ligeti emigrated from Hungary in 1956, rapidly took stock then kept ahead with a very different aesthetic. Then in 1958 Iannis Xenakis broke free of architecture, the Philips Building (housing Varese), Le Corbusier and even Messiaen (at his behest) to emerge as composer, of a mathematical, yet monumental aesthetic unknown to the total serialists of early Darmstadt. They're symptomatic. The two most prominent of these Darmstadters illustrate the divergence within. Stockhausen, after his beautiful severe serialism of the 1950s, beached up as a rather typical export of German gigantism, so to speak. The kind that younger German composers like Rihm and HK Gruber smile at, not on.

Boulez has become ever more French, ever more delicate in both evincing orchestral colour and timbre in more recent performances of French and other music - and in succeeding recordings of his own. And becoming rather perfumed himself. It seemed to come after such (perhaps Xenakis-like) monumental works as *Rituel: In Memoriam Bruno Maderna* (1973). Maderna's premature end underlined that of the old school. Disappearing from view as a composer for a few years as the BBC and IRCAM took shape beneath baton and budget, Boulez re-emerged as a re-composer. First, as orchestrator of the first four of his early *Notations* (1945) for piano, in 1979. These were blown into hard bubbles of exciting, youthful music, hugely dilated. After that alternated new works like *Répons* (1981) an IRCAM-generated piece using computer response with orchestra, the most serene music he'd yet written. And more re-compositions like *Le Visage Nuptial* (1950/89) for chorus and orchestra, more René Char settings, of a love cycle on its inevitable five-part

trajectory to disillusion. George Benjamin in a Huddersfield conversation with the composer in November 1989 told him it was his finest score ever. (Boulez said to the costive Benjamin incidentally: 'George, go home and compose.')

In this Tribute to Boulez's 75th, The Nieuw Ensemble, conducted by Ed Spanjaard, gave the concert. First came an *Éclat*-derived piece, the beautiful *Dérive I* roughly translated by Paul Griffiths as 'Drifting Derivatives' to give it its Latinate connections. Written as a personal tribute to Sir William Glock in 1984 as he retired from his last post at the Cheltenham Festival, its seven minute span encompasses a 26-bar opening slow movement, which returns at the end, more 'contrapuntally' inventive second part - a kind of prelude and fugue as Griffiths points out. It's scored for that evanescent French delicacy of flute, harp, strings, guitar-type sonority, and entrances with every subsequent performance. If you're unsure about Boulez, this is where to start. How anyone can not see Boulez - and Boulez not see Boulez - as getting more French each decade, more Debussy-like in both composition and conducting these compositions - is a question for Darmstadt die-hards or those who think *it went wrong with dodacophany.*

Eliot Carter offered a relief, and parallel. He too has mellowed - but at a far later age, being nearly 17 years Boulez's senior, and embarking on a 'late phase' only after 75, or perhaps even 80. His work after the incredible costive complexities of the 1960s - when he completed just three scores - has gradually flowered into an expressive, stunningly powerful fluency. Earlier thorniness hasn't softened, it's gained an excitement and clarity that communicate to the listener with huge visceral effect. As if a pitch of complexity was needed to release such forces. Is it too early to predict that most of his finest music has been composed since 1980? Not for most of us. If this is garrulity, let's have anecdotage. At 90, he finished his first opera *What Next?* and of course answered that with more works. From three works in the 1960s one cannot keep pace with the Fifth Quartet, Clarinet Concerto, Symphony in three movements that have rolled off pen and onto CDs - another facet of his popularity. Not even Tippett or the rejuvenated Goldschmidt were this creative in their early 90s.

Luimen thus came next, lasting 12 minutes. This 1997 piece, wrote Carter, was inspired by the sound of plucked instruments, particularly mandolin, guitar, harp. He knew the Nieuw Ensemble had superb players of these instruments and added trumpet trombone, vibraphone to make a kind of Phantasy not unlike that beloved of the British Cobbett Prize of c. 1906-1937. It was lucid, delicate, and spikily complementary to *Dérive I*. Their title, meaning 'Moods' was chosen by the ensemble. The mandolin plucks out a line, the guitar makes a solo riposte and the works ends with the full sextet. The interplay was remarkably gentle, the brass dynamics never threatening to

swamp the plucked instruments.

Boulez's *Éclat* (1965) followed, lasting ten minutes for fifteen instruments. It's middle Boulez, merely reminding one how attractive a composer he was even then in his smaller pieces. And Boulez's preferred middle-ranged instruments shimmer and play off each other. Those of quick decay (vibraphone, glockenspiel) are grouped against those of sustained sound, like flute or English horn. The vectors of sound generated from this tension eventually spawned the *Multiples* that now expand this work. Like all such pieces, *Éclat/Multiples* is a work full of infinite, unfinishable expansion. One facet of modernism for Boulez is the open-ended construction of a modern piece, how it can be revisited and re-worked for ever. This meristem of a piece glimmered, and rarely did one get the phantom ache of its temporarily-removed multiple growths.

Another was in the ordering of various segments of the piece, to be determined at the moment of performance. This was something originally derived from Cage, and such pieces as the expanded *(mais naturellement) Domaines* for clarinet and orchestra of 1971 attest to this temporary aleatory quality in Boulez. Its last real incarnation was merely in which pre-determined order you might wish to perform the orchestral *Notations*. Much of this decision-making has frozen in time, as it were. Performers proved reluctant, and gradually aleatory, chance performing or composing modes have dropped away. They proved their salt, that they were salt, liberating but hardly a meal.

An interval was followed by the single 38' piece *Sur Incises,* provisionally completed in 1998. This derived of course from another piece, *Incises,* a competition piece for piano written in 1994 - a rare return to the piano since the early 1960s. It probably lasted five minutes. This was the ever-expanded meditation on it, with three pianos, harps and marimbas (in this performance) or vibraphones. A kind of complement to Bartok's Sonata for two pianos and percussion, or the concerto for two pianos, this triple concerto needed space to resonate. Rapid toccata patterns alternated with bass strumming, and the whole emerged as the most pellucid, cogently varied piece Boulez has written. So clear did the repeated patterns shine out that at one time it sounded like the most homeopathic drop of acoustic minimalism had entered the soundstream. This, like Carter's orchestral pieces, was perhaps the most visceral music Boulez has written since perhaps *Rituel* 25 years earlier. Perhaps a fairer comparison would be *Kekrops,* Xenakis's piano concerto. But Boulez is both more grand and more intimate.

And Turnage's *Greek*

Diego Masson conducted the London Sinfonietta and a cast of just four. Dramatist Stephen Berkoff had famously objected to not being originally consulted but that had long been smoothed over to allow the rough edges to glitter jaggedly. Clare Venables' claustrophobic set with an inset room sometimes opened up in its foreshortened garishness (green home, the first café scene a terrible pink) but otherwise the flat backdrop with opening doors like a parody of French farce dominated. A couple of glittering chrome tables on a patio café prospering ten years on, suggested amplitude and contentment in the second scene. Various screen projections of riots mainly early in the action fleshed out neo-Fascist time and context; yobs vs. state.

Riccardo Simonetti took the heroic lead, the oedipally sexy Louise Mott his wife/mother and Richard Chew and Louisa Kennedy-Richardson the parents - the brief sister being Mott again who twinned with Kennedy-Richardson as the double-headed lesbian punk sphinx. The other roles - the policeman beating up Eddy, the 'real' father killed by Eddy, were taken by Chew. All sang extremely well, but Simonetti's single role was only alleviated by his not having to sing everything. A demanding but not impossible part. The whole cast is made up of these four in differing roles. There was the obligatory interval.

The Lawrence Batty Theatre was capacity-filled for this perennial break-through opera of 1988 - and now augmented by the success of *The Silver Tassie* in 2000. The most successful opera composer we've had since Birtwistle, and before him, Britten. The transposition of the Oedipus myth to a deprived 1980s-Fascist and Thatcher-infected East End. Eddy sets off to avoid the curse on his parents, fetches up at a café, gets into a fight with the barman and killing him, marries his mother unknowingly. After ten sexy years together his parents fetch up and visit as the couple are about to have sex They begin talking of the Sphinx. He goes and answers it with the stock response twisted (the third leg is a stiff prick in the evening for the wife, not a walking stick!). He kills that, a Lesbian double-act he becomes rather fond of with its expletives 'mother - fucker, fuck off, yeah get it over with, I was getting rather bored'. So then his congratulating parents warn of the Plague, and tell him who he really is - which triggers the usual recognitions. But not the stock eye-impalment. The climax famously flips over the Oedipal role. 'Bollocks to all that' as Eddy refuses to pluck out his eyes after a mock funeral. Instead he joins the cast in a paean to love and 'my golden bodied wife' and goes back after an extraordinary oedipal-erotic speech, to his mother-wife to a chorus of approval from his adopted parents. It still challenges, 12 years on.

The music is more jazzy than the *On All Fours* we saw earlier, as befits its

subject and greater confidence - something *Greek* taught him more than anything else. If Berkoff's language is a 'heady mix of Shakespeare and Cockney' as Turnage put it, his own is funk Stravinsky, lyrical saxophany (as one might term it) and a dramatic score that erupts with, not against its singers. He sounds unlike anyone else, allowing him to meld these qualities into a punchy (both senses) post-modernism.

The pit orchestra is modest, plenty of brass and percussion. The style also boasts a fractured melodic vocal content, eminently singable with plenty of *sprechgesang* for tang. Diction was mostly clear, and though about three left in the interval, including the shocked modernist to my right, one woman said she'd seen it five times and each time different. Repertoire bloodstream then. It's performed more than any recent British opera.

Holbrooke, Bettinson, Farrar, Bowen at St John's

19th January, 2000. As usual with musical concerts (bar Huddersfield) with the cheerfully subversive, perceptive and generous musician, Judy Anderson; always someone to tell you - or the music - that you're talking rubbish. The concert with the New London Orchestra and Ronald Corp - a superb sinfonietta-styled body specialising in lighter and light-textured music - opened with Joseph Holbrooke's *The Birds of Rhiannon*, of c. 1910. Holbrooke (1878-1958) was absurdly nicknamed the 'Cockney Wagner' by snobbish middle class critics unaware of musicians' roots, their own snobbishness or that 'the Cockney Strauss' might have sounded more clever.

The music's taken from Holbrooke's Celtic operatic cycle (paralleling Boughton in this and *The Immortal Hour*) *The Cauldron of Annwn*. It's 'all romantic horn calls and coloured half-lights... a gorgeous score' as Lewis Foreman, reviewing, said. Its Wagnerian tunefulness does indeed explain its popularity, but the reason for its decay and further oblivion is also operatic. First, it's avowedly a condensation of motifs from *The Cauldron of Annwn* and although a symphonic poem, was not conceived from a tabula rasa as such. Perhaps it explains the succession of static 'wows' that come to ear when hearing it like this. Wonderful starts that go less far in this context than they do in the opera. Holbrooke had in common with George Lloyd a superb ear and a tuneful, not very harmonically dense fecundity. It allowed him with several other precocious operatic composers, a rich palate with the opera, and a rather thin and undeveloped purely orchestral voice. Not, emphatically, the actual sound, but the lack of motivic development, where beautiousness as such is left in Edwardian hangings for a breeze to gust up and down with nostalgic effect.

The grain of voices and plot provided Holbrooke, perhaps, with his specific weight, as it did with Lloyd in his masterpiece, the late *Symphonic Mass* as well as the operas. Stanford is similarly seen as misjudged till we know his operas, by all accounts his finest work. I mentioned to Judy that Korngold was similarly incomparable when writing opera, but in the orchestral music slightly thin-sounding, as in the *Baby Serenade,* though not the symphony or concertos. She disagreed. 'Korngold was a composer who could really develop a theme, had more harmonic resources. Holbrooke's going nowhere attractively - a short beautifully evocative prelude to an opera, stretched out too long. Shame. It's really attractive.' Still, it lasted only ten minutes.

Ronald Corp and the NLO had commissioned Oscar Bettinson (b. 1975) to write *Hour Tree,* obviously a world premiere. A theatrically conceived piece for clarinets, placed centrally, where a melodic twirl is passed from them to the ensemble and back, repetitively. We were told we'd go on recalling the melody

during the interval, and it was memorable; but that was banished by the next piece. Bettinson had taken from Birtwistle the theatre play of the piece, and as Foreman says, it works better live than in a recording. A perhaps diplomatic way of saying it's not as memorable, or is too drawn out by itself. Foreman praised its 'brilliantly-imagined, hard-edged music' and it certainly wasn't as soft-grained as some pieces that Corp had premiered - not that I find that problematic unless the work isn't memorable. This isn't modernism so much as cut-down MacMillanism - decidedly as opposed to second-rate MacMilllan. A melodic resource shyly peeping out through sassy attitude. Its palate owed something to minimalism; heard through a guilty post-modernist. Both Colin Matthews' and Simon Bainbridge's early experiences with the same minimal/modern package in the 1970s came to mind. Bettinson has a modern sensibility with some true organisational gifts - just what Holbrooke on this canvas lacked. He's as not precocious as Tom Ades or George Benjamin, but like Macmillan or Simon Holt will start delivering when he's about five years older.

After this the second work on CD (and thus owned already!) Ernest Farrar's *English Pastoral Impressions*. Farrar was in fact born in the week in July 1885 that saw the births of Benjamin Dale and George Butterworth. Farrar and Butterworth were both killed, Farrar in September 1918. Dale was interned in Germany, and wrote less after the war, with a final surge just before his early academy-exhausted death in 1943. Butterworth's small output is most often recalled, but Farrar left much, particularly orchestral music composed in s small space, that is of true value. He taught Finzi who wrote his small *Elegiac Requiem* for him. First, he had a vivid palate, and as Foreman notes the second movement 'Bredon Hill' (what a surprise) foreshadows *The Lark Ascending*. So much of this is memorable and evocative, and should be known as much as Butterworth's *The Banks of Green Willow* and particularly *A Shropshire Lad*. Farrar had later-developing melodic gifts than Butterworth, and of the two Butterworth on this and other orchestral showing still suggests the stronger gift, but not by much. He was simply more precocious - like Benjamin Dale - than most English composers of the time, still forging an idiom. The finale in fact contradicts this, with its title *Over the Hills and Far Away* encapsulating a melody rather different to that one, and wholly memorable. 'Now that's truly stunning, a real disc-overy that'll live outside compact discs; it's got concert hall and Proms life in its nostalgic sap.' suggested Judy. 'And it's big enough for a second item, which is pretty elusive with a diet of miniature British tone poems; often a bit ruminative for an opener too. Makes me want to walk round St John's Smith Square in January.' The one to take whistling to the toilet.

No free wine for reviewers... But CDs on sale, I succumbed and bought Virgil Thompson's film scores for just £12, which I didn't know existed in the Hyperion catalogue. I learnt Fred Perry was there to judge whether the final

item was worth recording.

York Bowen (1884-1961) was another matter again; dismissed absurdly by Tom Service of the *Guardian* for 'Wannabe Teutonism' this has to be countered vigorously, and was implicitly by Foreman, who regarded it as the most revelatory piece. With Bowen's early piano concertos and symphonies this forms a pre-war part of Bowen's output that Foreman felt might contain the best of his orchestral work. Certainly the bulk of it. The Viola Concerto, naturally written for Lionel Tertis in 1906, was a big-boned work (13'16"; 10' 26"; 12' 16" - Foreman's timings), one of the first, preceded by McEwan and Cecil Forsyth only - the latter wholly obscure. (McEwan's, incidentally, could be an early minor masterpiece judged by his later writing for cello). Outram really dug into its romantic, confident and forward-looking Edwardiana. Bax might well have been inspired by it when the indefatigable Tertis caught up with him to commission a concerto (called Phantasy) in 1920. Certainly it's instructive to recall that at this date there were no major British string concertos, or concertos of any character around, save the recently unearthed Stanford Violin Concerto in D, Op 74 (1899) of 38'.

The first movement's tune could easily have turned into memorable swagger but was chromatically developed to something finer. The second seemed to enshrine a half of 'Danny Boy' and flow somewhere else. It evokes a pantheistic Englishness but with a different more angular slant than say Butterworth, Farrar, or even Bax's Irishry. Bowen is less thoroughgoingly English. He perhaps had something of Medtner in his larger-scaled music, too, as well as the piano pieces inspired by a similar pianistic virtuosity: a sense of large-scale purpose, lacking in say the Holbrooke piece. The finale was quite rousing, and not at all the simple rondo-finale you'd expect. Outram shimmered the long-breathed passages - a feature of Bowen, contrasting with punchy short themes - to a resounding close. Judy was enthralled. A masterpiece, and as Foreman said, mysteriously absent for so long - as its composer was obscured mainly - and should be on CD.

The Alan Bush Centenary Concerts

Alan Bush (22. 12. 1900-31. 10. 95) is one of the most remarkable, prolific, and neglected of that group of British composers born at or soon after the turn of the century, including Rubbra, Finzi (1901) Walton (1902) Lennox Berkeley (1903), Richard Addinsell and Gavin Gordon (1904) Tippett, Rawsthorne, Constant Lambert, Christian Darnton, William Alwyn (1905), Benjamin Frankel, Elizabeth Lutyens, Arnold Cooke (1906), Elizabeth Maconchy (1907), and Howard Ferguson (1908). Remarkable, as his fate resembled the similarly Marxist-inspired Darnton: baffled ostracism. Darnton in fact gave up composing altogether from 1948 to 1968, feeling his music was incompatible with the party line. The CP-card-carrying Bush proved more resilient. After composing such masterpieces as *Dialectic* for String Quartet Op 15 (1929), and the Busoni-length and choral finale Piano Concerto Op18 (1938), he tuned his lyre to Zhadanov's truth in 1948: reject Western academic formalism, write whistling symphonies for the workers. And for his Marxist beliefs he suffered a virtual blacklist from 1938 to abut 1953. Then, after a small window in the 1950s, he was tacitly blacklisted with many other British composers for paradoxically aesthetic reasons, by the fiercely modernist William Glock, Controller of BBC Radio 3, from 1959 to 1972. Naturally it had a tone-row effect in concert and other contemporary musical life.

His musical style - as evinced in his earlier, Leipzig-trained period (where the RCM Professor became the student, learning philosophy - is cumulative, toughly argued post-Busoni with a lapel of Englishness. Later work was more thoroughgoingly diatonic - bizarrely in voluntary line with Zhadanov's crackdown. The humanitarian Bush with a political broom.

There was a pre-concert talk at the Wigmore, on 1st November, and after the concert a memorable wine-flooded celebration in the basement Bechstein Room. It was there that John Amies first gave an excellent lecture to aficionados of Alan Bush. He played recordings of the quartet *Dialectic* we'd hear complete live later, and interviews he made himself with Bush in the BBC at various points, 1968, 1978, 1985 - one I recorded. At one point, there was silence at a question. I laughed at Bush's glowering silence, and everyone joined in. Yes, Bush fell silent at questions he disliked before answering, so I was right.

First in the concert was a chamber piece for flute and piano, *Three African Sketches*, Op 55 (1960). This used as the titles suggests, melodies from southern Africa, and the date lends a clue as to the immediate political inspiration (the Sharpsville massacre) that possibly occasioned it. This was paradoxically then, a beautifully crafted suite of necessarily melodic character, not meant for ungainly development. The variations are textured and the whole a delightful

answer to the French flute tradition.

After this came the *Dialectic* Op 15 (1929), played by the Bochmann Quartet, who recorded it for Redcliffe. Its near 15 minutes are hypnotic. The conversation between instruments, the Busoni-like textures (and harmonies), are subsumed in an already mature style, one that famously weeded its own thorniness later on. The sweep of argument is always tested against the grain of other voices that both underscore and sustain it, or question or even undermine. But it still soars in a kind of hoarse lyricism to its end. Its impact is visceral, one feels the thew of quartet-writing in this work as in few other British quartets.

Then Wills Morgan with Richard Black at the piano sang *Voices of the Prophets,* a four section work, unusually consisting of declamatory prose: Isiah Chapter 65, Milton's 'Against the Scholastic Philosophy', Blake's 'Selections from Milton' and the weakest piece, ironically a poem, made up for Bush's music - Peter Blackman, from 'My Song is for All Men'. But it contained much compassionate fervour that Bush found poetic - which is what matters. Morgan is a real intellectual driving force, as we discovered later. A superb (black) singer from Wolverhampton he trained at the RAM and Cleveland Institute, has recorded these pieces with the Artsong Collective - being one of the founding members - for CD. It's one of two versions now available (the other on Redcliffe, with Philip Langridge), both superb, but Morgan brings something that accords particularly well with Bush, a burning conviction and projection, as well as a superbly burnished tone. His championing of lesser-known British composers was something he confided later. This rendering of the four sections was particularly notable for differentiation between the rather monumental angry qualities of the first two, difficult to bring off with what in the Milton is in fact prose. The Blake section allowed a more declamatory style, shot through with lyricism, and the last touchingly, in making something more of the blond, Asian and black babies in arms of the poet's sentiment. Bush's humanity, as well as his humanitarianism shone out in the selection and setting of this last piece, which afforded a touching, moving relief to the monolithic qualities earlier.

After an interval we settled down to Peter Jacobs, and Bush's 24 *Preludes* Op 84 of 1977. The nearest British analogy is York Bowen's 24 Preludes of the 1930s, or far earlier, Stanford's. Perhaps if Rawsthorne had attempted a cycle it might have sounded superficially similar. But in fact like Bowen, Bush is keen to differentiate and stylise his pieces in a more chameleon manner that Rawsthorne possibly wouldn't have. For instance, No 16 'Rustics' evokes a post-Herbert Howells manner. The first piece slowly winds the cycle up, in an elegant lyrical andante that the second dispels more smartly. One of the staples of British piano writing, the chunky chordal progression, alternates with a filigree of steel wire. Each piece contrasts effectively, sometimes unexpectedly, if lacking say, the character of Frank Bridge or Arnold Bax, to name the two finest

British composers for piano - an extensive but not always bejewelled field. Since Elgar, Delius, Vaughan Williams, Holst, Walton and Britten all wrote very little for the piano. These constitute, with John McCabe's pieces of the same period, the finest British piano music of the 1970s.

The Trio *Voices from Four Continents*, for clarinet, cello and piano, Op 91 (1980) rounded off the programme. Its inspiration might have been Ronald Stevenson's Piano Concerto 2 'The Continents' of 1972, which essays a kind of grand tour in a more symphonic manner. The trio was more characterful than the flute and piano Sketches, though without the melting simplicity of the second sketch to provide a highlight - it probably needs more listening to. Bush always improves with repeated hearing.

Bush Centenary Concert, Maida Vale, 19th December 2000

There were just two items, the Tippett 2nd Symphony of 1957, and the Bush Piano Concerto, Op 18, of 1937, completed on his 37th birthday in fact. There aren't many times when the Tippet plays as overture to something larger, but this was one of them... It's still quite a shock to see a work such as this - where the original BBC leader's meddling in string-rhythms caused the breakdown of the first movement under Boult in 1957 - laid out so neatly, and dispatched so joyously. All of our party were quite transported, particularly Judy Anderson, with what Professor Ian Kemp referred to as 'the trumpet-tongue of genius'. Horns were prominent in three of the four movements, particularly, with a fantastic rush of adrenaline, at the close.

The four-movement layout is fairly conventional, almost classical, and classical energy is much to the fore. In fact the inspiration was pre-classical, hearing in Lake Lugano some tapes of Vivaldi with 'pounding cellos and bass Cs'. (Vivaldi's baroque energies of course fed early classicism). The sharp versus flat tonal feel of the work opposes the 'C' vigour with lyrical or what several have termed 'feminine' lyricism, defining the floated, layered effect of the shimmering tonalities. The first movement recalls the horn-calls of the Piano Concerto of two years earlier, and the fresh palate of it and the *Midsummer Marriages*. At the same time the development seems to presage the mosaic-like sudden quality of his very different second opera *King Priam* and the Second Piano Sonata of 1962. The second movement bathes in a rather magical language, developed from the first's episodes, and enjoys what the BBC programme-writer pursues with the operas as 'a world of hieratic ritual and rapt meditation'. What it really does foreshadow is the astonishing beauty of the second act of *King Priam,* and in particular the reconciling meeting between Priam and Achilles, when each gently prophesies the other's death by their respective sons. This was some way off, and to underline that, the scherzo

returns to the Vivaldi-cum-Beethoven motor rhythms, and the finale follows the opening with a four-part fantasia plan, again, not developing the parts exactly.

The curiosity of seeing the Tippett after so long is partly in realising that for so many there are now no difficulties at all. Its lithe contours and energy look almost diminutive laid out in the Maida Vale studios. The performance was particularly exhilarating, perhaps the breezy prelude to the hard graft of the 50-odd minute Piano Concerto next.

It ought to be pointed out that since the BBC don't see fit to serve the invited guests or let you pay, a quite legitimate way of getting one's coffee is to grab it from the open canteen a little before the interval ends, when some of the minders have gone off-guard. They then think you're on the staff.

Alan Bush's Piano Concerto was superbly despatched by Rolf Hind, who showed no signs of weariness throughout. And was almost note-perfect in a work demanding a kind of Busoni-like panache and heavy purposeful tread in sections that don't skitter. The overall impression is of a gnarled masterwork, that Bush is often at his best when most expansive, as in his operas, but here is in a world freed from his self-imposed Zhadanov-inspired simplicities, that thinned out many of his works' textures after 1948.

The furore of the first performance, apposite for March 1938, is famous enough. Not for scandalising the audience, but galvanising it in the revolutionary choral finale, to an exuberance that caused the conductor, Adrian Boult again, to turn round and unexpectedly perform the National Anthem out of self-preservation! It certainly was the main reason why Bush was banned by the BBC, effectively for 15 years, even though the official ban was lifted after the intervention of composers like Vaughan Williams. The work is in fact one based on a revolutionary work based itself on Beethoven's extraordinary Choral Fantasy Op 80 - Busoni's five-movement Piano Concerto Op 39 with choral finale. Only the all-male chorus there is singing the praises of Allah, and Randall Swingler's text in the Bush, to those of - if anything - Lenin in London. In fact the text is more humane than publicity suggests - Swingler was the nephew of the Archbishop of Canterbury and could never quite exhort the machine gun. But the text is remarkable enough. The BBC programme writer seemed still faintly disturbed by it, though noting even the *Times, Listener,* and *Musical Times* all praised it in 1938 - if also suggesting the National Anthem might have sounded unusually expressive for the audience after such a tract.

But Bush's scale is the most impressive thing. Two things emerge quite clearly. Bush was most inspired when writing challenging piano music he performed himself, and when setting texts. The first is thorny, dialectic in the sense of his String Quartet, generating a terrific rhythmic pulse that leaps coruscating into

argument. The other quality already hinted at, is the memorable thematic material of the sung text. The style of the former recalls Busoni, Hindemith, but most of all this remorseless, yet exhilarating logic neither of these composers displays in quite the same way, unless the Busoni *Toccata* of 1920. The sound-world is basically diatonic, with lucent harmonies cross-hatched by a scumble of chromatic cross-harmonies that nevertheless don't obscure the essential tonality. Hind often exploded little rhythmic bombs across the keyboard, then pulverised them into meaning. Paul Conway has written of the way these build up inexorably, with an intellectual rigour and power that makes the work seem far shorter than its 57 minutes.

One can only agree; each of the three movements seems to lead so directly from the last, without a tonal shift in the scherzo or slow movement in the way say Tippet might employ, that to differentiate the first three movements is quite difficult. They seem peculiarly cumulative, and the finale an arrival, a sudden exhalation. If you can imagine dragging a piano up *The Ascent of F6,* without the nihilist-imperialist-Freudian ending, you might get some sense of the vertiginous struggle. And the piano stayed in tune. The material is related, or at least familial in character if not theme. The *moto perpetuo* of the first movement leads logically into a scherzo of irregularly-barred cakewalk-like rhythms. Conway suggests 'a wild stratospheric ostinato like a music-box gone out of control' and this is exactly it. Both movements seem to push for the kind of release that a regular finale can't offer. The slow movement allows the piano respite, where it ripples in somewhat later, commenting on bass-noises in the orchestra. Like the ostinato rhythms, the sense of something rising irregularly but massively from its foundations, to be eventually shouted from the rooftops, as it were, isn't far off. One might of course expect something Gothic from this - not what Bush intended. Yet the same inspired disproportions here are recalled in some Britten works of the 1930s, like his *Ballad of Heroes* Op 14, with a text also by Swingler, or Piano Concerto Op 13 or the co-operative *Mont Juic Suite* he wrote with Berkeley.

'Friends, we wish to speak a little of this performance', spoken by the chorus, really does thrill with a kind of historical immediacy; a sense of something urgently relevant despite the sixty intervening years. The Apollo Voices, and later baritone Ashley Holland who had the most beautiful solo line to sing, dispatched the exhortations to betterment without sending them up. But the very quiddity of recited prose brought one back to the irregularly-barred scherzo, and the curious resolutions of mere musical formalism. After such cynical politics, and the knowledge of Bush's own political naivetés (which he never foisted on anyone, least of all his students) the kernel of Bush's idealism shines through. Bush's edifice seems a far more honourable and enduring Utopia, or hymn to a Millennium, than the one they refused to build down the road in Greenwich. The applause was loud, but not boisterous.

Art

Kathleen Walne

Kathleen Walne was born in Ipswich, Suffolk on 3rd October, 1915, the daughter of an engineer and inventor - another sister inherited these talents; her mother's father was a Cambridge don. Two brothers became commercial artists, but Kathleen Walne was the most distinguished. She won a design scholarship to Ipswich College of Art near the end of 1929, and was initially 'destined to be a book illustrator', in the design school. (Her preferred media, watercolour and gouche, stems from this time). Her meeting with Frank Ward from the painting school changed all that. Not yet 15, she decided she would marry him, and agitated to transfer to the painting department, bringing with her a tangy gift for watercolour. She succeeded in both objects, and they were together till his death in 1998. His transfer to the RCA in 1933 although separative, stimulated further exposure to London, something already well in hand. Frank Ward took his wife's paintings to the Lucy Wertheim Gallery in the Albany, where despite rejoinders from purchasers that her exuberant colour rendered their other pictures drab, helped establish her pre-war reputation. They lived in Chelsea. Wertheim included the painter in her '20s' Group. Lucy Wertheim herself refused to let her protégé work for Shell, and put her under contract in 1935 - and gave her a one-(wo)man exhibition. This attracted very favourable comments from art critics of the *Manchester Guardian* and *Spectator*, amongst others. Visitors and purchasers included H. G. Wells, Lord Berners ('one of the learners' whose Corot-like work would certainly have seemed a touch drab) and Margot Asquith. Further watercolours and drawings were exhibited at the Salford and other galleries in the north, and along the south coast, including Brighton and Worthing. The artist worked at odd hours and was occasionally prone to serving tea tasting of turpentine.

The war, and motherhood, changed all this again. Despite Frank's encouragement - he refused a military commission as a War Artist but painted anyway - the Walne drive was diverted for many years. He himself taught at Wilson's School till his retirement in 1974, when his reputation as a fine, open-minded realist grew till his death. Again, it was 'Aunt Luce', Lucy Wertheim, who stimulated Kathleen Walne's career. By this time, the late 1960s, Wertheim had moved to 38 Kensington Place, Brighton. 'When I was sixteen and a half' Walne recalled, 'she said that she had booked me to look after her in her old age.' The painters did so till Wertheim's death in 1971 - moving next door into No. 39 for good. The paintings by Helmut Kolle (who died in 1931, aged 30) returned (at No. 38) to stimulate Walne again, forty years on. Christopher Wood was still another prime influence. Since then her work has been rediscovered, and many exhibitions mounted, most notably at the Salford Gallery in 1989. She shared a very successful first 'rediscovery' exhibition at the Compendium 2

Flowers in Ginger Jar, 1988. Gouache.

Girl with Sunflowers, 1980s. Watercolour.

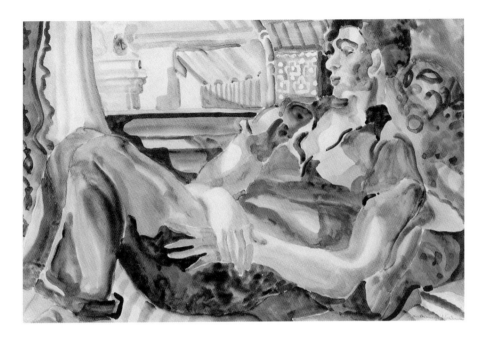

Reclining Boy, 1935. Watercolour.

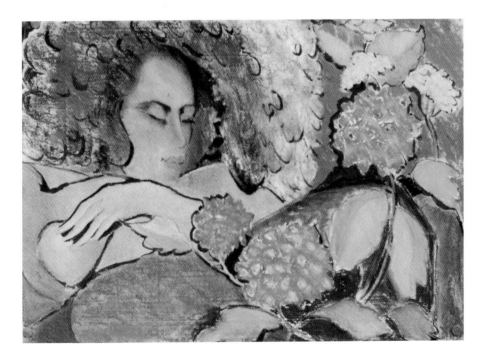

Rachel, 1990. Watercolour.

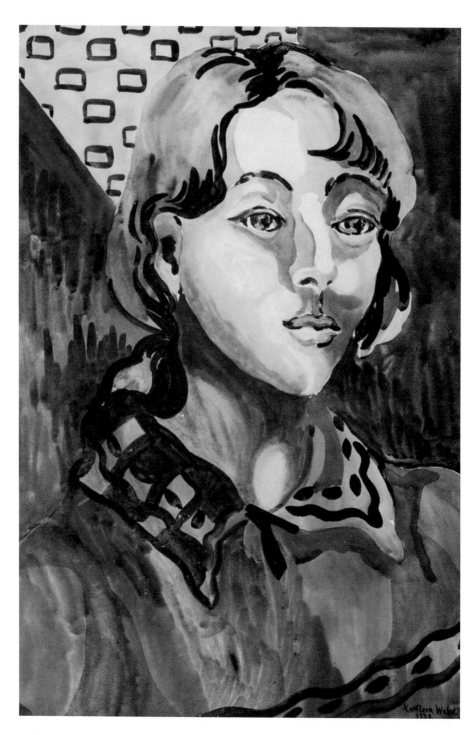

Self Portrait, 1938. Watercolour.

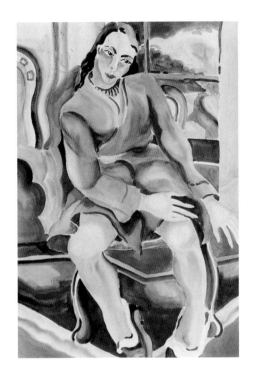

The Carpet Slippers, 1933. Watercolour.

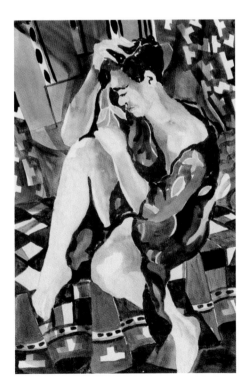

The Dressing Gown, 1932. Watercolour.

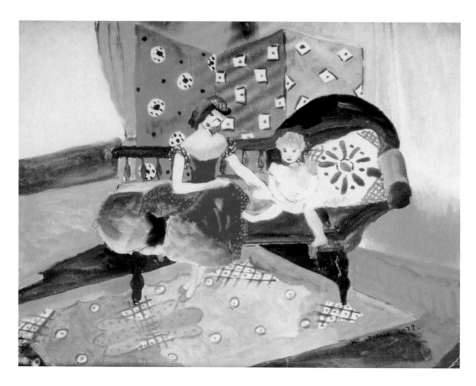

Mother and Child, 1937. Watercolour. Coll: Aukland City Art Gallery

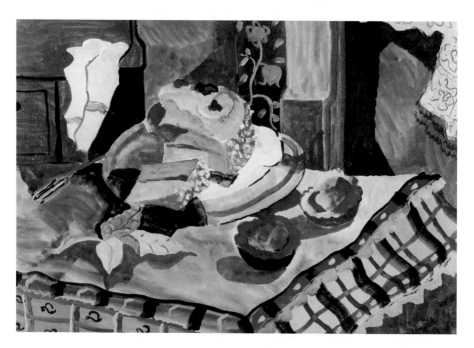

Cake, 1937. Watercolour.

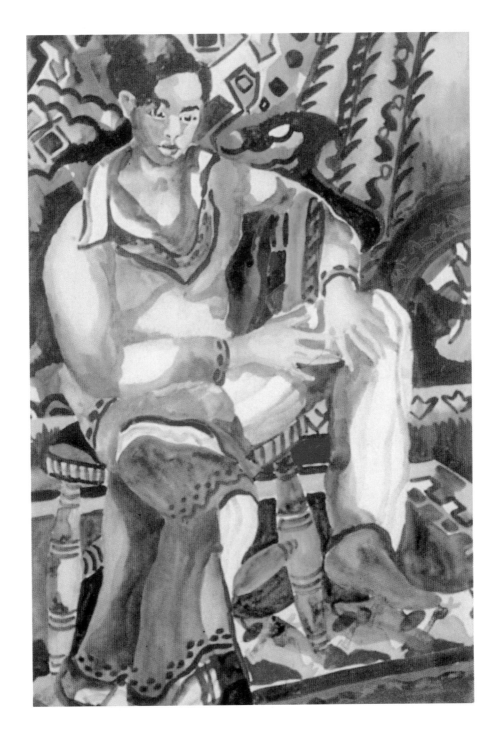

Boy in Pyjamas, 1936. Watercolour.

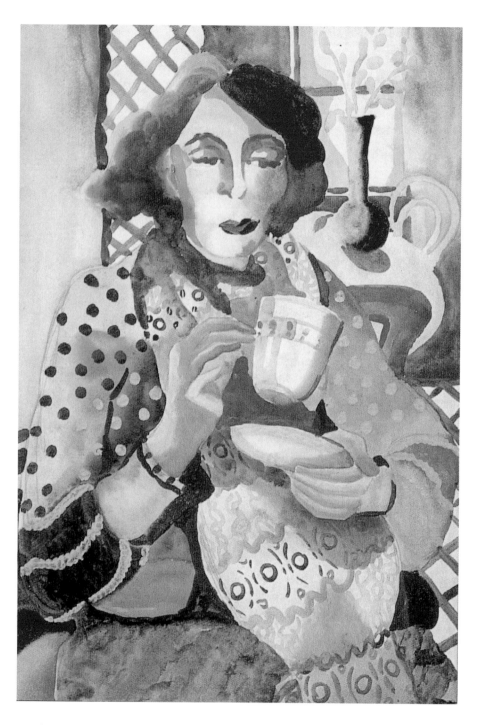

Mother Drinking Tea, 1930. Watercolour

Gallery, in Chelsea in 1972, alongside Frank Ward. A selected example of her work was included in the Permanent Collection at the Towner Gallery, Eastbourne.

Walne is instantly recognisable, a painter trained in design who expanded the patterning and primary colours partly associated with such work, to an aesthetic statement. There are some affinities with Wood, and some might detect Matisse, but Walne's evolution has been wholly individual. Her later career which began in earnest in the early 1970s, has shown a more expansive scope, and a more complex deployment of compositional space - sometimes recalling late Braque. Colour has become more various and delights often in vivid opacities (particularly of turquoise through mauve), as opposed to the translucence of much early work. But this too remains, juxtaposed with a richer palette. Her earlier concentration on the figure has widened to place question marks on context. Objects are flattened into and coloured out of their spaces. Much of Walne is a joyful question mark. Eyebrows were raised in the 1930s, but it is now more than time that eyes were, on this extraordinary artist.

Simon Jenner, with grateful thanks to the artist and David Buckman, whose *Mixed Palette: The painting lives of Frank Ward and Kathleen Walne*, is published by Sansom and Company, 1997 (ISBN 1 900178 01 X). All paintings © Kathleen Walne.

Mark Bryant

c20th Political Cartoons
Poison Pen Or Good-Tempered Pencil?

Rutherford had once been a famous caricaturist, whose brutal cartoons had helped to inflame popular opinion before and during the revolution.[4]

George Orwell, *Nineteen Eighty-Four*

In Orwell's dystopic vision of the future, the all-powerful ruler Big Brother only allows three of his original fellow revolutionaries to survive the subsequent purges and it is no accident that one of these, Rutherford, is a political cartoonist. Like the real-life leaders of the totalitarian regimes satirised in the book, Big Brother is only too aware of the power of the political cartoon to excite the emotions and to reach the soul of the masses in the most immediate way possible. As Hitler himself said in *Mein Kampf:* 'At one stroke... people will understand a pictorial presentation of something which it would take them a long and laborious effort of reading to understand.'[5] A picture, indeed, does paint a thousand words, but as James Cameron once said, it does rather depend on who draws the pictures and who writes the words.

But what type of cartoon drawing is the most effective? The novelist John Fowles in his essay 'Remembering Cruikshank' identifies the 'essential weakness' of one of Britain's acutest graphic satirists as being 'too much humour, not enough anger — a very English combination'[6]. It is a tradition that has continued through the 19th century and into the c 20th. We recall Fougasse's dictum of always using a 'good-tempered pencil'[7] - in order to hit the target. But then again Fougasse was primarily a social commentator - not a political cartoonist — and, as the only cartoonist to be editor of *Punch*, he was both a product of as well as a contributor to that magazine's rather genteel stance on 'picture-politics'. However, even this country's first staff political cartoonist, Sir Francis Carruthers Gould, confessed in similar vein that 'I etch with vinegar, not vitriol'[8] and the great humorist Ambrose Bierce declared that 'The only person pained by an offensive cartoon is its author; the only person pained by a ridiculous one is its victim.'[9] Even the admirable Sir David Low, no shrinking violet when it came to attacking politicians or wartime dictators, always did so and very deliberately -- with a sense of levity. His humour may sometimes have been a dark shade of grey but it was never completely black. As he himself says, ridicule is always the best weapon — malice rarely succeeds: 'It clouds the judgement'.[10]

But is this really the case? Sir Ernst Gombrich has commented that 'In fact, the satirists' attempts to turn monsters into figures of fun have usually

misfired.'[11] And even in domestic politics this has often held true — one only has to think of Vicky's creation of 'Supermac' or the Russians' christening of Margaret Thatcher as 'the Iron Lady'. What, after all, is wrong with malice? In his essay on 'Comic Art' in *English Humour*, J.B. Priestley goes further and sees this as the defining aspect of a classic political cartoonist of an earlier generation to Cruikshank - James Gillray:

> What distinguishes him, apart from his magnificent technique, is a malice at once
> so shrewd and passionate that it has a touch of sublimity about it. It was a bad day's
> work for George III when he made a lasting enemy of Gillray... never was any man,
> king or commoner, handled with more devastating malice.[12]

In similar vein, the power of the 'ugly' political cartoon in both war and peace in the 20th century has been undeniable - both at the time of first publication and to anyone looking back now. From the gruesome anti-Kaiser pictures of Louis Raemakers and Edmund Sullivan to those of the Nazi-hating Soviet 'Kukryniksi' trio (Kupryanov, Krylov and Sokolov), and from the virulent anti-Semitic work of the contributors to *Der Stürmer*, to Dyson's bloated capitalists and the ghoulish figures which feature in what is known as Vicky's 'Oxfam' style. These are pictures expressing extremes of negative emotion - of anger and hatred, of pain and disgust - drawn by people of commitment who, like Goya, like George Grosz, like the photo-montage artist John Heartfield, have something terrible to say and do so in the most poignant way possible. John Berger draws a parallel between Gerald Scarfe and Gillray, Goya and Daumier: 'what is essential to them is that they draw faithfully — and with pain the ghosts that crowd in on them'.[13] Yet what they are drawing are still cartoons and very fine ones at that.

But, it might be argued, perhaps these shouldn't be called cartoons at all? Surely it is in the definition of a cartoon to be funny in some albeit distant or perhaps wry way? This certainly seems to be the public perception - rightly or wrongly. Some years ago when working on a book called *World War II in Cartoons*, a friend turned on me for seeming to trivialise or joke about a frightful business; I was made to feel that I had committed some ghastly faux pas. When the book eventually appeared all was forgiven, of course - a single glance showed that these were not comic fripperies. To be sure, many of the cartoons were indeed funny, of the kind Kenneth Bird has characterised as 'humour under pressure', but equally many were quite the opposite. Cartoonists, after all, are people, and like anybody else, react to situations in differing ways. Nervous types often giggle; others may cry with happiness. When Henry VIII first appeared with his despised new queen, Anne Boleyn, their clothes were decorated with their entwined initials and the mob laughed at the lettering, 'HA HA HA' — but without any humour or warmth. And in wartime in particular, the 'pressure' on cartoonists can be so great that the

element of humour may disappear altogether in their portrayal of events.

This confusion about the place of humour in visual satire seems to continue in some people's minds with regard to contemporary political cartoons. In 1992 for example, MAC of the *Daily Mail* received a letter from an outraged inhabitant of the Home Counties when he drew a cartoon attacking the action of snipers shooting children in former Yugoslavia. The writer - who had obviously completely misunderstood the cartoon, as it was neither visually funny nor had a humorous caption - accused him of making a joke out of a deeply upsetting incident. He was evidently also not a regular *Mail* reader, otherwise he would have known that MAC usually includes a hidden portrait of his wife in his humorous cartoons, but deliberately omits it in the more serious ones.

The assumption that all cartoons are necessarily funny or at least contain an element of humour thus does seem to persist. Unfortunately, however, we are stuck with the word and its many very different shades of meaning, from animation to continuity strip, from single joke to the blackest of political drawings - and even, of course, its original pre-Leech sense of an artist's template. 'Caricature' would be a helpful alternative but increasingly these days in Britain the word is only used to denote portrait caricature which is just one element in the political cartoonist's armoury.

The danger is that the label 'cartoonist', with its bubblegum-and-freckles image, also thereby seems to imply that the artist himself is equally inconsequential and lightweight. This would be grossly unfair to cartoonists in general, but it is doubly so to the political cartoonist. After all, to survive let alone succeed in this immensely stressful profession, the political cartoonist has to sit down each day with a blank sheet of paper, absorb every aspect of the day's news, produce anything up to six roughs by midmorning and then create a cartoon which is topical, well drawn, features recognisable caricatures of leading celebrities, is in some indefinable but powerful sense 'telling', and also, if possible, is spiced (but not necessarily so) with some large grains of wry humour. But the most important thing is always the message - without that it fails completely. As the Dutch cartoonist Fritz Behrendt has said, 'The political cartoonist is a close relative of schoolmasters, missionaries, prophets and moralists: and his primary aim is not belly laughter, but the thoughtful smile which shows that the graphic signals have been understood.'[14] It is a 'knowing' smile - if it is there at all - and not a happy one. And an immense amount of effort - both in skilled draughtsmanship and heartfelt political commitment - goes into each and every drawing (there is, as someone once said, no such thing as an unsigned political cartoon). These are people worthy of our respect.

Typically, the cartoonists themselves make light of their current lowly status. In MAC's office at the *Daily Mail* hangs a drawing by Kliban in which an

insignificant-looking man, locked arm-in-arm with two glamorous escorts, walks down a city street as a uniformed guard pushes people aside. 'Out of the way, you swine' the caption reads, 'a CARTOONIST is coming!' However, not everybody, it would seem, sees things this way. Even amongst the closely knit professional community itself there are notes of discord. The distinguished cartoonist Bill Tidy no doubt appreciates the above sentiment generally, but he evidently does not think it applies to political cartoonists. In his autobiography he writes:

> political cartoons were of no interest to me. I considered them... and still
> do, the easiest and most predictable facet of the trade. The situations are
> presented on a plate, editors insist that the end product is over drawn to fit a
> large space, and usually such cartoons serve exactly the opposite purpose to
> what was intended — they please politicians so much that they write and ask
> for the original.[15]

The latter statement reinforces Gombrich's point, but it is significant that - according to Kenneth Baker at least - politicians normally only buy flattering portraits of themselves. Which further strengthens the argument in favour of the 'ugly' political cartoon - rather than a humorous one - being a more effective way of attacking an individual. The rest of Tidy's opinions of political cartoonists seem to me unfair, particularly regarding contemporary artists, though no doubt there may have been some of his acquaintance to whom these comments might have applied in the past.

Kenneth Baker has also pointed out that, ironically, 'politicians need cartoonists, for to be caricatured is a sign that they have arrived'[16] - a strange symbiotic relationship indeed. So much so, in fact, that the 'tabs of identity', as Low calls them, by which a cartoonist establishes a visual shorthand for his target, can even be invented by the politician himself for use by both cartoonists and stand-up comedians/impressionists alike. A well-known case in point is Harold Wilson's pipe; in private he actually preferred cigars. But it should be stressed that this inter-relationship does not always work out the way the politicians expect. Adolf Hitler, for example, once allowed an exhibition to be held featuring the work of anti-Nazi cartoonists. This, he presumably hoped, would prove how 'big' he had become - as Colin Seymour-Ure says in *The Political Impact of Mass Media* (talking of the role of *Private Eye* in Britain), 'by tolerating the Fool the King shows his own strength.'[17] Unfortunately for Hitler, it appears that he too fell into the trap of thinking that cartoons were necessarily funny (as did his fellow dictator, Mussolini, who was apparently a great fan of Donald Duck). In the event, many of the drawings were so savage that the show had to be closed down - proving once again the power of the odious as opposed to the humorous cartoon. Some Kings have been even less tolerant of their Fools. Daumier was imprisoned for six months for a single cartoon attacking Louis Philippe. Thomas Theodor Reine suffered the same fate at the hands of

Kaiser Wilhelm, and in London in 1987 the Lebanese political cartoonist Naji-al Ali was shot dead by his countrymen for his activities. No laughing matter.

 The political cartoonist is an important person. He is not an entertainer or soft-centred pedlar of jokes. He is no Fool, nor is he a fool. The cartoonist John Jensen has said that 'satire without purpose is mere derision'. Quite so. And by the same token the political cartoonist is not by definition or even primarily in the business of humour. He is a crusading journalist who is able to express him- or herself better than anyone else on the publication he works for, simply because he does not need words. And those who do not need words, do not need language, which means that they are able to reach infinitely further than conventional text-chained commentators, taking their message to the deaf, the illiterate and - perhaps most important of all to the countless millions who have a different mother tongue. At the British Cartoonists' Association's 25th anniversary dinner, Mel Calman took issue with guest speaker Miles Kington for being 'merely' a writer: 'Anyone can write,' Calman said, 'it's drawing that's difficult.' And, he might have added, drawing with purpose is tougher still.

 It has been said that in producing ugly cartoons you thereby produce an ugly newspaper, and people don't buy ugly things. This seems almost as ludicrous as to say that a canvas is sullied by the artist's paint. Low and Vicky both worked for Lord Beaverbrook in total opposition to the political standpoint of the papers they contributed to, but this did not stop sales. Scarfe's anti-Vietnam, anti-Nixon grotesqueries were not only a talking point in the *Sunday Times* of the period but ironically are now fabulously expensive to buy in contrast to the drawings of many other cartoonists working at that time and making the same political points. But they certainly are not pleasant to look at, nor were they ever meant to be. These are not lampoons but vicious personal attacks, redolent of venom and bile. As Scarfe himself has said: 'My drawings are often a cry against that which I detest, and in showing my dislike I have to draw the dislikeable.'[18] If you are in the business of news then your duty is to show it all, and bad news - as witness the Rosemary West murder trial - can often be good for sales.

 Editors, of course, occasionally do suppress drawings that they think go too far (Vicky produced a whole book of such rejections)[19], but fewer cartoons are 'spiked' in this way than people might think. Nicholas Garland usually only cites one (Maggie as the Iron Lady with her knickers falling down) and Steve Bell - after many years on the *Guardian* - had his first in November 1995 (featuring John Major as a talking turd). The political cartoonist, after all, has to be allowed to make his personal statement. But it is more often than not the bad-taste 'funny' cartoon that is dropped rather than the 'ugly' one. There is humour and horror, but to laugh at something tragic is beyond the pale. The sort of person who enjoys 'snuff movies', is in very real terms, sick. But this is

where the confusion persists. The political cartoonist is not by definition making a joke out of everything he draws. What he is doing is making a comment; sometimes it is funny, sometimes it is ironical, satirical, witty, mocking. But at another times it is simply ghastly, and the message cannot be communicated in any other way.

David Low admired Cruikshank as a 'clown in white gloves' yet was uncomfortable with his more brutal work. But as V.S. Pritchett - coincidentally the grandfather of the *Daily Telegraph*'s popular pocket cartoonist, Matt - has said, 'Low lacks the morbid genius of hatred.'[20] And there is a long tradition in this country of bare-knuckle satire, of cartooning, as it were, with the white gloves off. The vibrant, salacious and often cruel lampoons of the 18th century caricaturists contributed to the downfall of at least one Prime Minister, Lord Bute, and did great damage to many other politicians, as well as the royal family, in a time of unprecedented sleaze and corruption. In their drawings, Gillray, Rowlandson and others certainly didn't mince words. And their function above all was to make the public think for itself. To return to Pritchett:

> And here is the danger; a great deal of the high-minded disapproval of unkind-ness or irreverence in satire springs from anger at being asked to think again. Far worse, we are angry with the satirist for threatening our contemp-orary sense of security. In a democracy, a cartoonist teaches people to think for themselves... [21]

... and sometimes we have to think unpleasant things. And frequently the best way to communicate this is with an ugly drawing. Ambrose Bierce, in criticising this approach, said, 'We like to laugh, but we do not like - pardon me - to retch'. True, but if retching is the only way to combat poison then it is sometimes necessary to allow the political cartoonist to stick his artistic fingers down society's throat.

In Orwell's bleak book, Rutherford is spotted by Winston Smith in a cafe, a crushed and defeated man, his cartoons:

> simply an imitation of his earlier manners and curiously lifeless and unconvincing...
> At one time he must have been immensely strong; now his great body was sagging,
> sloping, bulging, falling away in every direction. He seemed to be breaking up
> before one's eyes, like a mountain crumbling.[22]

Rutherford, sadly, had succumbed to the system. But the system here, be it remembered, is no longer a democracy, but a totalitarian state administered by the dreaded Thought Police.

Britain has a proud tradition both in democratic politics and vigorous cartooning, going back to the days of Hogarth, but unfortunately in recent years the image of the cartoon has faltered. Indeed, "the term 'cartoonist' has

been so enfeebled by the countless numbers who have drawn purely for humorous effect that there has almost been lost all sense of his real identity." (Behrendt).

The role of the political cartoon is of immense importance in a democracy and in order to fulfil this function humour may often have to be discarded in the interests of Truth. Cartooning has been called 'the art of laughter'. This may still hold true of Disney, 'Peanuts' and 'Garfield' but for the political cartoonist it is, and always has been, a deeply serious business. And it is often far from easy - let alone desirable to get one's message across in a humorous way. Vicky believed that a cartoon was a signed statement of principles, and the medium of newsprint with its stark contrast of ink on white paper is perfectly suited to making direct statements of this kind. Colour, of course, also has its advantages in attacking the ogres of injustice, red in tooth and claw, but whether the ink is monochrome or rainbow-hued, the most effective political cartoons have often, undeniably, been very, very black.

This article first appeared in, *A Sense Of Permanence - Essays On The Art Of The Cartoon* (University of Kent, 1997) Copies available @ £9.99 from: Centre For the Study of Cartoons & Caricature, University of Kent, Canterbury CT2 7NU

4 George Orwell, *Nineteen Eighty-Four* (Secker & Warburg, Collected Works Edition, 1987), pp.79-80.
5 Adolf Hitler, *Mein Kampf*, Book II, Chapter VI (Hutchinson, 1969)
6 John Fowles, 'Remembering Cruikshank' in Mark Bryant (ed.) *The Comic Cruikshank* (Bellew Publishing, 1992) pp.143-176.
7 J4 Kenneth Kird ('Fougasse'), *The Good-Tempered Pencil* (Max Reinhardt, 1956)
8 Sir Francis Carruthers Gould, quoted in Ann Gould, 'The Picture Politics of Francis Carruthers Gould', *20th Century Studies* (December 1975) p.26.
9 Ambrose Bierce 'As to Cartooning' (1901) in *The Collected Works of Ambrose Bierce* (Gordian Press, 1966), p.86.
10 Sir David Low, *Ye Madde Designer* (Studio, 1935), pp.11-12.
11 Sir Ernst Gombrich, Introduction to exhibition catalogue 'The Art of Laughter' (Cartoon Art Trust, 1992), p.11.
12 J.B. Priestley, *English Humour* (Longman, 1930), p.49.
13 John Berger, quoted in Gerald Scarfe, *Scarfe by Scarfe*, (Hamish Hamilton, 1986), p.37.
14 Fritz Behrendt, 'The Freedom of the Political Cartoon' in *20th Century Studies* (December 1975), p.78.
15 Bill Tidy, *Is There Any News of the Iceberg?* (Smith Gryphon, 1995), p.75.
16 Rt Hon. Kenneth Baker CH MP, *The Prime Ministers,* (Thames & Hudson, 1995), p.17.
17 Colin Seymour-Ure, *The Political Impact Of Mass Media* (Constable, 1974), p.257.
18 John Jensen, 'Curious! I Seem to Hear a Child Weeping': Will Dyson (1880-1938)' in *20th Century Studies* (December 1975), p.39.
19 Victor Weisz ('Vicky'), *The Editor Regrets* (Allan Wingate, 1947).
20 V.S. Pritchett, 'The Manhandling Democratic Touch' in Mark Bryant (ed.) *The Complete Colonel Blimp* (Bellew Publishing, 1991), pp.156-7.
21 *ibid.* pp.156-7.
22 George Orwell, *Nineteen Eighty-Four* pp.79-80.

An illustration by Edmund J. Sullivan (1869-1913) from his book *The Kaiser's Garland,* which James Thorpe described as 'a whole-hearted hymn of hate' (*Edmund J. Sullivan,* 1948). The writing on the wall is the familiar 'Mene, Mene, Tekel Upharsin' from the Book of Daniel, indicating here that the Kaiser's time is up.

Edmund J. Sullivan, *The Kaiser's Garland,* London, 1915.

The German New Heathen

An anti-Nazi drawing by the Czech cartoonist Bert reproduced in the book *Juden Christen Heiden im III Reich* (Prague, 1935), published in German, French and English. The cartoon is subtitled 'Our Aryan myth is: "Love your neighbour - by tearing him to pieces".'

Bert, *Juden Christen Heiden im III Reich*, Prague, 1935.

An anti-Semitic cartoon by Fips from a 1940 edition of *Der Stürmer*, the weekly Nazi newspaper edited by Julius Streicher which ran the strapline 'The Jews are our misfortune!' *(Die Juden sind unser Unglück!)* across the bottom of the front page of each issue. In this drawing 'the Jewish conspiracy' lies behind the British bomb-aimer's every action and 'Murder' is written across the sky.

Fips *Der Stürmer*, No. 30, 1943.

'Thus speaketh the Lord of Hosts, saying, execute true judgement, and show mercy ...' - Zachariah, 7:9

A particularly poignant example of the work of Vicky (Victor Weisz, 1913-66). Adolf Eichmann had been one of the Nazi leaders responsible for carrying out Hitler's 'final solution' policy - the mass extermination of Jews in Europe. This cartoon was published in the *Evening Standard* on 26 May 1960, shortly after Eichmann had been discovered living in Argentina and arrested for war crimes.

Vicky (Victor Weisz), *Evening Standard,* 26 May 1960.

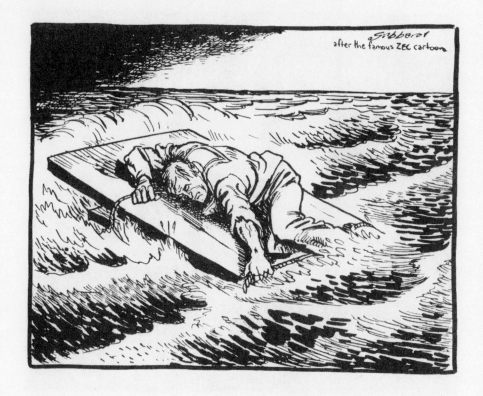

The Price of Sovereignty has Increased - Official

In this cartoon published in the *Guardian* during the Falklands War after the sinking, in quick succession, of the Argentinean cruiser *General Belgrano* and the British ship H.M.S. *Sheffield* with great loss of life, Les Gibbard (b. 1945) harked back to the famous wartime drawing by Philip Zec (1909-83) 'The Price of Petrol Has Been Increased By One Penny - Official' which nearly led to the *Daily Mirror's* closure. For this drawing Gibbard himself was branded a traitor by the pro-war *Sun*.

Les Gibbard, *Guardian,* 6 May 1982.

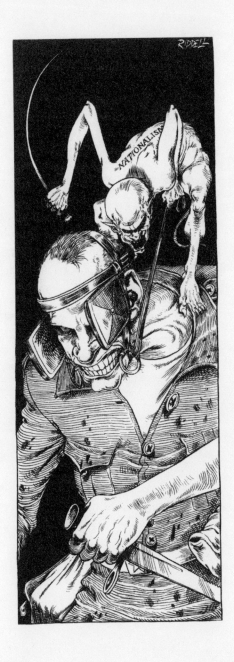

A powerful cartoon by Chris Riddell (b. 1962) published in the *Independent on Sunday* to illustrate a leader about the rise of nationalism in the Balkans and Eastern Europe in the 1990s.

Chris Riddell, *Independent on Sunday*.

The 1940s

Andrew Duncan

'Cyclic serial zeniths from the flux': or, Who was Joseph Macleod?

Who does not know *Listen to Britain*? In this classic montage-poem of the sounds of Britain in wartime, there is one moment which catches the instructed ear more than another: before the bit with the Canadian soldiers singing 'Home on the Range' in their stationary train, there is a snatch of the BBC: here is the news, read tonight by Joseph Macleod. The announcers began reading their names out to discourage the Germans from broadcasting pirate "virtual BBCs" on wavelengths close to the official one and unleashing black propaganda (Jews in the City, Churchill's helpless alcoholism, names of ships sunk in the North Atlantic). The announcer's name names the poet, by then a poet under the name of Adam Drinan, presumably because the BBC wouldn't employ someone of such obvious left-wing sympathies if such was obvious. Macleod, who wrote interestingly of lighthouses: "were it not for the halfmoon/ hung in a folded mist/ pinned across the oceanic way/ and beacon in turret turning/ four-sided agate within crystal(.)", and trans-Atlantic radio experiments, was always at the end of a parallel, "Q" beam.

In this strange stalk of central invisibility, we move from the BBC to Faber and Faber: who published Macleod's first book of poetry, *The Ecliptic,* in 1930. At that time it might well have appeared that Faber had, in Eliot, Pound, and Macleod, the three leading local modernists:

> Moonpoison, mullock of sacrifice,
> Suffuses the veins of the eyes
> Till the retina, mooncoloured,
> Sees the sideways motion of the cretin crab
> Hued thus like a tortoise askew in the glaucous moonscape
> A flat hot boulder it
> Lividly in the midst of the Doldrums
> Sidles
> The lunatic unable to bear the silent course of constellations
> Mad and stark naked
> Sidles
> The obol on an eyeball of a man dead from elephantiasis
> Sidles
> All three across heaven with a rocking motion.

But, it was not to be. Macleod (born 1903, died 1984) brought out one more book (*Foray of Centaurs*), and vanished from the scene. His next appearance was brought to my attention by rumours about the Festival Theatre in Barnwell

(now a suburb of Cambridge) being re-opened, in about 1994, after decades as a furniture store, to reveal walls covered with intact agit-prop posters from its period as a left-wing theatre in the late thirties. Yes, its director in that time (possibly 1933-37?) had been Macleod—Joseph Gordon. He wrote one or two plays for it, which I haven't seen. There was a magazine called the Festival Review, to which someone contributed poems, under the pseudonym Taurus, which look very much like Macleod's work.

The Ecliptic, a poem of some 1400 lines, is the story of one person's consciousness through their life presented in terms of the twelve signs of the zodiac (that is, the course of the ecliptic). An introduction gives a schema of the poem, for example: "CANCER. There is a phase in the twenties when this disintegration is almost complete. The will fails. The whole world seems to be a chaos of contradictory meaning without faith or effort." The simultaneous conception in terms of the animal emblems, and of the psychological tale, is surprising; the poem is fully externalised, is monumental and neo-classical. The lines are long, full, pictorial; he is not one of the modernists who accelerated and abbreviated, for a tough and terse effect. He reminds me of the Irish poet Denis Devlin, equally concerned with mythological imagery, with a Symboliste afterglow. The large-scale structure of the poem imposes a rigorous detachment from the immediate purposes of the self, allowing a certain serenity: he does not believe in the discontinuity of the universe; however, the impersonality implied in the twelve rotating principles, an inexorably receding starry axis, is unwelcome to a modern, ego-centred, personality. "Is there nothing more soluble, more gaseous, more imperceptible?/ nothing."

There is an account of the Festival Theatre in Norman Marshall's The Other Theatre, which tells us much about Terence Gray, for whom JGM at first worked: "I seek the unexpected reaction, the unanticipated pleasure, the irresponsible wrath, the readjustment of values." His production of Henry VIII had the christening of Elizabeth (and historical prophecy) scene played with the stage rotating, climaxing with throwing the baby into the audience. Marshall reproduces photographs of four of the stage designs for Gray, which are geometrical, multi-planar, and quite stunningly beautiful: "On these structures the actors can move on all three planes, longitudinally, laterally, and verti-cally(.)" (Gray) One of his messages refers proudly to the audience's "appro-bation, execration, praise, pleasure, and wrath." Marshall's perception of the "other" theatre in the 1930s so clearly predicts the modern pattern of poetry, with the audience for the small presses violently bored by the mainstream of Bloodaxe and Faber. Macleod's career, where obscurity gives *objet* status to his books, moved right down this split.

Seven teases for the pursuer, he published another seven volumes: *The Cove*(1940), *The Men of the Rocks* (1942), *The Ghosts of the Strath* (1943),

Women of the Happy Island (1944), *The Passage of the Torch* (1951), *Script from Norway* (1953), *An Old Olive Tree* (1971). I have seen five of these. Some of them were published by The Fortune Press, one of the classic marques of 1940s New Romanticism. Indeed, Adam Drinan made it into the 1949 New Romantic Anthology. Really, there are elements of the supernatural, indebted to Yeats' plays, in these works, set in the Hebrides. *Men of the Rocks* draws on a myth that the chiefs of the community return as seals after their death; its versification is based on assonance as used in classical Gaelic poetry. The use of repeating words is also drawn from that tradition. This verse structure is much more difficult, personalised, and innovative, than that of *The Ecliptic*. In *Women of the Happy Island,* he focusses on daily habits of work and exchange, converging with the British documentary movement in cinema. In fact, it is Michael Powell who has a comparable fascination with islands (and the Atlantic) and with ghosts. I believe that he stopped writing poetry because of the death of his wife: 'Now that the sun is stopping/ now that the paralysed moon/ is gnawn away, and the stars' hands/ fail at the signing of names' (from 'The Ambulance', *circa* 1953), although one or two poems appeared in the sixties. Indications are that there are several more books which have not been published at all; these are, most or all, deposited at the National Library of Scotland. Late in his life he was working on, and finished, a long and complex poem called *The Planets*. We wait for sight of his complete works; and of the long interviews carried out around 1980, but unpublished.

Since there is no publisher's name inside *The Cove,* perhaps his best book, I guess it is a self-published work: Macleod anticipated in this the small press phenomenon of the last forty years, and this is another reason why he has become a cult figure. There is a big scandal around the lack of reception of his work, but the few who have welcomed him have sometimes had obscure reasons: the American academic reason seems to be that he knew Pound, and that he forfeits modernist status (and on-campus hygienic chic) when he starts writing about class society and social relationships, which are not polite topics for the American upper middle class. The Scottish view of him, during his career, was more that all his reflective work wasn't poetry, because it was about thoughts rather than feelings; Robert Calder has rather made up for this, in our time. Weakened by my weaknesses, for the Atlantic shore and for the darkened side of modernity, I think we would gain from seeing this protean art-dialectic in its full ecliptic beam: starting in the vicinity of Sacheverell Sitwell and Mina Loy, moving into constructivist degrees of freedom, to socialist public art, to a regionalism adapting Celtic verse structure, to New Romanticism, to a poetic documentary in the manner of Charles Madge's later poems, to emotive elegy, and then to stages we haven't been allowed to see yet.

Joseph Macleod

Hesperornis

Alone, therefore of loneliness unaware,
Spreads her webs on the ice-cake igneum
Vast. Over her dazzled retinae
Hood draws for shield from the helian
Glaze by green wave unalleviate
Cast. Stretches suppler vertebrae
Ere mayhap lamineous wanderer
Palaeolithic armoured amphibian
Fast below her lazy vigility
Bolting escape. Alert on a pinnacle
She raised point of level monotony,
Mastering all (all as yet unaerial)
Gnashes teeth as saws that reciprocate,
Hungry for prey from proved inability:
Drastic, divine, has braved omniominous,
Dared what the poets dare, victorious
Over age-static exposed floor-denizens.
Last of her age, the urge of the coming,
Urged, is becoming. First of the future,
The hope that achieves what Men call failure,
The past.

(prefatory poem to *Beauty and the Beast*, 1927)

from *The Men of the Rocks XIII*

The falls sound: and the sound is a shape
The falls shape: and the shape is a changing sound:
The falls changing ever the same

Clever men stand to be stunned by the fall of them
Blind see laughter in the pounding voice of them
Dead stones rise from their grip in the force of them

 the force of the people
 the voice of the people

where water breeds no slavery of fish
where earth jumps beyond service of writs
where gravity wrests itself from the rich

In the song of its freedom I heard the oppressed could sing
in the roar of its power the friendship of fine machines
in its orchestration a joy that will never finish

In the reach of its arms shall strength be, and secureness
by the wit of its wires shall the emptied place have fullness
here at the last shall they prosper who have been poorest.

Developing in its plan the highland brain shall be made whole.
Songs in its praise again make gracious the home
and a crowd of kings the dispossessed shall enjoy their own.

Rotate, rocks! to free the muscles of the falls
Transmit, water! to spread the rumble of the falls
Condense, mist! to clear the blueprint of the falls

The falls fall, to a dipper's dive from moss
they fall, to the thin trill of a dipper on a rock
There sits the minister, the Rev. J. Guinne-Rois.

* *

from *The Cove*

Cracked is the concrete, potsherds of red brick lie upon
a shelving heap of tiles. On smooth cliff-down
gapes a dump where scavenger reeds hide
drain-pipes and piping, an old carboy-cage,
a shut sack of nameless rubbish.
Ring your heels on marble squares, formerly a floor,
no excavator to trace the lie of rooms.
Thrift covers worn steps, feverfew the twisted rods, and at one end
where electric cables branch from an unbotanic root
wrenched off thumb-thick, put in your vasculum
this grey corolla segment of a graduated compo disc.
Not fifteen years from here
across time Franklin played
wireless beam dirigible as a water jet
rippling to a white yacht in the south of the world.

Not forty years from here
in another of his lucky Decembers
through cocoa steam in Newfoundland Marconi
heard three first pips
an "s" centrifugal over time.
Already these superannuated miracles
have been dismantled. Still they stick up from the cliff
in hewn granite for ever. But no memorial as yet
rises up out of the grass, of lies, horror, mess of
imperial mischief, of furtive wealth,
of slavery retransmitted by discovery.
Our true international signals
let's sow them in the grass, here in this desolation,
in part silence of sea-fall far below,
mew of herring gull bewildered by hungry air,
and tiny voices of pipits
like disembodied spirits
as if to lisp "s".

* *

Granite steps and granite stiles
field-walls of granite cubes
bond of subinfeudated land
lips of prehistoric pots
megalith ports of colony springs
rocks that lift from tufted turf
toes from blankets, single stones
planted in the centred fields
for sheep to scratch; pillars of rock
rollers only a horse can shift
granite posts with sockets drilled
iron-plugged; crosses carved :-
 rock too hard for norman's tool
he had to fetch across his own
his stone his titles and his fiefs.

Enterprise Scotland

(from *Poetry Scotland*, 1949)

Her bairns stare at twisted tin,
nylon ropes, cultured colours,

fibre glass, gleg things,
in the mirror of their mother:
>>the love of a good maker for a good matter
>>the love of creative seller for thing created.

The hard ingine of a mother love
sorts and snowks, fichers and favours,
wales the best of the braw stuff,
sprushes with carved paper
>>tissues that scintillate and undulate
>>into and furth of her bairn-multitudes
>>that enlighten and illuminate
>>the minds and eyes of her bairn-multitudes.

The spate that spills in dummy hands
plaster legs, kilted hurdies,
gauchie breasts, ram stam:
of a sudden skailing and skirling
>>out among the tramcars
>>>>jaunty with flags and jewelly buttons,
>>out among the orchestras and artists
>>>>and clishmaclavers of strange tongues,
>>reunions of refugees and English visitors,
>>>>and her bairns looking on.

Lippen-full the haaf they ride
likes seals' heads on deep water;
gleams the gleo, and the brows are bright
on Albyn's and my sons and daughters,
>>and the eyes of me as a father's shamelessly peering
>>>>and speiring their faces and gem eyes,
>>>>the stern and the tender, the open or twisted
>>>>the fair, the dark, and the ruddy;
>>and the ears of me pricked for the sound of their speaking,
>>the soft scent of it, open lips of it,
>>for the smooth breath of it,
>>>>hanging echo of it,
>>>>limpid drops of it,
>>like flavours of burn water on a hot forenoon.

Aye, tousle some of them are, and not smart,
grumlie some of them, misleard and not snod;
the mimm and respectable, the blate and the blae,
wearing loathsome mixtures of emotional tartan,

with little but a grand eye for a good bargain,
and lamentable regard for the approval of London.
 nevertheless they are mine,
my own they are, and I love them; and they me.

But when I see them or scent them, even
I am like Adam of the old fable:
temporarily domiciled in Eden,
a man born with no navel.

The Selected Poems of Joseph Macleod, edited by Andrew Duncan, will be published by Waterloo Press early in 2002.

Simon Jenner

Dreaming Fires: 1940s Oxford Poetry

I

Nostalgia can often be its own exorcist. One sentimental version of a period gets ousted by another; they might even cancel each other in a blur. It's useful to recall the 1890s and 1920s in Sixties revivals, where perceptions of periods took on a virtual reality with kaleidoscope eyes. Revivals, like history and hippies, have turned into their own posthumous industries.

Literature in the 1940s has been bleared at in rose, blood, sepia, and khaki-tinted spectacles. The Dylan Thomas decade has been most recently brought to life by Bob Kingdom, enacting 'Thomas himself' in a one-man show to memorable effect. Such ventriloquism poses interesting questions. Are re-animated sound-bites now *de rigueur* to appreciating the poems, for instance? Certainly during the 50th Anniversary of World War II, the media played a minor role in presenting another view of the 1940s. The Last War poets were alternately dressed up in khaki, helpfully dressed down as not primarily 'war poets' at all, but generally aired in sepia. The problem with their generation particularly, is that sepia and khaki tinting are as close as makes no difference. Nostalgia, which has a squint anyway, finds wartime khaki the most sepia-impregnated shade of all, as Roy Fuller predicted in 'The Middle of a War'.[23]

> My photograph already looks historic.
> The promising youthful face, the matelot's collar,
> Say 'This one is remembered for a lyric.
> His place and period - nothing could be duller.'

That his 'photograph already looks historic' in 1942, 'his fate so obviously preordained' as the next stanza puts it, at least puts the war into its own perspective, doubly. Fuller's poem de-mythologises this war for the future, but also memorably addresses the mythologising we are all heir to, especially in wartime, when a photo is never a black and white affair, but by the very transience snatched away by death and destruction, begins to look ambered before as 'the original turns away.' Nothing dates like war. The poignancy of this is broken through by Fuller's self-conscious refusal to mourn himself, a refusal to let his poem be by one 'remembered for a lyric' in yellowed, death-enchanted pages. 'The ridiculous empires break like biscuits' he bites back:

> Ah, life has been abandoned by the boats -
> Only the trodden island and the dead

Remain, and the once inestimable caskets.

He breaks out of his lyric (distorting the last stanza in the process) and addresses the reader in black and white.

The Poetry of the Forties hasn't quite undergone a dye-change in perception, but if it had, the nostalgia for sewing officer pips on battledress is only a marginal shift from the closing-time declamations of Dylan, himself perennial. But having the images in tandem is an improvement. Or as one 1940s poet - Philip Larkin - put it, it's hard to lose either, when you have both.

That the poetry of the 1940s is no longer seen simply as a neo-romantic cul-de-sac dominated by the example of Dylan Thomas and the drink-charmed circle of Fitzrovia is hardly due to the memoirs. Certainly ever since Julian Maclaren-Ross's memoirs and the 1960s revival of interest, books on some Fitzrovia figures have propagated heroic myths, literature as stout ale, brown studies by other means. This again sepia, or stout-stained image persists, of artists crawling round Fitzrovia in search of tick or other credit. They were certainly given little enough of this in the austerity of the Movement period.

Such a jaundiced view of the decade was one clapped on by the post-war Movement poets; part of a programme designed to highlight their ringing anti-romantic stance, the Orwellian virtues of candour, common sense and plain speaking. A kind of cut-down 1930s. Using the time-dishonoured formula, Movement poets strove to create the impression that their verse involved a radical departure by stamping a highly selective, caricatured view of the previous decade, a brilliant forgetting of the recent past. This has become a commonplace since the war: the shrill reaction bolsters the hyped equation. Some poetic generations now succeed each other so rapidly they have no time to tread anything down, but have it trodden out for them in anthologies.

Whatever the ultimate verdict on the Movement, their success in this manoeuvre aided their cause. Movement poets defined the texture of their poetry by routinely contrasting it with what they loosely referred to as 'the poetry of the 1940s.' The work of poets such as Thomas, David Gascoyne, George Barker, Edith Sitwell, W.R. Rodgers and the poets who had appeared in the neo-Apocalyptic anthology *The White Horseman* (1941) represented all that they most despised. Conflating Apocalyptic excess with neo-romanticism, they saddled a decade with a riderless aesthetic. As Blake Morrison has put it:

> By taking these figures to be 'the poets of the 1940s' the Movement inevitably produced a distorted picture of the decade, but it was one that allowed their own work to appear to be a radical departure, the 'new poetry'.[24]

Morrison exonerates the Movement poets from damning Forties poets wholesale, claiming that they 'on the whole admired' the poetry 'of Roy Fuller, Alun Lewis, Keith Douglas and Henry Reed...'[25] However, there is scant evidence of any public avowal of such admiration. Robert Conquest for instance met one of the more Audenesque Forties poets (and the finest new poet after Douglas), Drummond Allison, just before the latter's death. He privately admired him and wrote an elegiac Ode, incorporating some lines from a variety of Allison's poems including 'O Fields Already Lost'. But incomprehensibly he omitted the dedicatee's name in his Ode 'For the Death of a Poet'[26] and only in 1994 at the behest of Allison's latest editor has he belatedly stated: 'I think only Keith Douglas competes with him among the poets of the war... If he'd survived, he'd have become one of the leading poets of our time....'[27] It is strange Conquest took fifty years to publicly honour his friend.

Even the Movement's much paraded distaste for Thomas was a very partial affair. Conquest certainly found much to dislike in him. But Philip Larkin, as we shall see in his letters, the late Donald Davie and John Wain all expressed at least a qualified admiration for Thomas's verse, often much more. In 1963 Wain edited an *Anthology of Modern Poetry*.[28] It included eight poems by Thomas, more than any other poet except Yeats, who got eleven. Larkin was allotted two and even Wain's admired Empson only three (Graves was accorded the accolade of seven). Nor did Wain share the Movement's hostility to foreign influences. He was in fact particularly keen to point to the wealth of great poetry abroad.

Wain qualitatively divided the Forties into war and post-war periods. Introducing an anthology both generous and eclectic caused him to polarise - and simplify - these too starkly, concluding: 'What 1940 needed, Thomas had. It did not argue: it sang, declaimed, thundered...[29]

This conventional overview is reinforced by the anthology's contents. War-poets whose work would dissipate this impression of the 1940s are represented by just one poem: the romantic 'War Poet' by Sidney Keyes. This does not even represent Keyes. The then little-known work of Douglas, Allison, early Larkin, Alan Ross and the even less well-known Geoffrey Matthews, is conspicuously absent; and the exclusion of the well-known Reed, Fuller, G. S. Fraser and Alun Lewis ironically lends the anthology a distinctly romantic bias. The Movement aesthetic clearly made no lasting impression on Wain. His verdict on the qualities of late Forties poetry is however properly severe; redolent of someone castigating the life and times of their own juvenilia.

Post-war exhaustion has certainly set in here, but partly because of the heat exhaustion afflicting any critic of these years, especially those who lived through it. There was simply far too much poetry swilling around by the end

of the war, and whatever the excellence of some of it, it was often drowned in the urine yellow paper effluence labelled War Economy Standard. These years after all saw not only Thomas's *Deaths and Entrances* (1946), but Reed's superb single book *A Map of Verona* (1947). These contained war work and certainly were noticed. But Bernard Spencer's *To the Aegean Islands* also came out in 1946, as did Larkin's uneven *The North Ship,* which the 1930s poet Charles Madge was almost alone in noticing. Madge himself should have had a book out, but Eliot dropped him from the Faber list, and through Tambimuttu's legendary muddle, Douglas's *Alamein to Zem-Zem* (1946) was not accompanied by a promised *Collected Poems,* only fifteen at the back of *Zem Zem.* Tambimuttu had - inadvertently - struck again. Such accidents distorted the contemporary picture, but should not now.

Wain too, was perhaps looking back with an anger to a poetic youth lacking icons. And since he was about to herald a dawn where he himself was so prominent a worshipper, one can easily forgive him for making a dark night of the soulful from bread coupons. One of the more unpleasant symptoms of recovery is a worsening of something that's held out for so long. In this case, bread was needed elsewhere. Bizarrely, it was one of several items only rationed in 1946 when poetry should have been, and the entire rationing siege lifted in 1952[30] - in time for the Movement eucharist and post-war prosperity. Much the same could be said of the poetry. The outward symptoms were very unappealing indeed, the truth somewhere else.

Strictures aside, Wain is wrong to suggest the advent of war spelt the death of the colloquial, combative style of Auden's generation. What he described as 'argumentative' poetry certainly didn't lose its relevance, nor did the example of the Thirties. Intellectual groups 'at universities or in capital cities' which he felt had evaporated, did form: at Oxford and Cairo. And it was in these milieux that much of the decade's finest and most influential poetry was created.

Wain too, wished to signal an end to the Grateful Convalescent stage of 1950s poetry. Nevertheless, the belief that Forties poetry was predominantly Bohemian or apocalyptic in tone dies hard and the significance of the so-called Apocalyptics has been messily exaggerated. The latter were a very 1930s phenomenon after all. In a fiery reliance on personal and social renewal through the subconscious, Apocalypse architects Henry Treece and especially J.F. Hendry, were heralding an end to tradition. Despite a certain romantic similarity of language (often mere sloppiness or spilt surrealism) the neo-romantics were defending theirs. Yet these disparate Siamese twins - fused to a mass by such anthology introductions as (surprisingly) Kenneth Allott's in his *Penguin Book of Contemporary Verse* - have never been separated. G. S. Fraser, himself an almost accidental Apocalyptic, straddled the decades to exert a profound, rather unacknowledged influence on such figures as Wain and Davie,

in his poetry meetings in the early 1950s[31] was in at the switch-over, and puts Wain too into a 1949er context:

> In the 1940s many potential talents were nipped in the bud... or ran to seed or to waste... there were no dominating figures.. but this open-textured world. was not hostile to good poetry. Nor were the little magazines wholly absurd.. they contained articles on.. American poets like Wallace Stevens.. discover[ed{ ten or fifteen years later... I wrote a long review of Empson's *The Gathering Storm* in 1940... though it made many of the same points as Wain's {1949 article}, had no effect on anybody at all. But it would be possible.. to make an anthology of poems.. and articles..{of} the 1940s that would compare very well with... the 1950s. The reputation of a decade is often an agreed fiction. It is part of literary tactics for every new generation of young men to run down their immediate predecessors.[32]

These tactics succeeded beyond any local aim. In fact, Fraser identifies the key shift of new poets of the 1950s more in 'a new attitude to their audience'[33] than any shared aesthetics. As recently as 1993 John Heath-Stubbs, wishing to 'correct an impression which still seems to be widespread among critics of modern poetry' complained:

> It {the New Apocalypse} seems to be used as a term to cover most of the poetry that was written in the 1940s. In fact, the Apocalypse was quite a short-lived movement and not many of us took it seriously. I myself met no member of the group until long after it had ceased to be of any importance... Norman McCaig also contributed some poems to *The White Horseman*. They were more formless and more unintelligible than the others. He has now become one of the best poets in Britain and I apologise for reminding him of these youthful indiscretions.[34]

Such prejudices as Heath-Stubbs deplores have only just begun to be challenged, usually in reference to The Movement itself. However Davie in his 1966 postscript to *Purity of Diction in English Verse* (1952) claimed that he wrote this book partly as 'an angry reaction to the tawdry amoralism of a London Bohemia that had destroyed Dylan Thomas, the greatest talent of the generation before ours.'[35] He also suggests that this reaction to Bohemia focused a critical response in writers like himself and the late Kingsley Amis. 'That point of intersection, or an area of agreement around it, came to be called The Movement... {its significance} considerably blown up in the process.'[36] Here he echoes his (accidental Apocalyptic) mentor, G. S. Fraser. Davie's analysis of 'Bohemia', and postulation of 'the academy' as a refuge from it, nicely polarised the poet's options. Romanticised wartime conditions were thus conflated with the conditions for bad writing, despite Davie's praise of Thomas (and of Ezra Pound) as antidotes to becoming 'Little Englanders'. Bernard Bergonzi, writing like Heath-Stubbs in 1993 (in *Wartime and Aftermath*), neatly summarises the doublethink of writers like Davie who admired Thomas and yet were in confused reaction to the kind of poetry he seemed to represent:

Like other writing of the 1950s, Movement poetry was in reaction against what had
gone before, though it was not clear exactly what. Dylan Thomas was the most likely
target, though he was seldom mentioned directly; an attitude to poetry that valued
craftsmanship highly would have had difficulties with the fact that Thomas was an
ingenious and fanatical craftsman... The New Apocalyptics were the usual
whipping-boys, and their importance and influence were greatly exaggerated;
indeed, the poetic history of the 1940s has been misrepresented ever since.
One would never guess from Movement polemics that poetry showed great variety
during the war, when Roy Fuller, Drummond Allison, Norman Cameron,
Keith Douglas, and most of the Cairo poets were producing the kind of
work approved of by the Movement.37

Like Morrison, Bergonzi links the misrepresentation of the 1940s with the
Movement poets' polemics. But it's too tepid a counter-blast, a brief caveat to
a still accepted narrative. To say the 1940s are misrepresented is a forty year
cliché, but it remains one because nothing substantial follows to nudge the
cliché into an opinion, despite several books.

So it's a tribute to the effectiveness of the propaganda surrounding the
Movement's launch, that its gorgon glare on the poetry of the 1940s though no
longer unchallenged, remains nearly set in stone. So tranced a target was in turn
largely set up by an entrancing man. Movement apologists exploited the fact
that the Forties possessed a self-defeating propagandist in Tambimuttu of
Poetry London; an editor who persuaded a whole readership that the decade
was neo-romantic - and full of other fantastical dragons for Kingsley Amis to
yawn to in his 'Beowulf'. Such fine neo-romantic work that did appear here or
in Wrey Gardiner's *Poetry Quarterly* was hopelessly diluted by inferior verse
haemorrhaging stage blood exit Left. Racism played its part in stigmatising
Tambi, but he cultivated exoticism and the role of Durrellian (or even
Fowlesian) mage to mesmerised readers and assistants. No wonder his cause
was caged; it was better suited to television. It should never be forgotten that
he generously published poets like Kathleen Raine, and Michael Hamburger's
translations, at considerable financial risk. This was an enormous service
deserving far wider recognition. Nevertheless, thanks to Tambimuttu, Forties
poetry is still commonly associated with heady irrationalism, romantic
posturing, vaguely pretentious mythologising and with what Heath-Stubbs
aptly described (in the *Poetry Quarterly* in 1950[38]) as 'a general discontent
with the social-objective way of writing which prevailed in the thirties.'

This returns to Roy Fuller's poem; the powerful myth-making forces at work
in any nation struggling for survival. How more dramatically true, then, of the
blitzed capital. London, too, as the poetic thoroughfare, in terms of major
distribution and magazine activity, has naturally attracted most attention.

Whilst rightly reviving interest in Cyril Connolly, McLaren Ross, and yes,

Tambimuttu, engaging surveys such as Andrew Sinclair's *War Like a Wasp* (1989) happily perpetuate the myth of Fitzrovia's dominance of the 1940s. Understandably. Tambimuttu's metropolitan promotion of neo-romantic poetry and excess as the new aesthetic was, as Hamilton has said of The Movement, 'a publicity stunt... which brilliantly succeeded.' It has always been dangerous to take Tambimuttu on trust, too. But he should be given the credit for inaugurating poetic hype (as distinct from real movements), a new fashion that perhaps Conquest and others have learnt rather too much from.

Thomas fumbling with the rent-free room of A.J.P. Taylor's caravan, and wife, furnishes one 1940s Oxford. In fact it saw much of the most enduring poetry of the war period, including that of Douglas, Allison, Keyes and the early Larkin - the four poets focused on in my own study - and stands in an altogether more ambiguous relation to the poetry of the 1930s. And it's significant - though hardly surprising, given their Oxford voices - that Auden's strong influence is detectable in all them, albeit modified (not muffled) by the charged circumstances of war. Wartime presaged more than charged romanticism. Its deadpan dislocations fulfilled several 1930s prophesies in verse. These, and the techniques they accessed, struck many of the most intelligent and incisive of the later poets, as fit models for a provisional island.

Cambridge-educated Davie has ruefully noted that 'for the past fifty years each new generation of English poets... was formed or fomented or dreamed up by lively undergraduates at Oxford.'[39] It's no part of my purpose to offer a general survey of the poetry of the Forties such as A.T. Tolley's. Outside my scope - vital when considering Thomas's modernism, for instance - is any assessment of the very different poetry of the neo-romantics, who began in earnest in the early 1930s and much of whose best work dates from the 1950s when they'd fallen from fashion, although persisting as a poetic influence. Indeed, much of the best neo-romantic poetry was written either side of the 1940s, the period with which it's become inextricably linked and the nexus of neo-romantic fame and fortune. Fascinatingly, neo-romanticism became one of the newly ancient springs feeding the sometimes saturated delta of 1960s poetry, in particular its modernist Cambridge revival. When this, too, again became unfashionable at the end of the 1970s, several modernists (mainly based in Cambridge and London, and represented in e.g. Andrew Crozier's and Tim Longville's *A Various Art*) began to re-trace their lineaments through neo-romanticism. Such poets as Nicholas Moore and Dorian Cooke were ruthlessly sought out and published.

Part of the reason for this is the Cambridge links to neo-romantics like Moore and Alex Comfort; following on drier poets like Terence Tiller and the precocious Empsonian follower Brian Allwood killed in 1944, who more typically reflected their late 1930s roots and put forth copper dahlias - and a few

frightful symmetries. After similar Audenesque incursions, Moore's was a very different journey - one wonders mischievously if in some manner a complex flight from F.R. Leavis whose odd toehold dominance of Cambridge English might - inadvertently - have harrowed up at least some poetic souls. The one exception is Gervase Stewart.

Moore, a nobly upstanding pacifist tends to be remembered, literally, for his devotional: 'Darling, you see between my legs...'[40] He wrote copiously, and became unfairly most famous for being most silly: 'Darling, I still remember the unpleasant warmth of your legs.' He needed rescue from such immortally mortal lines, and despite Heath-Stubbs' claim that 'he was just about the worst poet who has ever written in the English language, beside whom Martin Tupper was an intellectual giant and William McGonogall a metrical virtuoso'[41] has justly received it. Comfort, an anarchist who bitterly waged war outside Lehmann's comprehension, was once famous for his pastorally-wracked *Elegies* ('I believe in winter'[42]). He became so again 32 years later, for a wholly different Seventies-summery romanticism in *The Joy of Sex*, that ultimate Leavisite release and perhaps apotheosis of Moore's *Phallus Ethica*.[43]

Another pointer is the slacker pressure of Cambridge poetry volumes from the 1940s. There's no equivalent of the attention-braying *Eight Oxford Poets*. Cambridge University Press contented themselves with a creamily handsome, decently humanist catch-all anthology *Poems of This War*, edited by Patricia Ledward and Colin Strang, published in 1942. It includes good Cambridge poets like Alex Comfort and Moore, and had it concentrated with more Oxonian narcissism on its own university talents, and not the anthology milk-poets of the past few years, might have sharpened poetic identity and - as happens - activity. The volume otherwise comprised minor Oxford noises like John Waller and John Hall, through watery Thirties poets like Laurence Whistler, Clifford Dyment and Emmanuel Litvinoff, to Tambimuttu himself ('Where, O where will we find us after wreck?' to which one is tempted to reply 'Poetry London'). Pleasant individually, but collectively a Long Weekend. The recently killed Canadian Bertram Warr makes an interesting appearance, but David Gascoyne shines out of the fug. Moore returned to edit *Poetry from Cambridge in Wartime* in 1946, a year later than Oxford's ambitious William Bell in the equivalent Fortune Press volume. And P. M. Green edited *Poetry From Cambridge 1947-50*, when Oxford had four anthologies covering 1946-51. This is a terminally vulgar but useful indicator of poetic activity - or more vulgar standards, which have their own rude health. Oxford stands peculiarly alone - not only amongst universities like Leeds (which after the war became so vibrant with poets and poetry) - but as a lightning conductor for grounding talent.

Sadly it's still necessary to point up the significance of a vibrantly talented

group of poets, contemporaries or near-contemporaries at Oxford during the early 1940s, and to their successors later in the decade. Together, their work constituted a link between the 'argumentative' poetry of the Thirties and that of writers of Larkin's and Hill's generation which has gone almost unrecognised.

This Oxford group included writers as diverse as Heath-Stubbs, David Wright, Michael Meyer, Amis, Ross, and Matthews, as well as the four above-mentioned poets. During and after the war this remarkable succession continued with Elizabeth Jennings (the presiding genius), Christopher Middleton, Al Alvarez, John Longrigg, Martin Seymour-Smith, William Bell and Geoffrey Hill. Some indication of their own strong group identity should be made, not least because several were very sympathetic to the older poets. Hill for instance was influenced by Keyes and championed Douglas.

Allison, Douglas, Keyes and the early Larkin were incontrovertibly the most important members of this loosely associated earlier group. Postponement, deferral, deracination, anxiety at the prospect of imminent annihilation: these are themes and motifs shared (to a greater or lesser extent) by them all. Much of their poetry - particularly Allison's - transmitted an elegiac continuation of Thirties modernist procedures, modified by the fact of war and political betrayal. Of the four, only Larkin survived. This fact tends to obscure the links between his early verse and that of his Oxford contemporaries. The point is that Larkin himself did his best to suppress it - as we shall see - in one of the most strangely influential spats of literary pique in 20th century literature.

II

The prime influence on poets of the Oxford Forties generation (mostly born between 1918 and 1922) was Auden. This isn't surprising: his verse was continually exciting, deploying a language both literary and slangy. The imagery he drew on - Marx, Freud and a whole vortex of Thirties concerns - opened up a spiral of opportunities. More than Eliot, the sheer range of Auden's appropriations made a huge impact even on the poetic generation after his own. The startling adjective and the rhythmic, prosodic virtuosity were fatal attractions to the callow and clever. What attests to Auden's potency is that the callow and clever of 1940 were attracted too.

An Auden selection, *Some Poems*, appearing in 1940 proves Faber have never been slow to capitalise on Auden. It's the most eloquent testimony to a vogue - perhaps tinged with anxiety that this would now fade, and a desire to drain the lees of the market. If so, such fears proved groundless amongst the undergraduates, who probably constituted the largest share of it. A slim volume (but not

as slim as the cabaret songs of 1994), it was clearly designed for mass circulation in greatcoats and snatched reading. Against this the very different pyrotechnics of Thomas failed to captivate younger poets till surprisingly late in the 1940s.[44] Against wartime dislocations, Auden's voice was not an especially comforting one. Nor were his more sanguine wartime volumes particularly taken up. Yet as the work of the Oxford poets show his Thirties work continued to appeal.

This was due in part at least to the vigorous contemporaneity and range of Auden's distinctive idiom. The Forties led to a huge widening up of experience for young men and women, particularly in the services; perhaps on an unprecedented scale. For anyone thus creatively involved with words a Thirtyish flexibility and inventiveness must have seemed the most positive of linguistic assets. An unexpected confirmation can be found in John Pudney's *Who Only England Know*.

> Some of this {Air Force} slang and jargon by its very vigour is extending the language...
> The more expressive airmen I have met use metaphors ... Consequently I was
> interested to find many who agreed with my notion that it is the most active
> and vigorous who produce first the compass for new expression, then the new
> words themselves...[45]

Leaving aside the disturbing linguistic Darwinism of such sentiments, Pudney makes an important point in a way he could not have foreseen. For Pudney the experience of active service contributed significantly to the enrichment and invigoration of the language. One of the war's lesser-mapped fall-outs has been highlighted by A.T. Tolley. Not only did the war kill several marvellous poets, it stifled development of others. Tolley, delicately, does not go on to make the rather disquieting distinction: the poets who developed rapidly at university were later servicemen, most of whom took Auden and MacNeice as models. Those - like David Wright and John Heath-Stubbs - who were spared on medical grounds and shunted into sedentary occupations, tended towards what Tolley terms 'a romantic, "literary" backwater in the poetry of the forties.'[46]

This is perhaps where neo-romanticism, defending ancient springs, lost ground to young servicemen or O.C.T.U. trainees brought into daily contact with the laconic but jargon-ridden idiom generated by the blood-groupings of war. Its stimulating qualities doubtless proved a little more fitful than Pudney would have liked, and he quickly owned to finding 'the phrase-crazes (so often *ad nauseam*)'[47] palling. Nevertheless Auden's language world was eminently the matrix to welcome and absorb such material, and the more service-bound the poet (reluctantly, in Allison's case) the more he was likely to employ Audenesque. Auden, certainly, would have found that piquant. This tendency was particularly true of the servicemen who contributed to *Oxford Poetry in Wartime* (1945) and returning ones who found their way into subsequent

volumes of *Poetry from Oxford*. (Matthews for instance was using terms such as 'flak' as early as 1940[48]). This all perhaps reveals a *zeitgeist* only experienced by younger poets for a brief period. Certainly the period from 1940 saw Douglas refining his verse, developing an idiom which deliberately brought a traditional romantic language into sharp, shocking collision with war's brutal vocabulary.[49] And it is those non-combatants who were not exposed to such varieties of new, sometimes horrifying, experiences who tended to romanticism. This happened to Larkin after he left Oxford for a routine and less stimulating environment.

Ultimately, these Oxford poets register most in common with Cairo-based Fraser, Bernard Spencer and Terence Tiller or with Lewis, exiled to Burma and even with Reed condemned to a vital but ingloriously mute posting at Bletchley, and everyone at the BBC. All suffered to varying degrees from war's deracinating, found their ore in its burning grounds.

The persisting habit of associating Forties poetry exclusively with Thomas and the neo-romantic London of Tambimuttu has its origin in a perspective both absurdly distorted and narrow.

III

For some of this distortion it's necessary to pass over the supremacy of Douglas and Allison to consider the effect of another poet, in some ways their equal, for long thought their superior. Keyes was aptly named for his extraneous importance as a war poet whose best work - 'Poem from the North' recalled his friend Drummond Allison's and Auden's rather than some of his more neo-romantic gestures. Keyes was by contrast to Douglas even better known in Oxford poetry circles, which crystallised in his anthology *Eight Oxford Poets*.[50] Taken on by Routledge, this allowed Keyes access to literary fortune. The anthology set out to proclaim an end to the 'Audenian school'. In its slightly muddled attempts to prove and promote a new Oxonian Romanticism already emergent elsewhere[51], it in fact embittered some at Oxford, and permanently distorted the poetic reality. And establishing Keyes's romantic persona and influence, did him posthumous harm.

Keyes was infinitely luckier with his own publisher, Routledge, and was in print with them till the early 1990s.[52] Two Routledge volumes fulfilled a public need for romantic gesture, sweeping rhetorical gifts, and a resonant certainty saturated in a vague, florid symbolism; real mythopaeic address grounding in striking closures.

An awareness of Continental models was Modernist enough; but in the 1940s,

particular poets - the later Eliot, Rilke, Yeats, and early Romantics such as Holderlin, seemed able to offer a war-distracting wholeness, in their various deployments of symbolism. It is redolent in the Eliot of the *Four Quartets*, in extreme forms with the Apocalyptic movement[53], and even implicitly in for instance the critical work of Louis MacNeice on W.B. Yeats.[54] as Heath-Stubbs for one has registered.

Keyes's precocity, fluency, his mastery of the striking phrase, and his romantic affiliations, made him ideal iconic material. He was what was needed, and his reputation has suffered for it ever since. But Keyes's attitude to romanticism did shift from one with which he was publicly associated through his own pronouncements, and which fuelled that public attitude. This might not be not particularly helped by Meyer's assertion in his stimulating memoirs *Not Prince Hamlet* (1988) that Keyes will be seen as ultimately superior to Larkin. In fact, the context is a very interesting comment on official literary history. He grumbles that Larkin only accorded Keyes 'a single page of Keyes's poems in his *Oxford Book of Twentieth-Century English Verse*.' It was perhaps bigger of Larkin to include a page of Keyes at the time he did, for as Meyer elsewhere recalls, Keyes excluded Larkin from his own anthology *Eight Oxford Poets*, which included work by Keyes himself, Meyer, 'Heath-Stubbs, Allison, Keith Douglas, Gordon Swaine, Roy Porter and J. A. Shaw. Those omitted included Larkin, John Mortimer and Francis King: Larkin never forgave Sidney for this.'[55]

Heath-Stubbs echoes this: 'Larkin never forgave Sidney for this omission, and in later years spared no opportunity of attacking his memory.'[56] Anthony Thwaite, the editor of Larkin's letters stated that Larkin 'always maintained that Keyes had excluded him from the book.'[57] Amis concurs. 'Philip was not represented; it appears since that Keyes, who might have known that Philip considered him a third-rate personage, left him out with some deliberation.'[58] Larkin's biographer, Andrew Motion, suggests Larkin's prickly defensiveness might have had something to do with it, disparagement answering disparagement like an Allison poem:

> He continued to grumble about Keyes.. The only memory of meeting him that
> he chose to preserve was one in which Keyes 'was wearing a bloody silly fur hat
> and had smelly breath.'[59]

Keyes's girlfriends had something to say about both memories.[60] Perhaps in selecting two of Keyes's poems in 1972, Larkin was burying his own hatchet in his own infinitely more prestigious anthology, possibly with a vicarious pleasure in doing better by Keyes than the latter had by him. Perhaps there was some operative guilt, as Edna Longley has suggested. In fact, the manufactured fault line between Forties and Fifties poetry partly runs across the personal

antagonism between these two poets.

However, it was Keyes's ideological stance that fuelled his antipathy to the then Audenesque Larkin. It also made him temporarily highly influential, and so particularly reviled by Larkin, as for instance when writing to Robert Conquest on the latter's prospective inauguration of *New Lines* and the following Movement. Larkin was fuelled not so much by a new polemics in poetry, but - astonishingly as late as 1955 - a rancorous desire to revenge himself on 'our Sidney', as he once referred to him in a letter to Norman Iles.[61] Certainly Larkin had no antipathy to for instance Dylan Thomas, whom as his *Selected Letters* makes clear he always admired; as much as did his 'Movement' friend John Wain.[62] His long friendship too with another neo-romantic, Vernon Watkins, is well known. Ironically, Keyes would have preferred the Yeatsian Larkin of 1943-44, an extraordinary (if apparently temporary) fulfilment of Keyes's more romantic programme.

It is ironic too that Keyes's personal liking for Allison had led to the latter's very Audenesque poetry being included, whilst Larkin's was not. And it was impossible to exclude the very un-romantic Douglas, almost *hors concours* for any Oxford anthology then. His work too has far more in common with Larkin and Allison than Keyes and Heath-Stubbs. Despite apologias by Heath-Stubbs, the possibility of personal dislike, or more of political poetics, remains. Larkin would weigh as one more Audenesque poet in an anthology designed to prove an opposite neo-romanticism. *Eight Oxford Poets* was altogether a mixed metaphor of a selection, and its results have been out of all proportion to its importance, even given the talents of those involved.

Keyes's Forties was specifically what Larkin acrimoniously wanted to lambaste and repudiate in the mid-Fifties. This, as Larkin's letters to Amis and Conquest make clear, was also an instance of the personal becoming political poetics. His consistent vituperation against Keyes is quite remarkable. Larkin's lifelong attitude prolonged a mutual antipathy that helped to blur perceptions of 1940s poetry. Larkin's intense dislike of Keyes's poetry (and all it represented) emerges clearly in his letters over at least forty years:

> What does annoy me is reading shit by Sidney Keyes wherever I turn. You pick up any two bob pocket magazine... & you'll find bullshitty poems or tossy 'Short Stories' all by our Sidney. I wouldn't mind if the man were any good but in my eyes at least he's absolutely crap all use & I am gnawed by pangs of jealousy. 'Sidney Keyes is already outstanding' says Stephen Spender in the Year's Poetry in *Horizon*. So is the Rock of Gibraltar... He can make four thousand a year & edit his own paper but he'll still be a sodding bad poet.[63] (To Norman Iles, 7 April 1942).

> Yesterday I saw a book with 'The Complete Poems of Sidney Keyes...' printed on the outside. They want fifteen shillings for it and they can go on wanting as far as I am concerned.[64] (To Kingsley Amis, 9 August 1945).

I think you are quite right in stressing the poor quality of poetry during the war - a period which can laud the poetry of Keyes is no period for me...[65] (To Robert Conquest, 28 May 1955).

And of course death is the great irresponsibility (sId NeY kEyEs Is DaFt).[66] (To Robert Conquest, 26 April 1956).

I'm glad he (Clive James) has no time for Keyes or Roethke, both entire phonies in my view...[67] (To Anthony Thwaite, 21 May 1974).

I reckon Heaney and Co. are like where we came in - Keyes, Heath-Stubbs, Allison, Porter, Meyer. Boring too-clever stuff, litty and 'historical.'[68] (To Kingsley Amis, 21 November 1982).

That he should rate the twenty year old Keyes as 'phoney' as late as 1974, was remarkable given Keyes's youth. Significantly too, the only time he allowed any praise to Keyes was in 1944 - when the latter was recently dead. Larkin, still reluctantly, admits:

I *still* don't like him. He has been getting smashing reviews, comparing him to Keats... But I do admire the way it's a long time before you notice he doesn't rhyme hardly at all. That is an admirable feature, & an accomplishment I envy...[69] (To Norman Iles, 16 April 1944).

Larkin owns to being 'gnawed by pangs of jealousy'. This, a sense of grievance and personal dislike of Keyes, directly fed his encouragement of Conquest's ambitions. It certainly had little to do with poetics. Larkin's admiration for Thomas and Watkins was balanced by a dislike of Keyes, but also by a disavowal of Conquest's promotion of future 'Movement' poets.

Conquest was another poet of that generation conceivably revenging himself for missing out on some just meed of praise in the 1940s. Notwithstanding his caveats on Conquest's equally 'literary' 'Movement' and his admiration for Thomas, Larkin applauded the opportunity to repudiate the Forties. This period Larkin disavowed, since if it could praise Keyes then 'it is no period for me.'

More to the point, it had not praised Larkin; and for this Keyes was at least partly to blame. Such rancour is conceivably justifiable; *Eight Oxford Poets* served several of its contributors well as an entrée to own-volume publication, and London notices.[70] Keyes and Heath-Stubbs went to Routledge; Allison, posthumously, only to the Fortune Press (in 1944), as did Larkin.

Larkin's response, at the time, was to defend the use of 'good' Auden against the 'bad' of *Another Time* - already distinguishing between the 'English' and later Auden. This would have placed him with Douglas and Allison, whom he

liked personally. Keyes himself, in his foreword to *Eight Oxford Poets* disavowed any such sympathies: '...We have, on the whole, little sympathy with the Audenian school of poets.'[71]

Keyes as a TLS reviewer pointed out, was writing against the evidence. Keyes's foreword is certainly disingenuous, at the least wishful thinking, when including such 'Audenians' as Shaw, Allison, and Douglas.

IV

Literary history can be altered by literary accidents - and personalities. Larkin's animus against Keyes somehow enshrined the Forties for him. It fuelled Larkin's bid at recognition in another decade, that might underwrite his existence. Without him the Movement might appear what for many it has always seemed: a journalist-manufactured and limiting prescription, a kind of literary Beveridge Report. Tambimuttu with his contrary polemicising in *Poetry London* had conveniently furnished the Forties neo-romantic myth, summarised in Thomas. Yet when the Thomas-admiring Larkin wrote to Conquest, the poet scapegoated for Forties 'excess' was unequivocally, always, Keyes.

This would not matter if the poetry didn't. But (Larkin aside, straddling both periods) the best poetry of the Forties does seem in retrospect more forward-looking, incisive and cohesive than much official Movement and later Group poetry. It vitally transmitted to later poets like Geoffrey Hill the poetic intelligence, contemporaneity, verbal excitement, social and psychological concerns and metric virtuosity so dominant in the 1930s. Also prevalent were strands of surrealism and fantasy, strongly wielded in the poetic arguments of Douglas. Unlike other poets of the period he was able to creatively absorb these and traces of neo-romanticism without losing his poetic balance like Keyes, or swaying from one influence to the other, like Larkin. It's a further tribute to Douglas's powers that most strands of Forties writing could meet in him. Poetically, he dominates the decade but in a wholly retrospective manner and has more to offer later generations of poets. This is not to belittle Thomas. But ultimately Thomas does not lend himself to poetic imitation.

The Oxford poets had surprisingly few of the limitations their callow experience might suggest. Despite this narrowing of tenor, they absorbed - self-conscious enough of their limited stay - an extraordinary range of experiences. Some, like Keyes's were chiefly literary. But Allison and above all Douglas showed an unquenchable voracity and annealing fire.

Douglas has finally been recognised as a minor classic, championed by and

influencing many, including Hill and Hughes. Allison can be flanked alongside with his more thoroughgoing Audenesque. He isolated the sense of postponement articulated by so many Forties writers into a poetic strategy of his own, and is peculiarly moving.

Larkin, who like Allison would live in Belfast, similarly writes in an Audenesque manner, to 1943. It astonishingly prophesied his later maturity with just such a feeling for deracination, and in the same imagery he would later reinform it with. The Forties clearly formed him as a writer, and his mature poetry in one sense offers an oblique elegy for those permanently deracinated by psychological upheaval or simply death. Alan Ross's poetry of uprooted post-war Germany similarly vivifies a report on haunted experience.

On Douglas's more romantic flank, the poetry of Keyes with its similarly politicised awareness (particularly in his blues poems) failed to integrate this fully with a clash of influences: his healthiest were Auden and his friend Allison: less happy were incursions into the windier reaches of Eliot and Yeats's rhetoric. Larkin, seeking Yeatsian closures not gleaned from Auden, ironically absorbed this same influence, with similarly mixed results. It is an accident of literary history that Larkin's Yeatsian period, and not his on the whole finer Audenesque one, was available to readers for more than twenty years longer. Keyes's blues were similarly withheld, and their publication in the same year as Larkin's Collected Poems - 1988 - alters perceptions of both writers. It also more decidedly illuminates mutual territories.

Hill, Jennings and Seymour-Smith, amongst other Oxford contemporaries, fully absorbed the poetic stimulus. The keen international flavour was still prevalent there till around 1953. Hill and Jennings both early discovered their very different poetic voices. Hill particularly seems to have imitated and quotes from Keyes and later Douglas, as well as foreign poets (for instance, Pessoa). Thus the two finest poets since 1945 - Larkin and Hill - originate as poets from either end of a remarkable decade of Oxford writing. Behind them, Douglas with his rare poetic intelligence emerges as many like Edna Longley suggest with one of the finest reputations made since the war, as extrinsically important as Larkin or Hill, as the latter would certainly agree.

This would still signify a reshuffling of literary history, albeit an extremely important one, had not the survivors of the Forties coalesced so remarkably. Oxford writers like Wright and Seymour-Smith, and Cairo poets Fraser, Lawrence Durrell, Fletcher and others met as a loose poetic group from 1957. This eventually spawned the extraordinary X magazine, which ran from 1959 to 1962. In contrast to the Movement's social acceptances, it advocated artistic and sometimes political upheaval.

This is crucial, since much prose too of the 1940s anticipates more imaginatively the Fifties hatred of what Douglas termed 'bullshit'; sometimes pungent in prose accounts by Douglas himself, Hillary, Amis (*My Enemy's Enemy*), Larkin's two novels and the work of Dan Billany.

The privileging of a too-quickly deployed model of literary history is a contemporary product, understandable but potentially very damaging. Ironically, such a mode of literary publicity began with Tambimuttu in the 1940s, and continued with Conquest and Larkin. It proves how effective London's trend-splitting was. But in the Forties, the best literary production tended to centre on Oxford or Cairo, and both groups were publicity victims of an emptier centralised legacy: literary London. Deracination has become sexy recently. This is a history of what happens when it wasn't.

Such a powerful continuity of Thirties themes, literary styles and the creative interplay of different genres didn't fizzle out. These were developed and transformed by many of the best writers of the succeeding two decades. This could arguably be traced further, at least to 1962, when simultaneously X ceased publication and Al Alvarez, yet another Oxford Forties poet who deplored theMovement's narrowness, published his *The New Poetry*. This heralded the new decade's rather dazed absorption of American and foreign influences.

Writers and their best-realised themes sustain real interest, not movements. Some of the finest poets of their time were marginalised without a context, or clear line of literary descent. And with such writers as Allison an exhumation is vital. Retrospective paradigms are dangerous. More than attempting another one, there is simply the need to point to the urgency these texts own now, for contemporary readers and writers.

23 Roy Fuller, *Collected Poems*, London, André Deutsch, 1962, p.53.

24 Blake Morrison, *The Movement: English Poetry and Fiction of the 1950s*. Oxford, Oxford University Press, 1980, p.25.

25 *ibid*. p.25.

26 Robert Conquest, *New and Collected Poems*, London, Hutchinson, Ode: 'On the Death of a Poet', pp.33-9.

27 Drummond Allison, *The Collected Poems of Drummond Allison*, ed. and introduced by Stephen Benson. Bishop's Stortford, privately printed at Bishop's Stortford College, 1994. p.35.

28 John Wain, ed.: *Anthology of Modern Poetry*, London, Hutchinson, 1963.

29 *ibid*. Introduction, pp.27-8.

30 Bread rationing, luckily, finished in 1948.

31 Both Donald Davie and Martin Seymour-Smith have noted the effects the critical discussions had on the Movement.

32 G. S. Fraser, *The Modern Writer and His World*, London: Pelican, 3rd ed, 1964. Ch. 20, 'The War Years to 1953'. p. 323.

33 *ibid*. Ch, 21 'The Movement and the Group', p. 347.

34 John Heath-Stubbs, *Hindsights : An Autobiography*, London, Hodder and Stoughton, 1993. Ch. 6, 'The Merton Circle', p. 102. McCaig (1910-95) was not that youthful, just another neo-romantic who developed late.

35 Donald Davie, *Purity of Diction in English Verse*, London, Routledge and Kegan Paul, 1967, p.198.

36 *ibid* . p.197.

37 Bernard Bergonzi, *Wartime and Aftermath: English Literature and its Background 1939-1960*, Oxford, Oxford University Press, 1993, p.162.

38 John Heath-Stubbs, *Poetry Quarterly*, Vol. 12, No. 3, Autumn 1950, p.135.

39 Donald Davie, 'The Varsity Match', *Poetry Nation*, No. 2 (1973), p.73.

40 Stanford, *Inside the Forties*: 3: 'At the Dorothy'. p. 42.

41 John Heath-Stubbs, *Hindsights*: Ch. 6, 'The Merton Circle', p. 101.

42 Alex Comfort, *Elegies*, London, Routledge, 1944. 'First Elegy', p.8.

43 'What do I do now - ejaculate? ' the master is supposed to have asked with Lawrentian ambiguity, confronted with late Edith Sitwell. Martin Seymour-Smith, *Macmillan Guide to Modern World Literature*, London: Macmillan, 1985. p. 247. Seymour-Smith even at 16, refused an exhibition to Downing, Cambridge on the grounds of Leavis's disciple-seeking manner, and proceeded to St Edmund Hall, Oxford (home of fellow-satirists Oldham and Grigson) but was otherwise well-disposed to him.

44 Seymour-Smith, Interview 26th June, 1993. 'Much later than you'd think... Some didn't like [Thomas], but many regarded him as great...'

45 John Pudney, *Who Only England Know*, London, John Lane/The Bodley Head, 1943, pp.31-2.

46 Tolley, *The Poetry of the Forties*, Ch. 12. 'The O.C.T.U. Generation', p.250.

47 *ibid*. p.32.

48 Geoffrey Matthews, *War Poems*, ed. Arnold Rattenbury, Reading, Whiteknights Press, 1989. 'To a Friend joining the RAF', p. 24. 'Flak' - derived from German initials c.1938 - had already replaced 'archie', the First War term for anti-aircraft fire. Addenda, *The Oxford Shorter Dictionary*.

49 For a further discussion, see forthcoming book, *Dreaming Fires: Oxford Poets of the 1940s*: Ch. 3, 'Douglas and "Bullshit"'.

50 *Eight Oxford Poets*, ed. Sidney Keyes and Michael Meyer, London, Routledge, 1941. (Publication date 2 November - see Meyer, *Not Prince Hamlet* , p.44, below).

51 For instance, in the work of Thomas, Barker, Gascoyne and others. The later 1930s had seen the rise of such groups as the Apocalyptics, led by Henry Treece,

and J. F. Hendry. Much of this can be seen as a reaction to the omnipotence of Macspaunday. More specifically, since many of these poets sympathised with the socialist credos of the earlier group, it recorded political disenchantment. They, too, remembered Spain.

52 I refer here to the 1962 reprint, and 1988 revised *Collected Poems,* still edited by Michael Meyer.

53 Although Henry Treece is synonymous with the Apocalyptic school, it was the more sober J. F. Hendry who in fact wrote most of its polemics. A.T. Tolley discusses this in *The Poetry of the Forties,* Ch. 7 'Apocalypse and After', especially pp.109-110.

54 Louis MacNeice, *W.B. Yeats,* London, Faber 1941.

55 *ibid.* p.42.

56 Heath-Stubbs, *Hindsights,* Ch. 5, p.84.

57 Philip Larkin, *Selected Letters of Philip Larkin,* edited by Anthony Thwaite, London, Faber, 1992, p.26 n.

58 Kingsley Amis, *Memoirs,* London: Hutchinson, 1991. 'Philip Larkin', p.55.

59 Andrew Motion, *Philip Larkin: A Writer's Life,* London, Faber, 1993. Chapter Six. p.45.

60 Sarah Smith, Interview with Renée-Jane (Scott) Ette.

61 Larkin, *Selected Letters:* To Norman Iles, 7 April 1942, p.34.

62 *ibid.* pp. 28, 46, 55, 79, 133, 218n, 260, 264, 292, 303, 342, 345, 373, 378, 447, 660, 662, 754, 758. Admiration ranged from the adulatory to the occasionally critical. A note of asperity is only introduced when writing of Thomas to the more disapproving Amis. e.g. To Kingsley Amis, 11 January 1947, p.133.

63 Larkin, *Selected Letters,* To Norman Iles, 7 April 1942, p.34.

64 *ibid.* To Kingsley Amis, 9 August 1945, p.105.

65 *ibid.* To Robert Conquest, 28 May 1955, p.241.

66 *ibid.* To Robert Conquest, 26 April 1956, p.260.

67 *ibid.* To Anthony Thwaite, 21 May 1974, p.506.

68 *ibid.* To Kingsley Amis, 21 November 1982, p.682.

69 *ibid.* To Norman Iles, 16 April 1944, p.88.

70 Meyer, *Not Prince Hamlet,* pp.55-6. Keyes, in a letter to Meyer of 26 March 1943, from Algiers (en route to the Tunisian campaign) comments gleefully: 'I consider myself 8 Oxford Poets' front line!' This puns on his now overseas status. He had been 8 Oxford Poets' front line poetically and politically, well before that, and knew it.

71 Meyer, *Not Prince Hamlet,* quote from Foreword to *Eight Oxford Poets,* p.44.

James Keery

Burns Singer and Fitzrovia

> I had been seventeen when I was last in Soho and I had been a poet 'the greatest poet
> in the world', if I remember correctly. But I doubt if I remember anything of that
> period. It was an explosive mixture of ambitions, expectations, love and rebellion,
> during which I had no reasonable expectations and could enter into no normal
> relationship with either a man or an idea, much less a place. Everything else was
> driven away by the caterwauling insecurity of my belief in myself.

Singer's memories of Fitzrovia in the well-chronicled 1940s have a familiar ring, but there is nothing bleary about them: 'Soho. It had often been remembered, as a place that was a kind of home, much more of a home than my parents, more sympathetic to me than the deliberate incisiveness of a Scottish University...' For Singer, the 'University of Soho' was simply the most attractive of the 'Options' on offer. In 1945, barely seventeen, he had begun to read English, but failed to complete his first year: 'Two terms were enough to convince me that a full course of Eng. Lit. at Glasgow University would kill my interest in English Literature and cripple whatever talent might then have been mine'. In the spring of 1946, he fled Scotland and took up a post 'in a dubious private school', where he spent several months 'teaching mathematics to helpless adolescents', until the headmaster died of a heart attack, 'perhaps precipitated by my incompetence'. Fraser recorded some vivid impressions:

> I first met Jimmy in 1946, when he was probably still in his 'teens, in the Hog in the
> Pound in Oxford Street, at a lunchtime gathering with the Ceylonese poet, Tambimuttu...
> I remember thinking both that the barman ought not to serve someone so young and also
> that this slim, fair child was remarkably articulate about poetry... Tambi had stopped
> seriously trying to edit *Poetry London* - it came out at irregular intervals...
> but his warm, irascible glow, his wild resourcefulness and utter helplessness, still gathered
> all the poets of London around him. I remember Jimmy as young, slim, fair, wispy,
> fey, proud: he was Jewish, Polish, Scottish and Irish by ancestry, and he
> looked Polish, a madly reckless young light-horse cavalryman ...

It was towards the world of European refugees that Singer gravitated, and before long he had struck up a friendship with Jerzy Peterkiewicz, who remembers his first visit to 'some shabby lodgings in Earls Court': 'he was still asleep - a book on Joyce was asleep with Jimmy; on its cover a hand holding a real rose. Proved unforgettable: the image and the impoverished poet'. In *Remake*, Christine Brooke-Rose recalls her first impressions of Peterkiewicz, whom she married in 1948:

> At the centre table Tess chooses, sometimes opposite, sometimes next, sits the most
> beautiful young man Tess has ever seen, with a halo of curly black hair above staring

blue eyes and a delicately curved up nose. A young Beethoven. Also using the Library as an office, there punctually at nine. Reading books in German and English and some other language.

The 'other language' was Polish. Peterkiewicz was a postgraduate student at King's College, having fled Poland in 1940 at the age of 23, and studied for four years at St Andrews University in Scotland. He had been introduced to Singer 'by a young German refugee... involved in the Stefan George circle' (probably Karl Kilian Mayer), and his own poetry, like Singer's, was beginning to thrive in the Apocalyptic climate of the mid-1940s.

Study of the magazines and poetry of the period dispels the misconception that the Apocalypse had run its course by, say, 1940, when *Seven* was suspended, or by 1943, the date of the last Apocalyptic anthology. Only special pleading, with resort to superfluous distinctions, between the Apocalypse and Neo-Romanticism, for example, can obscure the fact that the Apocalyptic style, and the quintessentially Apocalyptic theme of (im)mortality, did, as its detractors have often rather inconsistently alleged, dominate the decade. Charles Wrey Gardiner, editor of *Poetry Quarterly* could welcome both in the same breath as early as 1942: 'Neo-Romanticism and the Apocalyptics have tinged the literary scene with colour and richness and hope...' Henry Treece's preface to *The Crown and the Sickle* (1943) conflates the two: 'This, the third Apocalyptic anthology, contains no manifesto and presents no editorial policy distinguishable from a general desire to collect and display these international examples of a new romantic tendency ...' Treece might be suspected of ulterior designs, but not the hostile author of a 'London Letter' to *Partisan Review* in the autumn of 1944, who also conflates the personnel of a selection of Apocalyptic magazines into a single 'movement':

> I am startled and frightened by the lack at' talent and vitality. The crowd who
> are grouped about *New Road, Now* and *Poetry London* - and I suppose these are
> 'the movement' in so far as there is one - give me the impression of fleas hopping among
> the ruins of a civilization.

Orwell's distaste foreshadows that of the subsequent 'Movement', as in Larkin's reminiscences of 'the undergrowth of *Poetry London* and *Poetry Quarterly* in which he had 'become entangled'. Yet all of these magazines, and several others, deserve more credit, and a longer look, than they have been accustomed to receive. Some are still almost unknown to science: *Counterpoint*, for example, makes no appearance in *British Literary Magazines: The Modern Age, 1914-84* edited by Alvin Sullivan (not even in 'Appendix G: Magazines with Short Runs', which does list, for example, *Focus, Prospect, Resistance, Review* and *Tempest*), nor in *Little Magazine Profiles* by Wolfgang Gortschacher (heavily indebted to the former). *Counterpoint* Volume One (possibly the first and last, though there is an ad for Volume Two) is a large-format magazine printed on

art paper with a lurid cover by Gerald Wilde and colour reproductions of paintings by Paul Nash, Cecil Collins and Bryan Wynter; it is undated, but internal evidence suggests 1944-45. Conrad Senat dedicates his magazine to Tambimuttu, extends a cautious welcome to 'the Neo-Apocalyptics as such' and prints work by a remarkable number, including Henry Treece, Stefan Schimanski, Ruthven Todd, W S Graham, George Barker, Norman Nicholson, Lawrence Durrell and R S Thomas (one of his earliest pieces, 'A Priest to his People'), together with an article on Dylan Thomas. Incidentally, in his hostility to the Apocalypse, Anthony Sylvestre anticipates and exemplifies the conclusions that result from any attempt to restrict or disown it:

Although the New Apocalypse poets are the real heirs of Thomas, the neo-romantic label cannot be attached to them alone, and, in fact, there are poets not of the New Apocalypse who have derived from Thomas, and digested his influence. Those I have in mind are George Barker and Vernon Watkins... Kathleen Raine and Lawrence Durrell, who, with Watkins and Gascoyne, are to my mind the best poets since Auden, might be labelled romantics, but with very little justification.

Vernon Watkins 'not of the New Apocalypse'? He was a prolific contributor to *the white horseman*. Doubtless, like Dylan Thomas and Norman McCaig, even Nicholas Moore - 'a decidedly unwilling recruit' (A.T. Tolley)! Kathleen Raine no romantic? She was the charismatic centre of a group of Apocalyptics, one of whom, Tom Scott (eight pieces in *the white horseman*), apostrophised her in an extraordinary sonnet ('the name Raine of course is also rain which to me is a symbol of immortality): 'In burns o immortal rain baptise me love'.

Significantly, it is with the Apocalyptics that many of the refugee poets of central and eastern Europe made common cause. The earliest work of Burns Singer, both original poems and translations from the Polish of Peterkiewicz, is a paradigm of this interrelationship. By the summer of 1946, the two poets had put together a joint collection, *Verses and Visions*. This unpublished typescript consists of a sequence by Peterkiewicz and twenty pieces by Singer. It is perhaps worth recording that I had selected one poem from the typescript and given it first place in Singer's revised *Collected Poems* (due from Carcanet in March, 2001) before discovering that Wrey Gardiner had anticipated me. 'Cain' appeared in *Poetry Quarterly* Vol. 8 No 3 (Autumn, 1946), Singer's first published poem:

Cain

As dear and deaf to shiverings of mercy
As the cold club to Abel's wound, you freeze
To heaven while I drift to days and fearless
Ways.

You must explore the tomb, its limits, silence,
Sound: and sit in villages where no sun sets,
And no man rises. I must live by violence.
Cats

Will wake in winter. Through my wealth of alleys
Lions and rats will swarm. And I more old
At moonrise than sunrise wane by the hilly
Shore.

But never forget the price you paid for silence,
The hot moment or the cold hearafter. See,
There are laurel wrinkles on my brow, nor does the sky dance
Die
WITH ME.

'Cain' is a portrait of the artist as a young outcast (with paradoxical stigmata of immortality in 'laurel wrinkles'). Its power is intrinsic, but it is also a remarkable prolepsis of 'Magnificat', which dates from 1952:

I come to you
Across this painful
Noise of my journey
Without a wreath.
I bear no grudge nor cargo. I carry death.

You will surprise
Me at the last.
We two will meet
Where no sun warms,
I, murderer with my body in my arms,

And you with me
As I at last
With you, alive
Past apprehension,
The dizzy annunciation, the slackening tension.

The 'murderer' of 'Magnificat' is a Cain with tragic experience unforeseen at this period, both perpetrator and victim (Singer's mother hanged herself in 1951, and Singer had to take down her body; he suffered intense guilt for the rest of his life, twice attempting suicide himself). Yet in a sense it appears to be envisioned, just as Singer was to envision his own death, often metaphorically,

but, on one occasion, uncannily: 'I/ Died, as you know, of natural causes and/ A seaman's cowardice' (Singer died of heart failure in Plymouth in 1964, having returned to marine biology). The echoed phrase is haunting: 'where no sun sets'/ 'Where no sun warms'; and there is a clear parallel between the expressions, 'I must live by violence' (rhymed and contrasted with 'silence') and 'this painful/ Noise of my journey'. At any rate, despite the manifest debts to Thomas, 'Cain' is an admirable technical achievement for a poet still in search of his own voice.

Singer's contribution to the next issue of *Poetry Quarterly* (Vol. 8 No 4, Winter, 1946-47) was a translation of one of Peterkiewicz's poems from *Verses and Visions* entitled 'Jealousy'. Singer and Peterkiewicz resumed their collaboration in the mid-1950s, publishing their classic anthology, *Five Centuries of Polish Poetry*, in 1960. As late as 1961, the TLS accepted one of Singer's Apocalyptic translations from *Verses and Visions*, under the new title of 'Stigmata':

> Eternity has pierced my hands so that I bleed
> The cone of both lung lobes has been infected by heaven
> Time slithers off beneath my feet:
> eternity, prehistoric, an excavated skull, stares...

'Jealousy' was part of a feature entitled 'Poems from the French, Polish and Czech'. In 1945, Wrey Gardiner's Grey Walls Press had published *New Road No 3*, a 200-page hardback book subtitled *Directions in European Art and Letters* and edited by one of his contributors. Fred Marnau was a young Czech refugee who wrote in German and had contributed to *The Crown and the Sickle*; his own poetry (translated by Ernst Sigler and collected in *The Wounds of the Apostles*) tended towards religiosity, yet he produced an admirable issue. The featured 'fleas' include a British contingent of Alex Comfort and John Bayliss, editors of Nos.1 and 2 (the only issues he had seen, to be fair to Orwell), Herbert Read, Ruthven Todd, David Wright, Nicholas Moore and Denise Levertoff alongside Czech contemporaries (including Jaroslav Seifert, Franticek Halas and Vitezslav Nezval) and the illustrious dead of several European nations, such as Esenin, Gumilyov, Trakl, Gozzano, Apollinaire and George. The poet whose absence is most palpable is Paul Celan, whose 'Todesfuge' ('wir schaufeln ein Grab in den Luften...') is the great Apocalyptic poem that Comfort attempted in 'The Song of Lazarus':

> I am too much one with the dead
> ever to fear them again. I am too much
> bound to those who have lost the power to speak
> ever to call my voice my own ...

I have been blind, but I have seen everything
I have died, I have been raised again
When they were gone I dug my way skyward
Follow me.

Another Czech, Pavel Tigrid offers a succinct rationale for Apocalyptic poetry, his 'eternal questions' reminiscent of Singer's 'final immensities' ('The Love of Orpheus'):

> pressure from outside, the stormy events of war and oppression, the apocalyptic *reality* of everyday horrors, swept away with miraculous speed all the artificial ballast which stood so often between life and art... Was not this reality pregnant with the eternal questions of poetry, life and death, time and space, good and evil, beauty and ugliness?

The longest contribution, at 33 pages, is a meditation on D H Lawrence by Henry Miller, which combines an ironic contemporaneity - 'It does seem significant that, with all the power that was in him, Lawrence strove to put woman back in her rightful place (a most unmodern view!), and that it is the women who are coming forward to champion him' - with a searching analysis of immortality as Lawrence conceived it: 'The fear of ultimate physical extinction leads him to immortalize himself through his art... Born a mortal he craves immortality; born of woman he appoints himself begetter... That which woman is terrified of, that urgent quest for something beyond her, which makes a real union forever impossible, is the sole preoccupation of the artist...' Miller concludes with a highly personal redefinition:

> Struggle is the creative element. ('Immortality is a question of character'.) Immortality, he would say, is a by-product of the struggle, not the thing to be sought in itself...
> The real fear, the real horror, he discovers, is in the frozen immortality of a life dedicated to ideals... By rediscovering his animal nature, by giving expression once again to his primal instincts, man will destroy the old being that was hidden away under the carapace of ideals. He must not go in this hideous biologic immortality. He must learn to die in his corruption, in order to be reborn, to enjoy a new spirit and a new body and a new life!

Miller's statements are highly challengeable, but they meet one criterion for Apocalyptic writing, enunciated in a later review by Singer: 'There is something to be said for judging poets by the way they use the word "immortality."'

James Keery's edition of the Selected Poems of Burns Singer is available from Carcanet.

Simon Jenner

Drummond Allison: 'We Shall Have Company'

I

'Malory as interpreted by a larky Marx'[72], the late Lord Bancroft on his once fellow poet would have appreciated fate's oxymorons. The career of his friend Drummond Allison was far more short and vivid: he died at the age of 22 in 1943. Thus his poetry can hardly be isolated from the Oxford where it flourished during the war's early years. Allison's undergraduate contemporaries included - as already mentioned - Douglas, Larkin, Amis, and among his more immediate circle of friends Keyes, Meyer, Heath-Stubbs and Wright. That Allison's talent, like that of Douglas and Keyes, was aborted by war, makes it nearly fruitless to speculate on how it might have developed. But not quite. By mid-1940, he discovered a voice which was to become wholly individual. The work he did produce during his three years in wartime Oxford and Belfast, has a jagged, vibrant distinctiveness, not easily categorised as either Audenesque or neo-romantic, though it contains elements of both, tending towards Auden.

Born on 31st July 1921 Allison was educated at Bishop's Stortford College, an outgoing friendly boy thrust into becoming Head Boy of School House. It was the characteristic double-bind pattern of his life; but Allison didn't shirk his options when it came to punishing bullies - or spending hours searching for new boys' missing coats.[73] It was a bright, progressive school (one master, Walter Strachan, posthumously reviewed his poetry[74]) which Allison took uncomplicated advantage of, winning an Open Exhibition to read History at Queen's College, Oxford. He managed only a surprising second in the war-abbreviated Schools, and transferred to read English. As a Queen's student, Allison rapidly made the acquaintance of Heath-Stubbs and Keyes who straddled him in age.

Their discussions took place at the infamous 52 High Street, where Wright, Keyes and Allison all resided. Keyes disparaged Auden, although influenced by him. 'Drummond, however, always championed Auden... "Everybody's being so beastly to him that I have definitely taken him under my protection."'[75] Allison's internationalism and sympathies with the political engagement of Thirties poets were understandable - his mother was of Viennese descent.

> Drummond rather hoped {his maternal grandfather} was Jewish. This was not because he had any romantic ideas... but because he always wanted to identify with any persecuted or disadvantaged minority. Drummond combined English puritanism with something of a Viennese charm.[76]

This cosmopolitan background shows, too, something of his capacity for empathy, reiterated in all the memoirs of him. One, Helen Holder (née Monfries) stated 'of all the people I knew at Oxford, Drummond is the one I would most like to see now.'[77] Another, Paulina Nichol (née Brandt) added:

> My memories of Drummond have never faded - Oxford during that year was
> an enchanted place, and on the few occasions I have been back to the city,
> I have felt his presence everywhere, and heard his excited laughter. He always moved
> at a gallop and words spilled out of him as though they could hardly keep up with
> his thoughts. It is a cliché to say that his was a doomed generation, and seemed as a
> result to have a greater hunger for life's experiences than young men growing up in
> peace-time. But it is true.[78]

Allison would not have found neo-romanticism an adequate poetics to square with his acute social conscience - and his excited laughter. Spilt words needed a Thirtyish diaspora of dropped references. Given this, his interests perhaps naturally extended to films and film scripts. He wrote film reviews as well as submitting poems to *Cherwell*. David Ellis remembers:

> Drummond's idea was to set up cameras and just keep them running in streets to
> see what people really did... a bit like some of the early Warhol 'factory' products!...
> in many ways he was a much more 'modern' and less conventional person than the
> other poets and people around him.[79]

He also acted (being College Secretary of the Eglesfield Players). Allison's poetry differs from that of his more staid contemporaries in a particular way. Wartime instabilities are reflected not just in the poems' themes and images but in their formal and syntactical structures. His poetry also differs from Douglas's in that the experience it draws on is not service time but living on borrowed time. Writing to his mother at Christmas, 1941, he introduces a selection of 19 poems:

> The Key-note throughout this selection of poems is impermanence. Change is
> repeatedly described, expected, regretted... What is there for the poet to put his feet on,
> and where does he find anything immune from time's depredations?
> Only in the hardness and vigour and intense interest of *matter*.[80]

Impermanence creates an acute nostalgia for thingness: a teapot, a frigidaire, a hug, plate glass, the memory of a Slade School lover's body pressed with a gas mask, even a Sunderland flying boat, comic porpoise messenger of war. Allison was unmatched in evoking this. 'You can see how it was:/Look at the pictures and the cutlery./The music in the piano stool. That vase' as Larkin wrote in 1958.[81] Images of postponement, deferral, mapping obviously enough to the situation of young men awaiting call-up, play a central role in his poetry. The imagery's potency however can't wholly be explained in such pat literal narra-

tives: it vivifies a more general uncertainty, dislocation and instability which all his generation shared. In this and in his syntactical deferrals (especially his subordinate clauses) Allison resembles no one so much as Reed, though far more vivid and saw-tooth in execution. His interest in a kind of Mass-Observation film-technique underlines his sensitivity to ephemerality, the plate-glass fragility of experiences like walking down a high-street hitherto taken for granted.

His own manner and speech-rhythms were intimately bound up with his poetic resources. Allison, Heath-Stubbs confirms, was 'an unstoppable and witty talker. There was something about his character which made him talk almost non-stop. He was entirely without inhibitions or shyness in tackling other people.'[82] The same headlong rush attends his poetic style. Allison - who managed an extra term at Oxford due to a stage accident - left for Sandhurst in May 1942. He trained at Plymouth and the Northern Ireland Battle-School. He was commissioned into the East Surreys, attended an Intelligence course where - along with other intellectuals like Robert Conquest whom he befriended at the time - he was failed. 'Drummond, and most of the rest of us, did badly, due... to the personal nastiness of the instructors, particularly in Drummond's case. If he'd been transferred, he'd have survived.'[83] He was seconded to the West Surreys. being fatally wounded on an attack on Monte Camino on 2nd December 1943, at the age of twenty two years and four months.

Hamilton, praising Allison's qualities calls him 'the most absorbed and striking elegist of Auden's "low, dishonest decade."'[84] Vernon Scannell, Tolley, and Douglas's biographer Graham variously praise his distinctive voice. Tolley rightly suggests that Allison resembled the young Auden in his linguistic excitements.

The distinction between the young and older Auden alerts one to the excitement engendered by the language of The Orators (1932), rather than the more commanding tone of 'In Memory of W.B. Yeats' (1939). Tolley's opinion that 'the violence of his poetry is a reflection of his sense of the violence of the times, in face of which he finds no easy explanatory schema'[85] brackets him with Douglas, with whom he can be more fruitfully compared without negating his friends' influence.

The distinctiveness of Allison's voice and of his idiosyncratic poetic strategies is well illustrated in a 1942 poem such as 'O Sheriffs'. The poem celebrates too Allison's interest in films, his recognition of their ephemeral language. If Hollywood could not portray 'what people really did' the movies were what people really watched. Terse humour and nostalgic sentiment negotiate a half-affectionate, half-mocking tribute to the heroes of the popular movies that provided audiences with an essential mode of escape from the tensions of the

early war years. And it's difficult to read 'deputy', even silently, in an Oxford voice:

O Sheriffs[86]

O Sheriffs hung with long pearlhandled guns
Showing your stars, coachditching dark road-agents,
O Pony Express on Sioux-surrounded plains.

Mushers of huskies, dudes in border towns,
Rustlers of painted mustangs down thin gorges
And tumblers out of rustler-run saloons.

O Darrell who the revolving logs defy,
O Billy caught with bacon, mad-eyed Hardin
Daring to draw each pallid deputy.

God like a lone and lemon-drinking Ranger,
Or at a far fur-station the half-breed stranger,
Them string up undecayed and stellify.

This is a valedictory piece for the 'flicks', and its popular sub-genre, the Western. Here as elsewhere, irreverence and sneaking sentiment compound to create a spirited elegy for flickering wartime existence. It's typical of Allison that he should 'stellify' something that has apparently little connection with the stuff of elegy being horribly enacted all around him in the Blitz. His response is oblique, and sidesteps the burden implied in the famous newspaper complaint 'Where are the War Poets?' that prompted C. Day Lewis's riposte of the same title:

It is the logic of our times,
No subject for immortal verse -
That we who lived by honest dreams
Defend the bad against the worse.[87]

To that extent, Allison too flouts conventional expectations of the role of the wartime poet. It seems typical, too, that he should elegise seedily heroic myth. These celluloid sheriffs are really as apocryphal as the Arthurian legend he deals with elsewhere. But the cinema was a peculiarly vital medium in wartime, both as propaganda and escape. Allison did not write on such war propaganda films as (say) *Millions Like Us*, or *One of our Aircraft is Missing*. That would have amounted to wartime commentary on films that were themselves a wartime commentary. A self-reflexive act would have returned Allison to the notions of war, merely refracted at one remove.

What Allison attempts and succeeds at is writing on what 'millions like us' would have enjoyed as pure entertainment: Westerns, the largest genre then in the cinema. Its clear-cut morality is wistfully recalled with the tragi-comic realisation that war holds nothing so clear-cut, or literally black and white.

Allison's syntax warrants particular comment here: only in the twelfth and final line is the main verb, the unexpectedly imperative 'string up' finally released, retrospectively noosing together the unsuspecting dudes and rustlers ironically but warmly invoked in the preceding lines. The deferring of that final clause - 'Them string up undecayed and stellify' - gives it a particular clinch. Its 'them' acts with a force accumulated from all the preceding litany of names. The effect, when the ending is left so conspicuously ambiguous (are these bit-part figures of the traditional Western left unceremoniously hanging from a gibbet or are they apotheosised as stars hanging in the sky?) is that of a series of Chinese boxes opening onto a false bottom.

Drawing together the final lines of the last two stanzas is an off-rhyme: deputy/stellify, with the first two lines of the last stanza actually rhyming as the whole puffs itself to a comic peroration. The writer's penchant for alliterative and internal rhyme here takes on the intonation of the robust yawp of a celluloid cowboy. The sheer unexpectedness of the conclusion is carefully calculated, and it's appropriate that the God who controls this lawless celluloid universe should have only the dubious authority of 'a lone and lemon-drinking ranger'.

The poem's quirkiness twangs with Mid-West syntax: '*Them* string up'. The bathetic vocative 'O's reinforce it as a spoken party piece.[88] The grotesque exhortation is to God as a 'lone and lemon-drinking Ranger', to immortalise these stars in lynching them up to the sky. 'String up', finds its verbal apotheosis in 'stellify'- and shines too with pearlhandled guns and painted mustangs. A stellar glittering contrasts these and 'mad-eyed Hardin' conjuring the huge eye-whites of the old movies, to 'dark road-agents', 'thin gorges' and 'pallid deputy'. So sheriffs 'showing {their} stars' outshine their rival contexts, enact their own stellification. It's all suitably bright and monochromatic. The mobile images of coachditching, defying revolving logs, and mustang rustlers, surround the sheriffs' stance of 'draw' or 'defy', to their less brilliant satellites. Sheriffs, slightly mad themselves, boast an admirable moral fixity in a world mad with war. Like a kind of inoculation, they prove ritualised violence has a soothing effect on those in danger of being blown out of their seats. Only the word 'undecayed' strays with odd menace from the charred world of the Blitz.

Whatever Allison may owe to Auden technically (the undercutting humour, the exuberantly inventive litanies, the farcically insistent assonances and the comic off-rhymes), the tone is wholly his own. There is nothing here of Auden's

knowing social smirk and it's significant the frame of reference should be that of such an ephemeral but popular art-form as the 'B' Western, poised between Tom Mix and John Wayne. Allison deliberately addresses movie-going students and 'other ranks' rather than Auden's radical chic intelligentsia. More strikingly, the provisionality of his syntactical and formal procedures mesh with his quirky poetic strategies, rooted as they were in the inconclusive *zeitgeist* of the early 1940s. His writing delivers a provisional syntax for a time that couldn't respect too much hectoring about the ruins. His metaphors tend to huddle together at times as if expecting an air-raid.

The same preoccupation with time's uncertainty and duration (including the duration of war) that manifests itself so variously in Auden's *For The Time Being,* Eliot's *Four Quartets,* Waugh's preface to *Brideshead Revisited,* Larkin's *Jill,* and Douglas's telescopic reports of the desert war informs Allison's verse, albeit in a minor key and down to the minute: 'Synchronise watches, we are going dancing...'[89] is his haunted, cheerfully heartbreaking response. Unlike some of his contemporaries, Allison is never portentous. (Waugh's apologising for the food fetishism in his novel on account of it having vanished when he wrote it amounts to a recantation of nostalgia.) And Larkin seems to have revelled in the prospect of being cut 'ruthlessly down to size'.

From the very beginning of his brief career Allison's poetry was markedly influenced by both the tone and the political commitments of the Thirties poets, and he shared with them a similar delight in burlesque, pastiche, and parody as a means of warding off solemnity. The 1941 poem 'We Shall Have Company', Allison's first fully achieved poem in the context of his brief maturity, looks like a spoof, but has an underlying seriousness. Whereas Thirties poetry bristles with the antennae of impending crisis, Allison is writing after the outbreak of hostilities. Yet this does nothing to diminish his zany sense of comedy; if anything, it becomes more outrageous. The debunking even extends to the Marxist preoccupations of MacNeice and Day Lewis, here treated with a characteristically exuberant disrespect. 'We Shall Have Company' contemplates the elimination of his class, the withering of the State, the erasure by war of his nation, and his own personal extinction with a deliberately ludicrous equanimity:

We Shall Have Company[90]

If soon by violence and political police, if soon our class
Is to be flung through doors it opened with such care,
If the cream telephones are to be answered
By black slouchcaps and oil stained dungarees
While from directors' chairs the shop steward runs
Europe and love and every watchful author;

Till State itself can wither, fist unclench,
Till nature's cheques
Bear signatures appended by another;

Or if our nation is erased without a smudge,
Seamen and colonists and sad
Clerks in the suburbs who denied their sorrow,
Playwrights and princes and gladly unemployed,
Miners and centre-forwards, clergy proud
Of God their son; if under similar standards
I too go down with some self-conscious laugh
Like one too late
Discovering the examiners were serious;

We shall have company who haunt that highway's ghost
Which now the painstaking Atlantic gloatingly grinds.
We shall ride out on quaggas, on mastodon and mammoth,
Pat old triceratops in passing, stroke the dinosaur.
Sung to by pterodactyls we shall strew
Food for the roc, the great auk and the moa.
Giant sloth and sabretooth shall grow tame for us,
Neanderthal and Piltdown will be willing guides to us
And ichthyosaurus wallow no longer malevolent.

A celebration of the poet's own obsolescence is embedded in this paean to the outmoded bourgeoisie to which he only reluctantly belongs. The "We"s snobbish plural fixes tone and at the same time comically destabilises any 'poetic' one. 'We' replaces 'O' (Sheriffs) in a differently accented peroration. But not many at twenty are prepared to write themselves so willingly out of history, before they've properly entered it. The ambivalence thus generates an irreverent tension. Such irony would not preclude undermining the winning Party. Marxist historicism is stood on its pointed head by the simple expedient of introducing a longer perspective: pre-historicism. The 'We' is not simply unrepentant - a class that has failed to matriculate for the 'examiners': it is subversive and begs the question of where obsolescence ends. Not, perhaps, with the examiners. Cheerful nihilism dulls the edge of ideology. In the 'self-conscious laugh' there is little comfort for the 'slouch cap' inheritors. The poem enacts its own comic precipitation into - not oblivion but a prehistory party. Inherent in such an absurdist elegy for one class, is a warning to another.

The first two stanzas are suspended, Damocles-wise, mimicking the fate of the bourgeois victims of the impending revolution. But the resolving third opens onto something very different, a collision of mythic and contemporary themes Allison had kept separate. It's a typically 'late' Allison contrivance. Although elsewhere he tends to an aleatory or arbitrary deployment of myth images, he has here stanzaically delimited two worlds and resolved them with assured nervous humour.

Humour is, in fact, one of Allison's best suits. It's the strategy he employs to order and distance his emerging poetic vision, the manner in which he qualifies and composes his world in the context of his fears, and those around him. He employs his sense of fun like a flood-barrier, to incorporate in his work the otherwise too monstrous material of war. The clever undergraduate jokiness is, to an extent, a dry pose.

To 'go down with some self-conscious laugh' mimics the inconsequential front donned by the Oxford student who's failed his Pass Mods or to the revolutionary proletariat who've examined the middle classes and sent them 'down' with their own metaphor (Allison shared the class-guilt of the typical Thirties poet). But the notion of going down in good company also has rumbling overtones. The nervous self-positioning, the class-consciousness and the self-pastiching facade all betray a fundamental unease, reinforced by the jerky speech-rhythms and the jagged transitions. The reversion to the primitive world of pterodactyl and Piltdown Man envisaged in the final stanza is something more than a poetic guffaw.

Elegies pattern their own contemporary myths. It is Allison's confident answer to a time all too menaced by the conditional, the provisional, and the possible erasure 'without a smudge'. The threat of revolution has been temporarily replaced by that of war. Both involved genocide, complete erasure. This annihilation extends, in Allison's poem, to topography. The 'highway's ghost' refers to vanished land masses like the link from Dover to the continent. It also ghosts the suggestion of present peril. All land is ephemeral. We must look to our ghosts and draw comfort from their going. The scene is comic, and obsolescence might well repeat itself as farce. But it is a farce with a savage, surreal edge.

'We Shall Have Company', like 'O Sheriffs', is first a brilliant rhetorical performance executed with larky panache but the humour and ridicule is edged with panic; a bit like funeral cards for a comedian. The image of his class being violently 'flung through the door it opened with such care' is both comic and resentful, tinged with anxiety. Allison's ambivalence about his class affiliations is even reflected in the title, which at one and the same time suggests the mincing petit bourgeois locution of someone expecting visitors and the defiant resolution of one who's not going to go down without a bloody good fight. (He was, singularly one hopes, named after Bulldog Drummond.[91]) This is heightened with a recognition of a possible, somewhat pugilistic model for this verse: Kipling's 'If'. Parodying what he might have perceived as an apologia by an Imperialist, Allison textually subverts the premises of both left and right.

As in 'O Sheriffs' resolution of the successive subordinate clauses is repeatedly

deferred. There's a tart repetition of words in emphatic mock rodomontade. The whole poem's organised as some apparachnik puffing themselves up to an inflated bladder of an edict; you think he won't get to his point. But he does, in a huge opening up of rhetorical patterning, modelled on the strategic placement of the resolving clause - subordinating all before it in a bellow dissolving into (polite) belly laughter. So distended has the grammatical unit become, that Allison makes the whole of the third stanza a resolving clause for those previous to it. 'We' resolves 'if' in a series of mirror-like wry affirmatives. It underpins, too, the dramatic shift from the vivid contemporaneous dystopia of the first two stanzas, to the explosion of resolved hysterics. The menacing conditional is trounced by the future tense, riding back, so to speak, into the future perfect dawn.

Here as elsewhere Allison's syntactical strategies too reflect his generation's sense of the provisional quality of day to day life, of the ordinary sequences of life being put in cold storage 'for the time being' (in Auden's phrase), or 'for the duration' in contemporary wartime jargon. Allison's syntax subtly enacts war's displacements and suspensions just as his jagged humour filters its terror with outrageously irreverent laughter. There could be no question of Allison's generation seeking to emulate Eliot's *Four Quartets* (the latter three instalments of which appeared in the early years of the war). It explores from a more theological perspective, war's displacements and suspensions. For the younger poets of the war, such grand moral gestures were no longer viable. They have often been criticised, then and later, for it. Tolley and others have responded[92]. They could not repeat the First War's moral imperatives, nor deny the threat of Fascism, and to everybody, not simply combatants.

Allison's jauntiness and reckless bravado is typically English, and typical of his class: the poetic equivalent one might say of the gladiatorial insouciance of the stock Spitfire pilot (the ones who raised eyebrows at women Spitfire ferry pilots, which Allison wouldn't have). For an American poet such as Robert Lowell it was possible to memorialise the death during the war of a cousin at sea, in the traditionally grandiloquent rhetoric of 'The Quaker Graveyard at Nantucket' with self conscious echoes of earlier elegists such as Milton. Allison's 'A Funeral Oration' on the contrary is conducted in a typically reductive style. The first of those he commemorates, Douglas, is his brother, killed not in a Spitfire but a Wellington returning from a raid over Wilhelmshaven in December 1939. Heath-Stubbs recalls a bizarre incident when he and Allison were given a psychic message from his brother. 'Drummond said, afterwards, that he really did not think his brother would say "I liveth."'[93] This is just the tone of language Allison eschewed, partly out of respect and a disdain of platitudes. He cocks a snook at the traditional funeral elegy just as deliberately as Lowell honours and embraces it, and yet the impulse to mock and debunk does not shroud compassion. In its refusal to

mourn automatically in an "I liveth" formula, Allison's poem is characteristically unsettling and resistant to categorisation.

A Funeral Oration[94]

For Douglas whom the cloud and eddy ejected,
Though clad in dark Wellington he had deserved
Perpetual fellowship with those aerish beasts
Whom the eloquent eagle introduced to Chaucer;
But now the North Sea separates his bones
- Douglas who cocked an incessant snook at Death -
And crab and plaice make love wherever his soul
Shrived by a Messerschmidt cannon began to be sand,
They make light of his non-watertight prowess.

For Robert whom the wrath of the Atlantic
And untiring fire proved by the mouth of the River
Plate, but later the Mediterranean
Whose vaults he visited tricked and shut securely
In, and he penetrates forever the palaces of Atlantis.

For Colin last seen within sight of Greenland,
Who disagreed with all the gods and went down
The gradual stairs of the sea with the 'Hood', until
He could have used vacated shells for tankards
A vigorous white worm for a cigarette
And girl friends having swords upon their snouts.

In 'A Funeral Oration', the prepositional phrases opening each paragraph enacted a kind of subordination to a would-be conclusive main clause. This, however, never emerges, perpetually deferred, and the poem is finally open-ended in its structure. The absent main clause parallels, and suggests the underlying subject, Death. This - significantly - never fully materialised but left its traces, in Allison's compassionate jokiness. It's a humour the more moving for its genuine tact.

In each stanza there is a local resolution. The votive "for"s constitute an open-ended offering for the dead which could be extended to an infinite series, like the casualties of war that these two friends together with his brother are. There are dark jokes: Douglas's being effectively shrouded (iron 'clad'?) in the metal 'dark Wellington' not only delimits his continuing Middle English studies. The bomber of 1939 has frozen Douglas in an Iron Duke's period; he deserved another. The offhand tone subverts elegiac format. But the lack of closure reaffirms tension, even tragedy. Formal expectations are suspended, found wanting. The war itself will add to the list of "for"s. Any oracular Binyon-like comment will have to wait for the infinitely deferred outbreak of peace, as

Binyon did. No closure is possible in (what Fuller entitles) 'the middle of a war'. Underneath the sad, restrained comedy, Allison disturbs the tidy cenotaphs of feeling reserved for the 'fallen'. They are individually named but grouped, hovering between the perception of a single lost Lycidas, and 'millions of the mouthless dead' as C.H. Sorley predicted in 1915. This refusal to mourn either singly or in Sorley's 'pale battalions' is a subversion of elegy. It questions the consolatory finality of such modes. It touches anger.

II

Allison's restless agility is one of the factors that originally militated against his posthumous reputation. Keyes was still in print till recently, and should be again.[95] Keyes's fluency is condemned, yet is simultaneously used as an excuse to chastise Allison for not possessing those very qualities. Allison would have found some creative paradox as a footnote to his friend Keyes. He wryly and wrongly footnoted himself in 'An Epitaph': 'He at any rate knew the certainty/Of the second best's thick utility.'[96] Allison is as Tolley says 'more interesting in retrospect'[97] than Keyes. Even Keyes's great friend Heath-Stubbs admitted as much, echoing David Wright's comments in *Deafness* :

> Drummond was so much the clown, lively and humorous, that we did not always
> take him seriously enough as a poet. His poetry has in fact stood the test of time better
> than that of Sidney Keyes.[98]

Wright adds in the same recent Introduction to Allison's poems that they:

> have worn better than most of his contemporaries'. Keyes' poems were born from
> books, but Drummond's came from life and experience. Yes, the poems were uneven
> but all the same Drummond found his own individual voice, rare at that age; and they
> possess an energy which keeps them alive.[99]

But to trade one off against the other is invidious, like the faded fashion statements of New Poets with months of activity before them. Read together as a complementary pair (let alone Douglas, Larkin) increases wonder at such concentration of talent, never again seen since in such a group of young poets. Allison does not insert so neatly into either literary history or subsequent dismissals of his period. His own refusal to drink the fluid Keyesian line, and lack of Douglas's ego, rendered a creative intelligence nicely fitted to touching the dimensions of wartime or long term deprivation. Registering individual and collective subordination to the time, he lessons the reader in awkward transcendence, that becomes the less so the more he is read.

Allison matures. He develops a use of myth, from analogy to a wry questioning: of how we create myths of ourselves in history, and thereby our

predicament. This is developed into the last poems, that wrench solace and record despair at our individual capacity for doing this. We succumb to history, and our feelings frequently sabotage our respites from its grosser demands. Allison invokes an equivocal helplessness in being overwhelmed by events. Above all, he retains a humorous sense of proportion. His consistent technical manoeuvres to accommodate his humour, fear, and the duration demand fuller appraisal. That he should not be 'erased without a smudge' is attested to in just such a wry look at posthumous reputations:

Wade[100]

After the league of ogres hurtling logs
Against him as he climbed the cloven hills,
The serpent served with virgins in hot halls,
The barge bewitched and rowed by idiot dogs

He knelt unweeping at his father's tomb
Working out ways to cheat his ancestors;
He sliced his acres up, tore down the towers
And shared their thankless tasks with guard and groom:

Expunged from song the hero of The Churls,
Mentioned by Malory when absent-minded,
And no lies left about his grief amended
Who died refused by henwives and goosegirls.

'Wade' resembles Amis's 'Beowulf' in tone. Both are to some extent a result of the Oxford English reading syllabus. It also pithily resembles Allison's entries in the *Oxford Book of Short Poems,* where 'King Lot's Envoys' appears with 'O Sheriffs'. Auden's epigrammatic and lyric gift precedes them; Larkin's short poems directly follow. This is appropriate. Both Douglas and Allison belong to the line of terse lyricism that emerges for instance in Graves, and works through Empson, Auden and MacNeice to poets like Amis, Larkin, Hughes and Hill. 'Wade' also recalls Graves in its ironic recasting of history and myth in an epigrammatic guffaw. The penalties for renouncing tradition and civic obeisance are laconically set down. Cheating one's ancestors rends the patriarchal succession, the state. The Gravesian hero is 'expunged from song' for being Gravesian; for saying goodbye to all that.

Perhaps Allison begged too many such questions for some of his more staid contemporaries - like Conquest - to revive his reputation in the 1950s. He would not have then seemed a romantic relic, but as fresh as Douglas is seen to be today. Linda M Shires, noting his neglect, points out that Allison's 'wry summation 'An Epitaph'... could easily have been composed in the 1950s.'[101]

Hill's beautiful 'Merlin' was written in 1953, and echoes in its theme and two brief quatrains these short poems of Allison: 'By the long barrows of Logres they are made one,/ And over their city stands the pinnacled corn.'[102] Hill is more dignified, but the familial resemblance is striking. 'Expunged from song' Allison is not, but he and others, even Douglas, have been sidelined because of the exposure given to the Movement. 'Wade' is an object-lesson, perhaps, in what oblivion awaits cock-snookers. One cannot help noting the irony. Movement irreverence, except in Amis, tends to the dour and politically neutral. Allison and Douglas show up the Movement's lack of poetic vitality, alertness, and daring. Allison's peculiar contribution was to extend humour and the spoken voice, to fuse syntax to his themes of deferment. His poetry turns the war-suspended life to metaphor: specifically, the provisional and alien that all experience at some time. He is the poet of the conditional, and of how one becomes prisoner of collective myth, masquerading as history. It's worth recalling Hamilton's judicious comment. 'One wonders', he observes, 'how this, strange, uncertain talent might have developed under stress of the real thing. [War]. A familiar speculation, but with Allison one feels its pointlessness to be unusually exasperating...'[103]

Yet Allison did develop, and peculiarly 'under the stress of the real thing.' War, like poetry, happened everywhere in Britain in the 1940s, and Allison's response moulds itself to this. It is perhaps fairer to speculate - exasperatedly - on what his unpredictable post-war development might have been; and how it might have influenced contemporary poetry, in common with Douglas, say.

Douglas has gradually become part of the poetic mainstream, but his achievement was not an isolated one, nor do his Audenesque contemporaries emulate him. Douglas was greedy for experience, deserting to the Battle of Alamein. His poetic certainties and poetic intelligence made him the outstanding poet of the earlier Forties. But Allison's achievement, more local, more deliberately provisional in its conclusions, make him the more representative of his period. Another of Allison's Oxford poems celebrates the nerve-shot humour of stasis, waiting around for call-up. Some of the situations recall the bizarre stillness and scenarios of Magritte's wartime surrealist paintings. *The Sleepwalkers,* for instance portrays a fantastic stasis of nudes and vacant streets. Its hallucinated politics centre on the occupying German forces. These reduce life to a hushed interim, where silence invites complicity with the enemy. In Allison's poem, a related sense of war's stagnation is poised with wit.

A Great Unhealthy Friendship[104]

There was a great unhealthy friendship
Developed in a stark old district
Between a student and a God

Who languishing in opposite lodgings
Signalled across the street their greetings
And cared not whither it might lead.

At tables outside costly cafés
Or visiting asylums' inmates
They found they had too much in common
Till all each others' books were finished
Till they had slept each other silly
Till mind on mind preyed like the ichneumon.

The God departed without paying
And ever after human-shunning
Donned an impenetrable disguise.
The student took life like harmless poison
And never met a normal person
And won renown for formal views.

The Larkinesque end of the student inhabits a similar spiritual exhaustion, with more tragic knowledge in Larkin and in Allison more apprehensiveness. The latter's joke -'whither it might lead' - is causal, local. Even a God can only affect a single student in wartime before turning the process crass. And even in such a casual poem Allison's tendency to speed the latter half of a stanza is here aided by anaphora, and conjunctions twice in repetition (stanzas 2/3). It mirrors the conjunction of 'mind on mind' and, self-reflexive, sends up intellectual incest with a brio that the Movement might well frown upon.

Allison's achievement tended towards the elegy of place, usually Oxford in its distracted black-outs. His embodying what is recognisably his own jerky voice, to the extent of dictating syntax and form was a remarkable accomplishment. 'Voicing', enacting oneself, and writing one's own elegies conflate to an original stratagem. Under historical pressures 'all a poet (could) do today' (in Owen's phrase) is speak of indefinite postponement. This Allison managed in a personal idiom torqued out of contingency. By assimilating, even mimicking the shape of the time (as experienced), one is paradoxically the less displaced. It is a method that speaks for all distracted times. As the rhyme-schemes and consistent manipulation of line denote, it was a conscious tactic demanding trial and painstaking error common to all such ventures.

It's also a paradigm of the best Forties writing that it should take local risks in the dark, without either the afflatus of Apocalypse and neo-romanticism, or the mean refusals of the Fifties. Beside the best of Allison, Douglas, Ross, Reed, Fraser, Spencer, the latter decade's work without Larkin and Hill shrivels slightly.

72 Allison, *Collected Poems,* Introduction, p.29.
73 *ibid.* p.19.
74 *ibid.* Walter Strachan, *The Yellow Night:* Poems by Drummond Allison,
 The Stortfordian, April, 1944. p.202.
75 Heath-Stubbs, *Hindsights,* Ch.5, p.68.
76 *ibid.* p.66.
77 Allison, *Collected Poems,* Introduction, p.32.
78 *ibid.* p.32
79 *ibid.* p.26.
80 *ibid.* Notes on the Poems, pp.180-81.
81 Larkin, *Collected Poems,* 'Home is so Sad', p.119.
82 Heath-Stubbs, *Hindsights,* Ch.5, p.66.
83 Allison, *Collected Poems,* Introduction, p.28.
84 Hamilton, *A Poetry Chronicle,* 'The Forties', London, Faber, 1970, p.74.
85 Tolley, *The Poetry of the Forties,* Ch.12, p.251.
86 Allison, *Collected Poems,* p.126.
87 C. Day Lewis, 'Where Are the War Poets?'
88 Admittedly, such solemn occasions that the slightly less garrulous Keyes and
 Heath-Stubbs might have furnished in Oxford, leave this speculative, though not the
 matter of their influence, which is dealt with elsewhere. See, for instance, the
 unblinkingly solemn 'For Sidney And John', p.80 of *Poems,* an expression of real feeling,
 but also one of Allison's relationship to the two owls.
89 Allison, *Collected Poems,* 'The Cold Thoughts', pp.161-162.
90 *ibid.* p.98. Benson has possibly standardised the spelling of 'dinosaur' from 'dynosaur',
 and 'quaggas' for 'quaggers', as they appeared in Michael Sharp's 1978 edition of
 Allison, p.19. (*The Poems of Drummond Allison,* ed. Michael Sharp. Reading,
 Whiteknights Press, 1978).
91 Allison, *Collected Poems,* Introduction, p.11. 'He was christened Drummond because,
 apparently, when his mother first set eyes on him, she declared that he had the
 pugnacious chin of 'Bulldog' Drummond. the hero of Ian Hay's popular thriller of the
 early 1920s.
92 For instance, Tolley, *The Poetry of the Forties,* Ch.12, pp.238-9.
93 Heath-Stubbs, *Hindsights,* Ch.6, p.96.
94 Allison, *Collected Poems,* p.147.
95 Sidney Keyes, *Collected Poems.*
96 Allison, *Collected Poems,* p.173.
97 Tolley, *The Poetry of the Forties,* Ch.2, p.250.
98 Allison, *Collected Poems,* Introduction, p.32.
99 *ibid.* p.31.
100 *ibid.* p.122.
101 Linda M Shires, *British Poetry of the Second World War,* London Macmillan
 1985. 'Epilogue': p.153.
102 Geoffrey Hill, *Collected Poems,* London, Penguin, 1985, p.19.
103 Hamilton, *A Poetry Chronicle,* p.77.
104 Allison, *Collected Poems,* p.127.
105 *ibid.* pp.161-3.

Drummond Allison

Five Unpublished Poems

These five poems were excluded from Stephen Benson's superb edition of Drummond Allison's poems for two reasons - sexual delicacy and immaturity. Yet much earlier juvenilia was included, and these pieces are disturbing, astonishingly candid (about homoerotic encounters at school) and show despite some diffuseness more talent than many distinguished poets at a similar age (about 19). Quite apart from vitalising an impression of Allison somewhat missing elsewhere, they do poignantly illustrate adolescent sexuality with Allison's blurting melancholic cheer. Above all, they still bear re-reading. Their months but not year are given, and internal evidence suggests 1940. 'The Cold Thoughts', his masterpiece, discussed in my book, is appended to show how he matured.

Realisation that an Experience has been Valueless

So, while the rear lamps lose face and quail
without wheels on the verge of the dank blue unknown,
cold sweaterless swivelling at hips with snatching steps
down the street that is only a dwindle lacking precision,
head held sideways not the signal for tragedy
since this tragedy turns on nothing being tragic
– big stuff shapeless nor taken seriously,
but small stuff dried up issuing in dividends
nearly sucked back, so no source for speech.

Comfort yourself with rear-lamps as rear-lamps
for beauty objective is useless and harmless.
But emotion's matador enveloped your horns in
mind-huddling scarlet cloak, friendship and body.
Thoughts cut each other's throats.

June 1940

Hotel Waitress

Eggs your hair, celery your fingers,
bare elbow to wrist meat of boiled fish,
buttons down front of dress mushrooms; neck
white fat ham, lips best strips of lean,
oh forehead smooth chicken-flesh texture
of stockings sausage-skins burnt black, calves

showing beneath the pink insides.
But my teeth tapping together vainly
my gorge rising though the frolics of famine,
my fingers not knives and my thumbs not forks.

<p style="text-align: right;">*September 1940*</p>

A Knack at Necking Gets you Further

A knack at necking gets you further
than limitless desire,
the technique of a scheming poet
beats all spurned lover's fire.

Capital's cold self-seeking diddles
Reds rampant for mankind,
professors drunk with Oxford honours
change no stock-joggler's mind.

So I, who talk so much of sex-life,
quote Freud and Marie Stopes,
who preach free love and contraception,
fear - this clod knows lust's hopes.

<p style="text-align: right;">*September 1940*</p>

Any Time, Now

Any time now they'll let me into the secret,
any time now I'll know it's only their fun,
any time now they'll pull the mat from under my
feet, and my head will strike some spike of the stairs.

Games I tried first, saw God in the curve of blue rugger bags
thighing aside the tackler's talons, pads
flung new-whited in the dust of the lockers my idols,
half-miles holding a thumping heart my priest.

Any time now the umpire's index finger
will acknowledge the jeering appeal from a catch on the wicket.
Any time now will death the grim referee
spit the sound of no-side when I'm well in the twenty-five.

Books I sought next, lay half naked on guilt-groaning Swinburne
crouched in the loft over forbidden O'Flaherty, cried
Shakespeare was spiffing when others heard bell, with relief, mad
Malory's Merlin magic the morning-room floor.

Any time now the prefect will shout 'stop reading',
any time now they'll say it's time for bed,
any time now the bloods will burn the bookcase
ripping paper playwrights, slashing the poets with ink.

Then I found boys, sang raucously on cold car-rides,
gulped baked beans in the kitchen, watched in the baths
shirt leaving shoulders, running shorts sliding from hips, arranged
dusk rendez-vous for feeling behind classroom block.

Any time now I'll hear 'I don't like your friends, dear.'
Any time now they'll stop me making a noise,
any time now the head will have warned me for the last time,
any time now the matron will catch us in the dorm.

So to religion, listening round-shouldered to sermons
mouthed by mild missionaries, sunlight through strained-glass mauve
mixing me up as to whether I'm Paul or Luther,
seeing in sunset the infinite closing its eyes.

Any time now the burglar will take my prayerbook,
any time now they'll say I sound foul in the choir,
any time now lean rationalist guests will confound me
saying we all go through that stage some day.

Girls followed on, brown hair fell back on sofas,
flicks failed but hand touched hand as chocolate passed
stubbing numb toes the lingers at the bus-stop
stared through the fog for fear his hopes weren't vain.

Any time now she'll say she doesn't think so,
any time now she'll take his arm, my arms
any time now will lose her in an excuse-me,
any time now I'll miss my only chance.

Politics finally, Strachey, Palm Dutt and Lenin
scarlet the shelves, I lean forward clapping in the smoke
catching mere gist of ill-shaven economist's diatribe,

snarl later in pretended detail to group round fire.

Any time now they'll write me off as harmless
though any time now they'll smash the Labour Club.
Any time now they'll tell me 'Move off, sonny,
we've shoved your brawling comrades in the jug.'

Yes, any time now I'll feel a hand on my shoulder
while my mother murmurs breakfast's been waiting hours,
any time now I'll leap from my bed on the ceiling
breaking my neck on the floor thirty feet below.

July 1940

So it Sucks for Me

So it sucks for me
that you don't like sex,
fear a smell of dirty socks
in damp sacks
when a soiled hand seeks.

Don't flatter yourself
that the absence of letter
means the taste of friendship grown bitter
– it's only the calves get fatter
and the fingers during dancing hotter.

But I would still call white red forearm,
with pain of pleasure at ordinary month start
I gusting small hairs, love your gait
however bottom-swinging, and smart
under the eyes at so seldom short
glimpse down dress at juncture of breasts,
if it weren't for objective silver picture
instead of long real look, rapture
over dog on tree but not me, adventure
told first to strangers or parents, nature
to be dignified through drill, to remember the past
but to avoid consciousness of present hole,
to jeer kindly and stall,
to be serious with a fool
but laugh if he wail.

Yet it snubs to me
that the thought of ribs on ribs
rubs
on your mind's fine edge, that your heart grabs
eagerly at whatever jabs.

August 1940

The Cold Thoughts[105]

Oh! cold as any snowfruit, colder than
Compulsory bathing or some smiling Head
Master, untouched these thoughts have lately lain
Along the scalloped edges of the brain
Colder than greens long-left upon a red
Enamel plate. But now the Baker Man
Warms up the engine of his different van
- Now round and numbered is the noisy bread
Of war he must distribute - and in vain
Warns us of what we were: the sticks who ran,
The flying child, the optimistic dead,
All those cold thoughts are steaming now again.
For every morning then the bullfinch woke us
Boasting about his berries, or the persian
Scratched at the door. We saw the huge arriving
Grocers and guests and ghosts, we saw them leaving.
Sun served a fault or chose his old incursion
To crowd the net, changed ends as if to make us
Nervous, to try at last his hocus-pocus
Among those dark spectators (whose impassion
Forgave the crocuses their annual waving)
The yews themselves and larches. Till the raucous
Leghorns were quiet, the bats made full confession,
Christ and the bogey made their dangerous living.

I'm lost and losing and about to lose,
My mind like some forgotten frigidaire
After a party empty and the switch
Still on. And that verandah and deep ditch
Of dock and trampled nettle, landings where
Waits and the giggling girls and hoovers whose
Voices are stolen bore their witness; whose
Loss is announced at last! But darling where
We watched the yellow night, the losing which
Evicts all others occupied me there.
Lost God and garden (with their broken rose-
Trellises) need not ask each other which
Defeat has beaten theirs, what beauty those
- With love so obvious and why and whose.
So sorrow casts out sorrow, minus times
Minus makes plus. The truthful tapes are running
Across the minefields of my fear, and I

Can trace and follow them to-night. Though by
Fast flare and Verey light I see the tombs
Of what my cold thoughts killed or what my darling
Had put to death by tolerance, I say:
'Synchronise watches, we are going dancing, are advancing,
Spite of the blinded windows and the jaundice of the Thames.'

Battle School, July, 1943

Sarah Smith

Sidney Keyes - A Re-evaluation

The life of Sidney Keyes was dominated by the Second World War, an event clearly dictating his subsequent reputation as a poet. Born in Dartford on May 27th 1922 he died a Lieutenant in Tunisia, 29th April 1943. At the time of his death Keyes was a respected and experienced writer: S.P.B. Mais, writing in the *Oxford Mail*(1944), described him as 'passionate, bitter, full of concrete vivid images, crystal clear, but the fact that stands out pre-eminent in his work is his maturity.'[106] And Richard Church, in the same year, emphasised that 'he must be contemplated as a poet already mature.'[107] Ironically, the fact that both these critics refer to his maturity acts as a reminder that he was only twenty when he died, and that, perhaps like Rupert Brooke (with whom he tends to be compared routinely) such maturity is provisional. As well as the critics Keyes was also esteemed by contemporary poets; his death produced poems by John Heath-Stubbs, A.L. Rowse, Michael Hamburger, and Vita Sackville-West. In his autobiography, *Not Prince Hamlet* (1989), Michael Meyer recounts a meeting with another of Keyes's admirers, T.S. Eliot:

> He praised Keyes. 'Good poet,' he said forcefully. I said: 'He thought you were good too.' 'Well,' said Eliot, 'that showed admirable judgement on his part.'[108]

Keyes was only to have one collection of poems, *The Iron Laurel* (1942), published in his lifetime; *The Cruel Solstice* (1944) and *Collected Poems* (1945) were published posthumously, along with *Minos of Crete* (1948), a selection of plays and short stories. He also co-edited, with his friend Michael Meyer, the seminal anthology *Eight Oxford Poets* (1941), including poems by themselves, John Heath-Stubbs, Keith Douglas and Drummond Allison. Despite his relatively small corpus, in 1949 John Lehmann, considering the death of Denton Welch, again took the opportunity to stress the literary loss suffered by the deaths of Sidney Keyes and Alun Lewis.[109]

Keyes was extraordinarily prolific at Oxford, proceeding from being a contributor of poetry and short stories for the university magazine *Cherwell* while Meyer was one of the editors (and Keith Douglas's successor), he became sub-editor:

> He was a marvellous person for an undergraduate editor to have around, for he had
> a stock of poems of varying length (he wrote three or four a month),
> so that I could say: 'We're half a column short', or four inches or whatever,
> and he would provide something to fill the gap.[110]

Keyes became joint editor with Heath-Stubbs in May 1941, and - in the way of undergraduate magazines - also reviewed a variety of books, plays and concerts, occasionally courting controversy (in the way of undergraduate magazines). When editor of *Cherwell,* Meyer received a threat of libel from Robert Graves:

> If you remember the summing up by the judge in the recent Sitwell case, you will
> be advised to print the following apology, which will end the incident. If you do not,
> I shall have to write through a solicitor: but I don't want to do so.
> We regret that our reviewer, Mr Sidney Keyes, in our Feb. 5th issue referred to
> Mr Robert Graves as 'a flashy author' and as 'a partner in the Graves-Riding
> mutual admiration society'. We apologise to Mr Graves for the above statements
> which are untrue in substance and implication.[111]

These comments were unfortunately made worse by the fact that their relationship had just ended. Heath-Stubbs, in his autobiography, refers to an article written by Graves which was designed to distort the position Keyes had achieved as a poet during his life:

> Robert Graves, indeed, gave it as his opinion that Waller was the best poet of the
> Second World War. This claim is too extravagant, and I believe Graves made it simply
> because he needed a stick with which to beat Sidney Keyes.[112]

Keyes also wrote a spoof article for the *Cherwell* 'of A.L. Rowse reviewing his own poems, signed A.L. Mouse':

> Sidney's review concluded with the following sentence: 'The cover design,
> representing a turning worm, executed by my friend, Lord Passwater, is alone worth
> the money.' Rowse was not pleased at this review, though subsequently I heard that
> he had forgiven Sidney.[113]

Judging from the poem Rowse wrote in Keyes's memory, 'Answer to a Young Poet', this would seem justified.

Keyes was the guiding force behind the 'most important poetic manifesto of the Oxbridge war years',[114] *Eight Oxford Poets,* an anthology from which he famously excluded Philip Larkin. Despite the fact that Sidney Keyes had published some of Larkin's poetry in *Cherwell,* and Larkin never published any poetry from this period in later years, his rejection from the anthology was never forgiven, and he 'spared no opportunity of attacking [Keyes's] memory'[115], for example calling him 'a third-rate person'[116]. The animus against Keyes has also been noted by Meyer who describes Larkin's 'marked and oft-expressed hostility'[117] to Keyes's work as an example of his literary selfishness towards any new writer, also exhibited towards Sylvia Plath, Ted Hughes and Seamus Heaney.[118]

When Larkin chose to regard his rejection from *Eight Oxford Poets* as a personal slight he was beginning a vendetta that would last for about forty years after Keyes's death, almost until Larkin's own death:

> What does annoy me is reading shit by Sidney Keyes wherever I turn. You pick up any two bob pocket magazine... and you'll find bullshitty poems or tossy 'Short Stories' all by our Sidney. I wouldn't mind if the man were any good but in my eyes at least he's absolutely crap all use and I'm gnawed by pangs of jealousy. 'Sidney Keyes is already outstanding' says Stephen Spender in the Year's Poetry in *Horizon*. So is the Rock of Gibraltar... He can make four thousand a year and edit his own paper but he'll still be a sodding bad poet.[119]

This letter is intriguing, containing an admission of jealousy on Larkin's part; this was never admitted after Keyes's death, but the frequency of references to Keyes show that his death did nothing to make Larkin feel any more secure as a poet. His gross exaggeration of Keyes being found in any literary magazine one cared to open indicates his hypersensitivity to the mere mention of Keyes's name. The above letter was written in 1942, one year after the publication of the anthology, but Larkin spent the next four decades abusing Keyes as a poet and an individual. There is no evidence of what he thought of Keyes's poetry (or person) before the anthology. Larkin notoriously cultivated a hatred of many of his contemporaries during his lifetime, and Ian Hamilton makes the point that the 'really big hates tend to be reserved for sizeable poetic rivals. Ted Hughes is a recurrent, near-obsessive target, with S. Heaney advancing on the rails.'[120] If Ted Hughes is a near-obsession, being targeted for two decades, then it is almost an understatement to say that Larkin dedicated his life to the denigration of Keyes. Larkin, in denying being influenced by either Yeats or Eliot, attempted to eradicate the first five decades of the twentieth century with regard to any possible influence on English poetry of the 1950s:

> I had in my mind a notion that there might have been what I'll call, for want of a better phrase, an English tradition coming from the nineteenth century with people like Hardy, which was interrupted partly by the Great War, when many English poets were killed off, and partly be the really tremendous impact of Yeats, whom I think of as Celtic, and Eliot, whom I think of as American.[121]

It's been pointed out that had Larkin died at the age of twenty-eight '(having lived seven years longer than Keyes and four years longer than Douglas) he would be regarded as a minor novelist of the forties who wrote less successful poems'.[122] Estimating the abilities of any poet by the amount that Larkin hated them is, of course, unjustifiable; but he certainly never seemed to be able to stop seeing Keyes as a rival:

> Yesterday I saw a book with 'The Complete Poems of Sidney Keyes...' printed on the outside. They want fifteen shillings for it and they can go on wanting as far as I am concerned.[123]

The above quotation is from a letter to Kingsley Amis in 1945, a close and influential friend of Larkin who joined him in attacking Keyes. Another powerful friend was Robert Conquest, to whom Larkin wrote the two following statements:

> And of course death is the great irresponsibility (sId NeY kEyEs Is DaFt).[124]

> I think you are quite right in stressing the poor quality of poetry during the war - a period which can laud the poetry of Keyes is no period for me... [125]

The first quotation, dating from 1956, is stunning for its gratuitous nature, but the second, written in 1955, can be seen to set the tone for Conquest's influential anthology, *New Lines*, published in 1962:

> If one had briefly to distinguish the poetry of the fifties from its predecessors, I believe that the most important general point would be that it submits no great systems of theoretical constructs nor agglomerations of unconscious commands. It is free from both mystical and logical compulsions and - like modern philosophy - is empirical in its attitude to all that comes... On the more technical side, though of course related to all this, we see refusal to abandon a rational structure and comprehensible language, even when the verse is most highly charged with sensuous or emotional intent.[126]

The poets of the 1950s had to persuade themselves of the romantic decadence of the forties in order to justify their extreme rationalism, and to do this effectively required establishing a number of key names to attack regularly.

It's necessary to return to evaluations of Keyes within which the war is a pivotal event, but incidental to his life. As a poet Keyes was doubly unfortunate in being called up and passed for service in the Second World War. Had Larkin or Amis had to depend on an evaluation of their poetry as 'war poetry' they would almost certainly not be remembered. John Heath-Stubbs, whose poetry has close affinities to that of Keyes, was excused from service because of his eyesight, and he too did not therefore have to subscribe to pre-conceptions and post-conceptions about 'war poetry'. It's worth briefly examining Heath-Stubbs's position as a poet both in the forties and now. Depending on the position of the critic, the 'blame' for either Heath-Stubbs or Keyes being 'afflicted' with Romanticism has been passed from one to the other:

> They had a lot in common: Heath-Stubbs had been almost blind from the age of sixteen and he had known a lonely and unhappy childhood during which he, too, had escaped into a self-created world of the imagination. He shared with Keyes a taste for ancient history and legend and it seems likely that his example and influence further encouraged the younger poet to turn away from immediate external reality to literature, mythology and the interior life for the sources of his poems.[127]

Or, alternatively:

> Heath-Stubbs began as a technically ambitious poet, harnessing a wide range of verse
> forms to classical interests. After the death of his friend, the poet Sydney Keyes [sic],
> in World War II, and later on in the 1950s, his topics became more grounded in the
> real world. His subjects never quite became the post-war reality of the English welfare
> state, but his imagination shifted from the groves, silver-throated music and
> 'forests of my soul' of his youth.[128]

It is crucial for Heath-Stubbs's poetry, long labelled Romantic, to now be
perceived as a 'combination of romantic *sonority* and classical *subject-
matter*'[129] [my emphasis]. This stance has been backed up by Heath-Stubbs
himself:

> How a poet sees himself will often emerge from his poems. But, now and then, a poet is
> perhaps foolish enough to go beyond this and directly sum up his own poetic style,
> as Heath-Stubbs has done in his often-quoted phrase of, 'a classical-romantic
> manner which was pastoral'.[130]

Heath-Stubbs, like Keyes, has remained 'distinctly anti-twentieth century' in
writing 'a poetry that doesn't chase originality, that doesn't aim to contribute to
the dictatorship of the new.'[131] Keyes, however, was unable to correct the neo-
romantic label placed upon him and has remained isolated in this uncom-
fortably mixed literary period.

I'd like to use Keyes's poem 'Rome Remember' as an example of this misin-
terpretation. Keyes described this poem as a 'lament for Rome and Carthage,
for poetry and learning, for the innocent seasons and for us, who must be
anarchists because the age is against us.'[132] This poem uses a post-colonial
notion of the land remaining unpossessed by any race, or even empire:

> The bright waves scour the wound of Carthage.
> The shadows of gulls run spiderlike through Carthage.
> The cohorts of the sand are wearing Carthage
> Hollow and desolate as a turning wave;

Despite the description of Carthage as a 'wound', the ruins are merely being
worn, the land has not been scarred by the city; the land will merely absorb the
city in preparation for future conquerors, again observed by the birds of the
land. The poem is a warning to Rome to attend to the history of Carthage, itself
conquered by Rome. Despite being a 'city of soldiers', it too is only a temporary
construct. The Roman empire cannot shield itself in learning, as the Greeks and
the Etruscans found no immunity in their intellectual virtues:

Rome remember, the courts of learning are tiled
With figures from the east like running nooses.
The desolate bodies of boys in the blue glare
Of falling torches cannot stir your passion.
Remember the Greeks who measured out your doom.
Remember the soft funereal Etruscans.

'Empire' is only a concept to be formed and broken, a necessitation of violence. An empire born of 'chaos' that disregards the weaknesses of the conquered can only end in carnage. 'Rome Remember' is clearly a poem addressing the Second World War in the wider context of all war; however, because it uses classical imagery and doesn't mention Bren guns it has led to accusations that Keyes was out of touch with his time. Bernard Bergonzi has stated that Keyes had 'little contact with the day-to-day world, nor, one suspects, with his own deepest feelings'.[133] And yet contemporary reviewers appreciated this alternative to the social poetry of the Auden Group: Edmund Blunden, in his review 'A Young Poet', wrote: 'I invariably hail the man who revisits the myth and the pantheon of Greece and Rome and blends their beauties and their symbols with those of our own day.'[134] It's only been in later years that the presumption that any writer working during the Second World War should have written solely about the war has diminished any work which falls outside this area.

Sarah Smith's critical biography of Sidney Keyes will be published by Waterloo Press later this year.

106 'Books' by S.P.B. Mais: *Oxford Mail*, 12/4/44 - Review of *The Iron Laurel*.

107 Richard Church, 'The Poetry of Sidney Keyes': *The Listener*, 17/2/44 - review of *The Cruel Solstice*.

108 Michael Meyer, *Not Prince Hamlet*, OUP, 1989. pp. 63-64.

109 Foreword by John Lehmann, *Penguin New Writing, No. 38*.

110 Michael Meyer, *Not Prince Hamlet*, OUP, 1989. pp. 33.

111 *ibid.* p.274.

112 John Heath-Stubbs: *Hindsights*, pp.157-8.

113 *ibid.* p.79.

114 Linda M Shires, *British Poetry of the Second World War*, p.65.

115 Heath-Stubbs, *Hindsights*, p.84.

116 Meyer, *Not Prince Hamlet*, p.32.

117 *ibid.* p.32.

118 Christopher Driver: 'Iron in the Soul', *The Guardian*, April 1993 - Revew of *The Collected Poems of Philip Larkin* (paperback).

119 Larkin *Selected Letters*, to Norman Iles, 7/4/42.

120 Ian Hamilton, 'Philip Larkin: 2. The Selected Letters' in *Walking Possession*, p.130.

121 'A Great Parade of Single Poems: Interview with Anthony Thwaite', *The Listener*, 12/4/73.

122 A.T. Tolley, *The Poetry of the Forties*, p.268.

123 Philip Larkin *Selected Letters*, to Kingsley Amis, 9/8/45.

124 *ibid.* to Robert Conquest, 26/4/56.

125 *ibid.* to Robert Conquest, 28/5/55.

126 Robert Conquest, *New Lines*, pp. xiv-xv.

127 Vernon Scannell, *Not Without Glory*, p.77.

128 Richard Tyrrell: 'A Staffordshire Gent' from *Aquarius* 23/24: John Heath-Stubbs 80th Birthday Issue, p.94.

129 Bernard Bergonzi: 'Nine Days' Wonder'. *ibid.* p.25.

130 William Oxley: 'The Poet Behind the Voice'. *ibid.* p.57.

131 Richard Tyrrell: 'A Staffordshire Gent'. *ibid.* pp.94-95.

132 Sidney Keyes, Letter to Renée-Jane Scott, 26/7/42.

133 Bernard Bergonzi, *Wartime and Aftermath*, p.73.

134 Edmund Blunden, *The Fortnightly Review*, April 1944.

Vita Sackville-West

Several poets who didn't know Sidney Keyes at all well wrote elegies on his death; some several years later, like J. D. James. Unsurprisingly Drummond Allison, far closer to Keyes, found it impossible to write directly, and had little time before many elegies were written of him too. But it's worth reading these two unpublished pieces by very different writers to recall just how profound an impact his death and poetry made, and would make for many years, not least on Geoffrey Hill and Ted Hughes.

To Sidney Keyes

Ghost, that unknown once shared my Kent with me,
Loved things I love,
(O reader, note the tragic change of tense.
He loved; I love; he lived; I live;
He should have lived, I died, if one must die.)
Ghost that loved things I love,
Rilke's strange universe, and forthright Clare,
The brooding angels and the easy fields;
Van Gogh's wild colour splashed on gray Provence;
Landscapes of fact and landscapes of the mind;
Young searching lover of the things I love
Since all I prize is beauty in this wrong
World shifted crooked from its first intent,
You schoolboy ghost
Who could have been my son as years may count,
How strange to share so much, so similar
A sheaf in copious corn,
Yet not to share the final incident,
The last adventure of the moving soul.

Published by kind permission of Nigel Nicholson.

Michael Hamburger

For Sidney Keyes

O speak no more of love and death
And speak no word of sorrow:
My anger's eaten up my pride
And both shall die to-morrow.

Sidney Keyes, 'The Wilderness'

Suspended between death and life turned stale
He searched for peace even on battle-fields.
No solemn elegy can fitly sing
Of one who with such care carved his own coffin
'Lost in Tunisia'; and I for one
May never add to this impersonal
Epitaph, disturb his temporary tomb.

An irony more terrible than grief
Mocks all lament; for who can fathom love
That drives to exile, beauty that we fear
Because our hearts were bred in sordidness
And sunlight would wither them?
Moonlight made us flee, distorted trees pursued us;
Peace was hidden in long deserts not explored.

He found it; whether he be living now
Or dead, he tamed pride's ambition and chastened
The sleek ubiquitous beast of sorrow.
Became all that he strove to be: hero
Of peace, the most unwearying climber
Of the flowerless rocks, our heritage.
The dry sand levels lie unstirred; no bird's
Incessant crying breaks his requiem.

Maidstone, October '43

Published by kind permission of the author; who would like to emphasise that the above is juvenilia.

Statement by Professor Douglas Jefferson

The Anglo-Egyptian Union and the Cairo Poets in the Early 1940s

It would be difficult to give an account of the Cairo poets of this period without placing them in the setting of the club where they spent so much of their time. Of course they had a life outside the club and of this I can say nothing apart from the fact that Terence Tiller and Bernard Spencer were my colleagues at the Fuad 1 University.

The Anglo-Egyptian Union existed to provide an opportunity for British people and Egyptians to develop friendly relations. It was understood that no visitors who were not of the one nationality or the other could be invited. Membership was equally divided between the two sides. In general I think it fulfilled its purpose. Admittedly there were groups of Egyptians and groups of British (army officers perhaps) who had nothing in common with each other and no occasion to mix, and a casual visitor who did not know the club well might get the impression that there was little or no mixing. But my university colleagues and I all had Egyptian friends and acquaintances whom we met at the Union, and some of the more long-standing members of the university staff had developed quite close ties with senior members of Egyptian society. But I don't claim to have much knowledge of the degree of interchange between the two groups of members.

It was a dignified and comfortable club. (I have the impression that erroneous images of it exist in some quarters).[135] There was a large lounge with a bar at one end, tables with good arm-chairs, and a general air of quietness and amenity. There was a restaurant but it was also possible to have meals and drinks outside, on the spacious lawn when the weather was not too hot. There was quite a good library.

It was in this environment that these Cairo poets met to show each other their poems and talk about the next number of *Personal Landscape,* the informally produced poetry magazine that they organised. Occasionally they were joined by Lawrence Durrell, whose job was in Alexandria but who came from time to time to Cairo. This was the setting in which Keith Douglas was to be seen in the company of the Cairo poets and their friends. Most often he was by the bar, sometimes in the company of women. (No doubt there was some kind of poetry network whereby he became aware of the Cairo poets and they of him so that they could arrange to be together, but of this I have no knowledge). Keith Douglas of course contributed to *Personal Landscape.*

I should like to say a word about other people in this Cairo world. The teaching staff of the English section in the university included David Abercrombie, then in his early thirties, a phonetician who had a long and distinguished career. He died this year. John Speirs was a Cambridge graduate, a pupil of F.R. Leavis and a very fine critic. In the 1950s he contributed the major part of the first (mediaeval) volume of the *Pelican Guide to English Literature*. Ruth Speirs, his wife, translated Rilke and her work appeared in *Personal Landscape*.

Of other colleagues, Robin Fedden, Owen Holloway, Martin Lings and others I shall not try to say anything because I don't know enough of their work, but they were members of quite a distinguished staff. The acting head was Bryn Davies, a most civilised man who did much to make life in the English section enjoyable. Another name should not be omitted. In 1943 P.H. Newby was released from the army, as I had been the previous year, and joined the university staff. Soon he had published his first novel, *Journey to the Interior,* which was very well received. Howard Newby became, like myself and Bernard Spencer, a British Council Lecturer in Delta towns where there was an institute. He did Zagazig, I did Tanta, Mansoura and Mehalla el Kubra. This brings me to the British Council itself. Bernard Spencer had had a British Council job in Europe but came to Cairo as so many did when the Germans invaded the Balkans.

Arthur Cawley also came to Cairo at this time, having been in Rumania, and he became a director of the Cairo British Institute during these years. He is well known of course in the University of Leeds where he was professor of English Language for a long time. Another academic who subsequently had a distinguished career was Clifford Leech. He shared the administration of the Institute with Arthur Cawley.

Some mention must be made also of Olivia Manning, the novelist, who occasionally came to the Union. Her husband, Reggie Smith, had a job in Cairo (I have no details) and they had also been in Rumania before the German invasion. (I have not read her novels so I can't say anything about her response to Cairo).

I have referred to *Personal Landscape*. There was another poetry group that met in the Union and published their poems in the magazine called *Salamander*. I have a visual image of this group which always met at the bar while the other poets better known to me sat at tables in different parts of the lounge. I did not know the members except G.S. Fraser, later a lecturer at Leicester. Their doyen was Keith Bullen, a local schoolmaster who translated Baudelaire. Bernard Spencer declared good-humouredly: 'It's a murder - with slashings!' (Spencer

once caught Yeats arranging his bow-tie in the mirror. Yeats turned and said: 'Always adjust the mask.') It was Keith Bullen who threw his school room open to all comers on VE night. We were all there! Several women married to *Personal Landscape* poets danced with *Salamander* poets, and *Personal Landscape* people were shocked - it was tantamount to treason. There had always been a certain aloofness in *Personal Landscape*'s attitude to *Salamander*.

135 Professor Jefferson is tactfully referring to the BBC 2 TV series, adapted from Olivia Manning's two wartime trilogies (the *Levant* and *Balkan*), *Fortunes of War*. This was broadcast in the autumn of 1987. The image given there was of a small, seedy club.

Interview with Martin Seymour-Smith

29-30th June, 1993

We talked on the phone about the late Forties editorship of Poetry from Oxford, J.B. Donne and others, and the pervasive influence of Cavafy (through Lawrence Durrell) on poets like David Wright.

Donne - spelt like the poet. Now when I came up in 1948 straight from the army I didn't know any of them, I bought immediately I got there *Oxford Poetry* edited - which was then published by Blackwell at the publisher's expense then - long ceased now - by Kingsley Amis and James Michie. They'd gone, and were married students, as many of those who had gone through the war were. You could be but it was less common. I remember reading one piece, the only man I thought was any good - John Bayley, Mr Iris Murdoch as he later became. Since then of course he's given up writing verse, at least publicly, and never published a book of it anyway.

The dominant poets at Oxford had really gone down: from Keyes, when he'd been there, Heath-Stubbs and David Wright - all these people, even my ex brother-in-law J.C. Hall - had been there. Geoffrey Matthews was another ex-serviceman who went down as I came up, politically disappointed, stopped writing poetry did he? He only really came to everyone's attention as a very fine Shelley scholar, brought out the tough intellectual side of Shelley people used to overlook, amongst other things, when they compared him to Stainless {Stephen} Spender. Christopher Middleton I'll come to.

But still because it was so empty we had a poet called J.D. James who must have become a solicitor or something, wrote 'Lament for a Poet' about Keyes. They admired him too and W. J. Harvey - John Harvey - got to know him very well, very large, died, been in Japan, wrote a lot on George Eliot, excellent man; became a quite well known don at Keele, doing post-graduate work at Oxford. Wrote a poem I remember - they had critical works on each other, in the way poetitas always do, and bad and alas good poets. Someone quoted his line under his name W.J. Harvey 'Despair is not enough.' I remember having a big joke with Robert Graves whom I of course knew then, used to go and see, with Beryl his wife and so on - saying 'despair is not enough colon.' Which is a cold category of poem 'I have travelled I have fucked' etc. But there wasn't really anybody. Now I was I suppose one of the people to take over in that period; with J.B. Donne - edited *Oxford Poetry* I think twice.

There was Donald Watt, now Donald Cameron Watt, at the LSE, when we last

met, we got on very well. He said I hadn't changed... He dropped a glass - I didn't drop mine - and said 'I suppose people will think I was drunk'. No one knowing Donald would ever think he was drunk.

Now these people sort of ran *Oxford Poetry*, and I suppose I did. There was John Russell, he had published a book - Geoffrey Grigson at Routledge put in charge of poetry by Herbert Read, had published it - a heavy drinking man who wore a kilt. Quite accomplished.

But there really weren't any poets there until my last year when I was senior as they say, and that was Al Alvarez. Alvarez I remember meeting at his College - Corpus. And we were amazed to greet each other because no one knew anything and Al I could see did know something. Now Al was at that time writing poems that were utterly Empsonian, they were purely imitations of Empson. Wain took credit for Empson but I'll come to him. I still think that Al did produce six or seven poems, real poems, later. I don't particularly like the direction he's taken as a critic, *Savage God* and all that confessional and suicido-confessional verse, but he's always been sensible, he's not pretentious. Different sort of person from most, I think, you see. So that was the position. And all the verse that was written in my time was crap I think really. A poor crop. There were some who became crime novelists like Le Carré - the perfect reply to those who automatically equate Oxford firsts with first-rate minds as opposed to automatic minds. I know one poet, Sean Haldane, who was ashamed and sheepish at having got an Oxford First, but that was much later. And some turned scurvy politicians. The Thwaites and MacBeths came up later - I'll come to them.

Elizabeth Jennings was there but had long got her first, not up with us though only two years my senior, but at the Library. She wasn't part of the University any more. She was at that time outstanding. Her father was Medical Officer of Health for Oxford. She was a kind of presence, and been engaged to a man who played cricket... The last man she had anything to do with was the man I call Tweeter - Anthony Thwaite.

Christopher Middleton was there, at Merton, like Keith Douglas; but had nothing to do with the rest of us and was very superior; if you met him in the street he'd tell you off. But he was much looked up to in fact as he'd published his books at his own expense; in fact with Robert Caton of Fortune Press. {*Two by then!*} I knew Caton very well, because I did a book for him from *Oxford Poetry*. Fortune was a repository of lost Oxford causes. Christopher Middleton then had this great style and elegance, it was then much different. I think - he's a very good editor and critic of German literature, he's been very helpful - his poetry as I look back on all of it had a lot of know-how, too much know-how. He's very mannered, and he's avoiding saying anything about himself in it, right

through, which wouldn't be my idea of what poetry is. But.. you know, he says something like 'I'm a Byzantine pessimist' which strikes me as being very pretentious. But people do get pretentious about their own work. He was the only one.

I remember travelling with him to France on my way to work with Graves and I remember how superior he was about the *White Goddess*. Said he had some other theory which was superior! 'You've got to give up this White Goddess stuff.' As most people know I never had agreed with or liked the *White Goddess* but he assumed I had because I liked Graves's poetry. And he was very doctrinaire about it. The idea was poetic, and perhaps Graves should have left the original title *The Roebuck in the Thicket* but it would've been a wholly different book in 1944, four years before it came out, almost the month I went up. Middleton was quite impressive I must say. If he wasn't any more mature than the rest of us he *seemed* to be. *{He was two years older!}*. Yes, of course. At Merton I think. But there wasn't much verse.

I was editor of the *Isis* two years - six terms I think. I remember nearly being sent down because of a poem of mine I published - 'the nuns writhing in their sexless cells.' They were very angry and said nuns would be offended - quite right.

Now at the end of my time, 1951, the Professorship of Poetry had become vacant. I don't know who it was - complete nonentity of a prose man, never even written any verse. It had been people like H.W. Garrod, all right *but...* The great thing was we were the first people to start wanting a poet. At that time it was a new thing to want a poet as Professor at Oxford. Then it went off after Auden and Graves, and you got Levi and Wain, people best never setting pen to paper.

But C.S. Lewis at Magdalen of course thought he had it wrapped up. But we, the undergraduates, decided we wanted C. Day Lewis, and he was persuaded by someone - *not* me. He judged the best thing was to judge a poetry competition. Now I must emphasise that my poems were entered without my knowledge. It was won by Mitchell Raper, a man I was very friendly with, who wrote for the BBC part time, and had a private income. He didn't write bad poetry - and was undergoing a terrible personal crisis. Discovered he was homosexual. Just to underline what it was like, Graves for instance would tell people: 'I know this doctor, cure you in a fortnight.' When I wrote *Sex and Society* in '75 Spender came up and said 'You understand sexuality so well, couldn't you write a book on homosexuality?' Flattering, but I said 'Why can't you?' and he just said *'I can't.'* Old Mitchell always wanted to become an old queen, well now he's got his wish. Americans can be - homosexually - happier. Anyway, I got second prize I think. Day Lewis said 'Seymour-Smith is really the

best but he's not quite *réussi* - a prophesy for the rest of my life. Quite correct.

I *liked* Day Lewis, didn't have much respect for his poems. Grigson called him 'the dirty water running down the sink' in the 1930s. No - he was only rusty water. But Grigson predicted *Day Lewis will be Poet Laureate,* and I don't think Grigson made many mistakes, though by the time Day Lewis succeeded Masefield in 1968 he was rightly embarrassed. Of that group, Auden and Spender et al, I thought Stainless (Spender) the best poet, even told him so, later. One felt in the presence of a poet, even if he sometimes seemed so fucking hopeless... in a way a blind man crossing the road. As George Barker said of him: 'If you see a cripple walking, you know he wants to get somewhere.' So we did that, Day Lewis got it, the dons voted influenced by us. And that was fun.

J.B. Donne edited two *Oxford Poetry's,* I was doing the second with him. But then he wanted to put a poem of mine in that I didn't - it had something in it about a serpent kneeling, and being very influenced by Robert Graves at that time - he said: 'Martin, you can't have a serpent *kneeling...*' So I rang up this chap very bad-temperedly saying you won't put it in or I'll kill you, shoot you with my service revolver or something childish. And he said 'I'll take away your half-editorship of *Oxford Poetry.*' So this edition is really by me as well as him. Then later though I didn't keep the poem I found serpents can kneel, definitely, if you look. There's good precedent for it. Doesn't matter.

Now William Bell had just gone down, got killed in '48.

Yes. He was killed on a mountaineering accident on the Matterhorn. I remember the news getting back to Oxford. They all said he was very important, Faber published his *Elegies.* Looking back at him I can't see that he was any more than an ordinarily promising poet, might have developed, might not. But people were excited because they knew him. Drummond Allison, on the other hand, who of course had been killed much earlier, was a much more impressive person.

He was killed at 22, whereas Bell was killed at 24. (M.S.S. Yes) I can't under-stand Heath-Stubbs' sentiments that William Bell was potentially better than Keyes or Allison. I thought Allison the best and Keyes perhaps.

I think John was just being... well, you can't tell, can you?

No, except that Allison's poetry has survived whereas I don't think Bell's has.

No - I doubt it - no one looks at Bell now. That's not of course a good reason

not to revive him, but I don't think it'd be successful to do so, he's an ordinary immature Oxford poet.

Nick Bagnall, born in '24, who was up some time after the war (M.S.S. Yes he was in the war) *said he couldn't even remember who Bell was.*

Exactly. No they made a great hyping thing because he'd fallen off a mountain. Another man, Hollingsworth, backed off one, and I felt awful because I couldn't revise my opinion of him even though he'd backed off a mountain. I expect he was all right, I knew him in the army.

We talked earlier of Cavafy's imported influence.

Now that is important. Cavafy didn't become at all well known until E.M. Forster talked of him in his guide book to Alexandria 'there is this man standing at a slightly odd angle to the universe' - something like that. Then people started to read him who knew Greek. There got to be a regular Cavafy industry slightly later - John Magri (Faulkener) translated some, Ray Dalven who I don't know anything about did, her versions are sometimes the best, then of course Sherrard and friends of Kathleen Raine - not her normal taste...

One of the big poets of our time there, in Oxford where there was no poetry was Laurie Lee, very well known though he wrote very little; and he came to Oxford. I remember having written a particularly violent article in *Isis:* 'Poetry is for Poets'. And he got hold of the proof before it had dried and stuck it on my forehead before the Poetry Society meeting. You could read it in the mirror, no one else could. Nice man, very amusing. Don't suppose he knew Cavafy, knew Lorca, influenced by him - being in the Spanish Civil War, doing a *Romanceros Gitanos.*

Those poets and critics, literary people, in Cairo, in '41-'43, included Durrell, and George Fraser et al. And it was Durrell who got on to him, featured him in the *Alexandria Quartet* - don't think that was very effective. But the influence of his tone, and the way he translated into English. You see you could translate him in the way you couldn't Cernuda, or any other poets of that very high calibre - Mandelstam is terribly difficult. Cavafy in a way was easy, went into our language naturally, Greek having something in common with English - ancient and modern Greek. There's something in the tone - laconic and tender. Cavafy brought this laconic tender quality into English poetry.

We haven't seen that quality that much. Durrell wasn't that good, and in any case didn't much imitate Cavafy. John Heath-Stubbs has tried to achieve it, because of his life. It's nicely done, though it reads much more like a translation of Cavafy than it does Stubbs original, you see. He was always not quite with

it, a few charming, whimsical poems - like *A Charm against the Toothache*.

And his 'Elegy' on himself, of 1949.

But that you see followed David Wright, who'd already done that. David I didn't get to know until much much later, but John I knew right from 1950. Because he was seeing Graves, with the *White Goddess,* he and I are thanked in the Preface, something he mentioned to Robert about birds. Graves put him in, he always liked to acknowledge a coming man as he called him... a coming man, never came. He always hoped his career was just about to turn the corner, something held against him. How does he fare now?

He had an amanuensis, rather oleaginous, urging me to buy a Collected Poems, 'the best purchase you'll ever make' etc... but they're £25... I bought one for £15 in the end.

I remember one who sat in attendance, officiously, then just buggered off and became an accountant.

J.B. Donne you've mentioned, and there's Dennis Williamson, the latter editor of Oxford Poetry before you came up. The '48/'49 Edition...

Williamson became an accountant or estate agent, let's forget him - dismissed.

The point being its translations for instance of Neruda.

Yes, J.B. Donne for all his faults was on to Neruda, not only that he was on to Borges. But he never made anything of himself, was very nervous. Father was an armaments manufacturer, killed himself in his car - bonnet hit him. John was very upset, and guilty over the munitions.

Sounds like Miller's All My Sons.

Was like that. Did translate Neruda, was a very gifted linguist. What he did become in the end was an expert on African sculpture. Had private money - never had to do anything, just nagged me about what I no doubt owed him.

So - a strong internationalist influence - Cavafy, Neruda...

Not in Oxford, the Cavafy came in later. Now in Oxford what did we talk about, was all awfully weak. There was Alan Brian there, became the archetypically drunk journalist, got a first in English or was expected to. Into Metaphysicals like Benlowes. Really obscure, Silvester et al. He was another influence in a way, though he didn't write verse. Just became a drunk. He was

married to a hairdresser, everyone admired him for having a wife. But he was so drunk, even then... Well I was, but managed to appear sober for weeks... taken up the river...

Poets - Eliot of course, people used to read *The Waste Land* in ecstasy, aloud in College. Eliot was very much about. Graves I could not get people to see any virtue at all in. As for Laura Riding, it was impossible, they just weren't going to have it. Norman Cameron I knew of course, died in '53...

There seemed to be some sort of continuity - Bell, Williamson (M.S.S. Maybe I knew him). *I was particularly interested in the receptiveness to influences in the way the Movement period seemed to represent a shut-off to.*

Yes - you have to look at what Cambridge was doing. How Cambridge was at this time. There was another thing that Day Lewis organised - must tell you about this - not long before I went to Mallorca in '51; there was a big thing in London, the National Book League, he organised it, it was Oxford and Cambridge poets reading, and all of those people came, who were regarded as being important poets and all that crap. *They* thought they were... Day Lewis was giving it. Jill Balcon was there whom he had not long married.

Now all of them at Cambridge have become Sociologists, and they taught Harold Silver, he's a wag, sociologist. They'd published a pamphlet which they thought much better than the Oxford softs - 'soft city of gleaming spires'. I can't remember the name of it. It was talked about with great awe at Oxford, it began: "When I hear the word culture, I reach for my revolver" which they didn't know had been said by Hermann Goering or quoted by Goering from some idiot who'd said this. They attacked 'culture' and were very left wing. Their other thing was what Honegger particularly of course with many others had been into - futurism and so on. They didn't know this had been twenty or so years ago, that others had been into 'boom boom'. Theirs was a mechanical fecundity ecstasy and so on...

I remember getting up and saying: 'I can't manage this stuff, pistons.' And I think they would allow it was phallic. They also liked pistons as an example of the smooth running of society, I think generally Marxist. That was really quite interesting because they were more 'educated' than we were. I don't say, in fairness to myself, than I was. I think I was. I was very sceptical about everybody, I'd read a lot.

The impression you've created was of a clever bunch of criticasters to some extent.

That's right, I think so, it was all great fun, we were all very stupid. And they

wouldn't anyway listen to me about Cameron, Graves - even Empson, wasn't really accepted. I had heard Empson read in the war, 1943. And he was nearly booed, when he read with Wain *et al*, big stuff like *Missing Dates*. He was a great reputation, his critical works - *Seven Types of Ambiguity* - were thought very, very highly of indeed. Although I don't think that people had really taken it in. It was for one thing Cambridge English, you see.

The one person at Oxford was Lord David Cecil. This is quite important - I of course didn't read English[136] - I read History, the English School at Oxford was even then, thought of as very poor. Because Lord David Cecil was pretty wretched really - nice chap - but I mean not an incisive critic - or one who knew much. *Two Quiet Lives,* you know. Now if you try to think of Lord David Cecil being able to appreciate *Empson,* I mean it was not even that he wasn't a very charitable man, just incapable of understanding what he was about. His poetry was sort of secretly spoken about, by one or two people. Excepting, I have to say me (I knew about Empson very well), the man who brought Empson into the university's undergraduate fold, was Al Alvarez.

Not Jolly Jack Wain?

Well no - I've seen Wain following Empson around saying "Master" - nauseating yes - he *did* say "Master" - Jolly Jack Wain... not really. He again was a person who had been at Oxford at John's; he had made an impression - John Heath-Stubbs delights to say how he was originally "Barry Wain" because he was originally John Barrington Wain. Called himself Barry Wain like some kind of cheap gangster, but I mean it sounds like Craig Wain. He *wasn't* a gangster, but a very, very self centred person, very keen on himself. Let's say he made it rather more obvious than most of us care to. And he didn't have his success till *Hurry on Down,* which as Anthony Burgess has rightly said is an astonishingly bad-written novel. But he'd done some poems and gone to Reading as a lecturer after Oxford. He was the first one the Reading University (Whiteknights) Press put out, with Trypanis and Phil Oaks - completely forgotten as a poet - journalist. I remember Wain coming to a debate I took part in, where I got drunk coming in with a bottle and placing it on my chair, for which I was nearly booed - quite right too.

The debate was about some utter nonsense, Godfrey Smith had to caution me for swearing. Wain gave a talk and apparently - didn't know this till years later from George Fraser - I said 'I do not know who Mr John Wain is' and he'd taken a terrible umbrage *but I had never heard of him at this time.* The organiser of this ridiculous debate at the Sheldonian, seating thousands - serious, earnest - was Paul Almond who became a Canadian film maker then faded out - very *nice.* No, Wain had done Empson imitations.

But it was Alvarez who really put Empson on the map?

Definitely - no question. Alvarez knew Wain, admired him at that time. Then Al departed, he was all cerebral, but his poems certainly had some kind of bite. He used to say he had a weak ticker, hence a climber - may still have one. He suddenly after going down from Oxford in '52 became a Lawrentian. The suicide attempt he wrote about. Why his son's called Adam, primal man - very Lawrentian. Since then he's changed and I still think - although he writes in-flight information pot-boilers - only for money - that he's by far the most intelligent of that group. It was he who brought Empson in. Probably the poets after my lot went were more influenced by Empson.

Geoffrey Hill for a start?

Geoffrey I met, in my time. When we did with Derwent May I felt he had a face like an unhappy paper bag with a little black hole in it. Very stiff with ambition, but later I got to regard him in a different way. And I heard him being attacked this morning by Tom Paulin for not being 'demotic' enough. Paulin's got a real hang-up, loves Hughes.

But Hill particularly burst on the scene -

But burst on the scene much later. Oscar Mellor did Elizabeth Jennings's *Poems* after I'd gone down, in '52, a bang-out success, huge. He ran the Fantasy Press, at the same time publishing pamphlets by Pierce Young - completely forgotten, lives in America; George Steiner - you can get Steiner's verse - yes - 'and so they call me Concentration Camp Steiner' - if you remember Jack Benny's *To Be or Not To Be* 'So they call me Concentration Camp Reinhardt.'[137] George was even then - 1949 - into concentration camps, punishing you if you didn't suffer. One would have thought he'd been in one. But he wasn't. He would be a different man if he had.

He's in Robert Robinson's Oxford Poetry as Francis George Steiner. 'Three Grey Ladies, Sere and Shrunken' - it ends 'New England autumns haunted by salt spray/And ancient ladies riding through the wood.' Worth suppressing, Pound in his Nineties John Gray phase. Or Richard Le Gallienne.

Good God. No - Le Gallienne had humour for Christ's sake, was perceptive about Kipling when few were. Now if he'd been Algernon Steiner, he might've been a poet, a dithyrhambic alcoholic who wrote say three genuine poems before his liver packed up. And Francis might have kept him humble - I mean, if you're called Francis you have to tread carefully...

A sort of David Cecil gene would have cross-fertilised The Death of Tragedy?

Yes... an improvement. I warned them at Cambridge, you know, when they were going to give him that Extraordinary Fellowship. No, I know you feel more charitably, because in this age it's an achievement to perpetrate those nostalgically bad lines and then have the decency to suppress them... And then Al Alvarez, me - they were all called *Poems* - they did ten. And then some more - Tweeter, and... lesser men. In fact not men at all, men better never having put pen to paper... That put Geoffrey on the map, done in the Fantasy press - people thought it marvellous - 'through the burly air I strode' - very artificial I think.

I think so too. Always struck how much of it was taken off George Barker's True Confessions. And quite a lot more from Keyes's 'Buzzard' pieces and Arthurian poems. - Hill is surely Keyes's inheritor and learned more off him than nearly anyone else. I digress. But particularly that group of people seem to have been open to many other influences - a certain more intelligent type of modernism.

Yes - definitely.

For instance forms of Audenian influence, certain broader spectrums they were open to as opposed to say two or three years later when one gets the Movement. Which seems an artificially perceived fracture across post-war poetry where it's the sensibilities of Keyes and Larkin sniping at each other - Larkin posthumously.

You've got one book on the Movement, by Blake Morrison. He hardly mentions Norman Cameron.[138] This is the Movement, where after all I was included in brackets - 'minor imitators of Kingsley Amis/Thom Gunn' or whatever. But the Movement never existed at all. It's very interesting, I think no movement ever has. What happened was this.

It was Conquest's initiative. An article first came out in the *Spectator* by Anthony Hartley, a *pauvre type*. He edited very well, and translated the prose of the *Penguin Book of French Verse*. He really knew his French. But otherwise quite helpless. Wretchedly in love with the wife of a later Movement luminary (hence *pauvre type*) Kingsley Amis, he wrote an article having seen a Marlon Brando film. He got very excited, and as a leader writer penned for the *Spectator* - unsigned - a piece simply saying we needed 'tough, ironic and robust' poets.

But looking back from then, Eliot could hardly be called that. Something *did* happen - Auden and Eliot had become the mainstream influences, and thus boring. We didn't get anything but people reading *The Waste Land* in a

reverent voice, a much overrated poem. Auden the same - he'd gone off because of *The Age of Anxiety,* and other longer poems, and they simply didn't have the appeal of the shorter ones, leaving aside *their* merit. He'd wasted his lyric gift. Once you look at Marlon Brando thinking 'tough ironic robust' then who are the poets who are going to be?

Well first of all Robert Graves, quite obviously, very famous as a historical novelist, with poems coming out all the time. I've described to you what it was like at Oxford when I was trying to draw attention to his virtues. They wouldn't have it at Oxford, nor Riding. Then of course I was out there in Mallorca with him '51 to '54. The other poets who were 'tough ironic and robust' were Norman Cameron - wrongly thought of as a disciple of Robert Graves - in fact his style had long ago formed itself, at school. Of course 'ironic' is Empson. Now that fitted in with Wain's admiration for Empson, and his own villanelles that he was writing. Of course no one but Empson can, practically he's the only man for 'it is the pain it is the pain endures... slowly the poison the whole bloodstream fills...' You can't get better than that. He made use of that form - 'twixt devil and deep sea man hacks his caves.' Beginning a poem: 'And now she cleans her teeth into the lake' caused Graves originally to say - privately to me in the war: 'Empson is as clever as a monkey - I don't like monkeys.' But when Empson wrote about *The White Goddess* in the *Statesman* for which he was writing in the Fifties, saying 'Mr Graves hates the White Goddess', Graves began to appreciate him; although I don't think he read his poetry much, as he tended not to read his contemporaries.

So you got those three poets suddenly coming into favour. Then Conquest - as you know - published his anthology calling it *The Noman,* putting himself in. Those space fiction pieces - 'the valves hiss in their helmets' I remember. He was very annoyed with a review I wrote making fun of one line. He put in Elizabeth Jennings who had nothing in common with it, neither tough, not a whiff of irony - too ambitious - certainly not robust. After Mellor's Fantasy Poems of hers sold like hot cakes she got taken up, it went to her head, she was overrated, and got dropped. Cruelly used by the establishment. Her poetry's become diffuse and lacking any robustness; but it was never robust as such. The others were pretty crap.

At the same time, a rather unhappy man Howard Sargeant - edited *Outposts* for about eighty years - worked for a law firm. I remember he told me 'publishers are not philanthropists' - which is certainly something I have learned. Nice man, as Graves said... He edited an anthology which though forgotten now at the time was talked about as much as Conquest's - called *Mavericks.* This was published by a magazine edited by that extraordinary man Dannie Abse, called *Poetry and Poverty.* Now Dannie has never been a poet, even if he's persuaded others. His one decent poem was copied from a

newspaper, entitled 'Found Poem.' The others included in this anthology were Anthony Cronin, Sargeant himself of course - hopeless, such a kind man - probably more important than being a poet. And one or two like Elizabeth Jennings who overlapped.

And you?

No, wasn't in either. And therefore attacked both! David Wright was in *Mavericks,* as well as Cronin - these were more coming up of the Cavafy Oxford. You see Cavafy was much more 'tough ironic and robust' than what these people were for. Especially since reading poetry not English I've found the extraordinary ignorance of modern post-war poets and critics, they know nothing of Cernuda, thinking for instance Auden a good homosexual poet. Auden was ashamed of his sexuality, never could face up to it, writing disguised love poems to women really to men. Don't blame him at all, but wholly disingenuous, didn't want as Hugh Walpole once put it to be 'jugged' with those absurd laws.

All this was going on in the Fifties. The Movement made no headway at all because it was much more artificial a concept. It wasn't really happening. There were a few poets who were being influenced by Graves. It was a time of very poor technique on the whole - people didn't know what it was. Everybody's a poet now - you get people like Michael Hulse - awful - but it simply didn't mean enough.

The Oxford grouping seems to have been a far more fertile ground for picking up internationalist flavours. More open.

These things never happen. There aren't such things as movements. People get together to do something, like Reverdy, Huidobro, more robust than these Movement people. It never happened, critics who are not poets or people not critics come and try to find a tendency and make a dogma of it. If you say there was no such thing as the Romantic movement you'd have trouble; at the same time it's a very good idea to point out how difficult the concept is. With the Movement it didn't really happen at all - a lot of people attitudinising playing Brando writing Brando poems.

Gunn and his cigarettes.

Gunn indeed, his cigarettes and his rather boringly announced homosexuality, pubic lice which he wrote about. I think if Gunn had written about his pubic lice as something that appalled him in a real and true way that would be quite different. But he was being aggressive, then got under Winters' influence, whom he resembles not at all.

Gunn's latest collection The Man with Night Sweats has good things in it, several of extraordinary fright.

If it's fright that's a very good sign. I haven't read it. I'm sorry for him but on the other hand glad for his poetry. Getting old.

Talks of it, whether an old man's lust is 'enthusiasm or involuntary clawing spasm.' Returning to some of the individual poets who might have been influential in the later Forties. Keyes, Allison - was he remembered at all? - Bell we've talked about. Was Heath-Stubbs still around?

He used to come to Oxford and meet us, not many others, my friends and I asked him to the Poetry Society, I'm afraid we virtually ran it, very inefficiently, wrongly accused of drunkenness. We were sober and very proper at the meetings, but took the poets off and give them drink - found it very interesting. We had Ronald Duncan - that was awful. He said he'd never been so insulted in all his life - by me. Simply because I wouldn't pay his fare from Weymouth via Paris to Oxford.

He got insulted by Britten later on.

Terrible little man. We had George Barker, who gave a terrible talk he'd given to everybody before. I'd known George before too, as I'd made up my mind when fourteen to know all the good poets. Dylan Thomas had lived in Oxford for a time, in A.J.P. Taylor's caravan that I lived in. He'd had an affair of course with Margaret Taylor, and they'd locked him up in there to write a film script. He did *The Three Sisters,* bad film not at all his fault. I remember the caravan as very old fashioned, had a boiler; never lit it, stuffed with newspaper, and being terrified by a hornet. All my first girlfriends there too. It was nice, my wife and I stole the Taylors' punt and went miles up the river.

What about Francis Scarfe, you lodged with him?

Scarfe had some appointment in France. His wife, reputed difficult, had tenants stiff with angst with her as landlady, in the Woodstock Road. But I never met her. We much admired Scarfe because he had written at the time - 1942 - the most influential book on modern poetry - *Auden and After.* Routledge published it. It might appear feeble now but at the time was incredibly influential. Think it might have some nap still. Photographs of the forgotten 'Frederick Prokosh: An Exotic' captions. It did have a good piece on English surrealism. Because Roger Roughton had known Scarfe, gassed himself in a Dublin flat in '38 or '40. Nobody knows what he wrote now. Scarfe became a rather poor poet, but had written some charming surrealist poems,

one line being 'through the blue keyhole of my eye.' And he quite rightly selected the 'sensitive' Spender's 'Eye, gazelle delicate wanderer, drinker of the horizon's fluid line' - which is beautiful. It was a better book than Paulin or someone could produce now because it was dedicated to getting books out from shelves, reading and loving them. It's as Wordsworth said, it's no use liking a poet you've got to love him or her. And if you don't OK. But there was something of that feeling in the Scarfe; but it was still being read at the end of the decade, and early into the Fifties.

Was there a sea-change then? Douglas Jefferson of Leeds told me he thought there was. When you got back from Mallorca in 1954, for instance?

No. The Movement hadn't quite been invented. It was all John Smith, Called himself C. Busby Smith then J.C. Smith - which may have preceded the C. Busby Smith, eventually becoming John Smith. Little wizened gypsy of a man. He'd been my agent whilst I was in Mallorca. And I remember doing a review in the Statesman for Janet Adam Smith, *P.E.N. Poets for 1954.* A poem by Arthur Boyle I suggested was written at a party where you fold it then write the next line. I misquoted this and he made the most awful fuss. I also attacked Smith. He thought I'd attacked him as he'd failed to place a novel of mine in Mallorca - quite untrue. I'd failed to place it myself. He wrote asking if I had anything against him, and I replied no but maybe he should take up another trade. Very nasty, shouldn't have, but everyone agrees except Kathleen Raine, so we never mention him - she's Miranda's[139] goddaughter of course. We get on very well.

What about Drummond Allison, not mentioned in Oxford?

No, he wasn't discussed that much. Keyes was remembered. It was more contemporaries. J.B. Donne's verse was discussed or mine I'll admit. It was more 'Seymour-Smith's got some frightful thing in the *Isis* this week.' *Isis* has stopped now. We thought the *Cherwell* full of aesthetes, had a picture of a lavatory roll pinned up: 'The charge of the Light Brigade into the valley of breath.' We thought them effete, it was all great fun. Mostly became politicians, Jeremy Thorpe with a killer instinct. The son of the film critic C.A. LeJeune who'd called himself Tony Thompson until such a point as he saw his mediocrity, and changed to his mother's name. Had a thing against me. Even got up a plot at Magdalen where I was made to analyse a fabricated poet. Lost that one but got away with it. I'd been quite rude, unpleasant, but he became a Fascist and supported South Africa so I think I'd been right.

And J.C. Hall?

John as you know was my erstwhile brother in law, divorced from my wife's

sister Stella, so knew him quite well. He got caught in bed and chased naked round Baker Street Tube with a carving knife at one in the morning. Couldn't get that into his poetry, see? He tried it on with.. {}. He wrote to Douglas, but despite his veiled claims never actually met him, I don't blame him for that. Wrote two or three quite good poems. A pacifist during the war, picked potatoes with Benjamin Britten and Peter Pears etc. Francis King knew him... He, Keith Douglas and Norman Nicholson published - Staple Press - had a copy, worth thousands - *Three Oxford Poets*.

Like Eight Oxford Poets.

Which Keyes did. But Hall never met Douglas. Or Norman Nicholson, someone arranged this. John's poems were over-influenced by Hopkins. See how they bounce back in a bouquet of salt' - well that's all right for a young man. Of course his poems have scarcely been noticed more than mine... he didn't really have a sense of humour. One day when you could go down to a pub he said 'you and I Martin are not deep and cannot understand foreign literature' which annoyed me because vain I thought I could. John did a short course in the war, but couldn't come back... Simply wasn't bright enough. But produced a British Council pamphlet on Edwin Muir. He edited *Encounter* for a long time and was its Advertisement Manager, which he was very good at. He'd worked at Michael Joseph before. If he could have faced some of his impulses, to question them, might have been an interesting poet. Pompous. See?

Published by Secker and Warburg, Selected Poems 1939-84.

The last one, yes I know.

Before that, interestingly, his particular criticism of Douglas was that Douglas was pruning his long galleries of images - Douglas's own evasions perhaps, he thought in vivid pictorial metaphors - into something much more and interesting and strange. Certainly Hall was annoyed about this, prompting Douglas's letters back.

John's thing here was envy, we all suffer from it in ways we don't recognise, whether in a straight obvious form, or more obscurely - and John perhaps didn't realise.

Hall himself was clearly a very useful aversion catalyst in his rather decorative and evasive way of looking at Douglas's work - in other words he liked Douglas's early stuff because it was decorative, didn't like the later because more trenchant.

Because Douglas would have developed in a way that Hall could never

possibly have, and looked like becoming what they call a major poet. He would have been a very considerable person. He would have more highly regarded than Alun Lewis, but of course never actually achieved more. Although 'My God, the king of this country must be proud' and other lines of Douglas are very good, and individual poems - I do not think he could match, and there are other lines from Lewis - from *Orford Ness* 'the grey disturbance spreads.' There are also marvellous, tremendous lines such as: 'Tomorrow was a carton of abstraction, and in a nest of snakes he courted her.' That's the real thing, powerful, you don't get that now. I think he had sent the poem to Graves, because I always remembered until I just read it the other day again, surprised. 'Pit' replaces 'nest', I'm not sure. I think A.L. Rowse made him change 'pit' to 'nest.'

'Nest' has more sibilance, 'pit' is a bit more pithy.

I've been thinking about that. But there are other poems of Lewis, that's tremendous. *The Collected* 's come out, apart from Hamilton's. He put most of them in but Ian wanted to save him from emotion.

Well he would, wouldn't he.

Yes. But where do you match the emotive power of that? - you have to go back to Hart Crane: 'The bottom of the sea is cruel.' Yes - stunning. That's poetry you know and I don't quite find that in Douglas you see, very *near*.

Some of those first lines?

Of course he was much younger than Lewis.

Yes he only died at 24, Lewis was nearing 29. He might well have developed -

There wasn't a mark on his body. Yes, extraordinary. I've asked soldiers about that, they don't know - shrapnel goes off and nobody understands that. Awful.

Concussion? Shell went off literally above him, a down-blast.

Yes could have been fatal concussion of course. But after going through all that in the desert, then getting killed so soon in Normandy. Yes he knew he would be.

One or two other lines - 'Simplify me when I'm dead.'

Yes that *is* good. The poem too. But not quite as good as those Lewis lines, it's

more cerebral.

It's got a snarling sort of resonance which I don't think I find anywhere else, not like that, an attack I find terrific.

Yes he did have attack.

It's in a sense better than 'Vergissmeinnicht'.

The other poet Graves championed and I then read was the Canadian Bertram Warr.

Looked, can't find him. Is he good?

Graves thought so, he's not as good as Graves thought but he wrote one or two very good poems. Graves used to get a lot of poems in the war certainly from when I knew him in '43, in envelopes. He didn't regard most of it as good, which he was very sad about. Getting poems from soldiers in action, he tried to as I hope I would, write decently but try not to encourage them if he thought they'd be as he put it solicitors after the war. He was very good in those days, before the fucking *White Goddess*. But even then, he'd give you an upwards-piercing blue-eyed glance as if to say 'I know.'

I find just a few later poems marvellous. 'A Shift of Scene's replete with that disillusion, which your biography pinpointed as 'a shining sliver of the old Graves'. Riding was a fitful influence post-war, and Graves later in the Fifties. Jarrell started praising him highly in the Forties. Did the U.S. take him up earlier than here?

Slightly yes. But that was Frost. He'd had two, three American contacts, e.e. cummings praised in a limited way, more important Frost, and vitally so Ransome - who wrote to him apologising for introducing him to Riding, which rather missed the point.

I still think 'Sick Love's one of the most astonishing poems in English of the century, more in that one poem than even Hart Crane managed.

Yes - Crane's work was almost accidentally generated, written in drink, worked on after, knew his time was short. Graves always maintained Crane was hot and jumped off the ship to cool. No, you might think at most you're doing that, but of course aren't and Crane wanted to end it... Yes at Oxford Willy Willets, a Chinese expert as you know stole my Crane inscribed to Tate by Crane and given to me by Graves, and a Gertrude Stein. 'Well, you'd do the same, wouldn't you?' was his only comment. At Oxford Willy had a genuine

doppelganger we all knew; he now works in a Taxi-cab office. I trust it wasn't the bad karma he might have accrued for stealing my books; if it was, I'd do everything I could to help him off it.

Graves was then isolated, so left no particular mark on early Forties poetry. Another tributary that seems by contrast prematurely dried was the Cambridge group in the Thirties. It seems almost ignored and starved, Leavis lowering.[140]

Bronowski's *Experiment*, started with - apart from his own appalling verse, 'delineate the darkness' being the best known, a social climber who went on to write *The Ascent of Man* - Empson and John Davenport who of course drank and who quite rightly knocked your editor Miron Grindea downstairs for as you know removing Dylan Thomas manuscripts. Miron remonstrated, was preparing to go back up the stairs with his face all bloody to remonstrate with Davenport. I restrained him. It was his karma to be knocked down once by Davenport, but not twice. Looked younger then - God, was younger then. 1954. Davenport very genuinely tried to help me once, went round trying to find £100 for me in 24 hours to pay off a debt. Didn't quite manage it, but I was touched - he wasn't a likeable man, someone you'd get close to. So I was doubly touched.

On the Penguin cover of 'The King's Canary' which he wrote with Thomas he's referred to as 'once considered as one of the most promising Cambridge poets in that generation' but must have produced those parodies, the one on Empson was surely beyond Thomas.

Definitely. The others in that group are Reeves whom you'll have to hear of separately, Raine, Empson.

Other hopefuls who faded into the Forties - Clifford Dyment went nowhere and nowhere. You said he told Reeves at a party they'd both been dropped from Roberts' new edition of the 'Faber Book of Modern Verse'.

I don't know if Roberts meant to do that. I know Dyment went up to Reeves at a party, just said 'you and I have been dropped by Michael Roberts from the new edition...' and walked away. When I saw him at George Fraser's he admired Cecil Day Lewis. He thought he was a very great poet and therefore Day Lewis said Dyment was and called him Clifford. I'm afraid I asked him about the vacuum cleaners he sold as I genuinely wanted to know. He was very nice about it. There are one or two poems, I've got Dyment on those shelves, he's all right.

Died in '71 aged 57.

Don't know what of. He was a very nice man.

Those Thirties poets didn't impact on the Forties. Only one Cambridge poet, Gervase Stewart, 1919-41, Fleet Air Arm, wrote an Audenian leave train work Poem 1V, in Gardiner's The Terrible Rain . The fighter pilot (1919-40) A.N.C. Weir wrote a line which at nineteen I admired: 'flings itself silently into eternity' till I realised later he had good taste (pillaging it off Crane).

One or two you might've missed. Bernard Gutteridge? You know him. Asked Hamilton was he any good and Ian made a very good remark: 'No, interesting.'

Strange loping periodicity of verse. Not as interesting as Henry Reed, you've always thought him exceptional.

Yes. With Reed you're coming into someone quite different - just *A Map of Verona*, the *Collected* I've not yet read. He told me a lot about Hardy before my biography commission.

Reed like Allison seemed to produce a verse of suspended clauses, the syntax seeming to mimic the postponement. Unlike Douglas with his more centred clauses, with the desert as metaphor. Wrenching back to the later Cambridge poets, the Cambridge successors of the lost Gervase Stewart in the later Forties produced nothing?

No more than Oxford. At Oxford there was one man I should mention who wrote pastiche Laura Riding, don't know what happened to him. Had ginger hair and went to Africa. Pastiche can't be poetry but it was so extraordinary I had to publish it. He was the only person till Robert Nye I'd met who'd read her - when he was sixteen.

You had little success yourself in trying to persuade people at Oxford of Graves's virtues? You thought you knew those?

I thought so. Still couldn't convince them, it was arrogant. Yes. Other contemporaries were more bound up with J.B. Donne. I remember Robert saying 'your friend J.B. Donne is as a poet a dead loss do you agree?' But I liked Donne, was close to the people I was close to. With John Donne I had the famous row. He was naive and couldn't see jokes, where my irony landed him unintentionally in trouble. *{Devastating story of Donne, Seymour-Smith and a famous poet expurgated out of editorial delicacy}.* Became an expert in African sculpture. A case of private means complicating one's life.

Hill, never particularly bothered by the Movement came up then. Influences... I think Keyes did, also literary, 'the body's nationality's pure Hill, Keyes's

Arthurian and historical poems with birds. Keyes would've been at Blackwells, huge print run. But Hill was shrewd, less shrill.

Very likely, he would definitely have read Keyes. Began very ambitious, doesn't like being attacked as by Paulin. Remember admiring him, telling David Wright in the Sixties. With Tweeter and Martin Dodsworth gave him the Faber prize - there was no one else near him. I have some respect for Hill, because although I think it all comes out of books, he's been prepared to suffer a bit, and keep himself in the background. Doesn't throw his weight about, even in the TLS. He wanted to be a serious man who thought rather than was wheeled out to give celebratory lectures on Tennyson or something, like Tweeter. I was asked to write Tennyson's biography but turned it down. I think he lives in a fantasy because his life is so drab, and in some illusory future where he's a star. I invented another life for him where he could live on another planet which was more interesting. The other idea I had was, he's only an OBE, this OBE isn't quite good enough to get him a knighthood, and he wakes up in the middle of the night and thinks, 'Will I make it? and will they give it to me just a year before I die?' And I thought, give him another life and he could be knighted at the age of eight, while he's still at school. Prep school. And then they could explain, 'It's because of his last life.'

At the Faber party by the way I introduced my daughter Miranda then fifteen though looking older, to Robert Lowell saying 'this girl's never heard of you' which I thought would cheer him. His face went into a snarl of rage.

Hill and I met, having not met since glancingly at Oxford, and he'd seen my review in the *Spectator* saying 'warmth in these poems is like a sunset seen through a block of ice.' Which he sincerely loved. Before, I'd told Wright of his over-literariness. There are one or two *poems,* but it's as Reeves almost wholly unjustly said of Keats' Odes 'that's *very* great.' That angered me, but these people love poetry.

Hill's verse is overloaded.

Just a bit stiff, not quite Larkin's equal, which he'd admit - he's genuinely modest. It's just that I suppose I've a sense of humour and my sense of irony goes rather too deep.

What interested me about Hill at Oxford was his absorption of Donne's translated Neruda, Cavafy...

And Pessoa particularly. You can see why he likes Pessoa - someone else. Where you get that with that very nice Faber man Christopher Reid, he's simply playing, good though it may be it's simply not moving, no individual lines. With

Hill you do get certain lines. Despite everything, and I don't like to say this, but it's Larkin you get the best lines in.

I was interested in the refreshing ambience of some of the early Forties poets Hill drew on. Something that was no longer there later.

Not Neruda. Hill would never terrify a lawyer with a cut lily. Too shy.

Cavafy? The Cairo influence we talked of, people who brought that influence back with them.

Yes - they were sensitive to it. John Atkins, who edited *Darts* that's really 'Farts'. People were enchanted by Cavafy. Betocchi wrote a marvellous poem on him, perhaps better than Montale and Quasimodo who are marvellous. Better because such a superb generosity. Died while I wrote him a letter in a cafe, and his daughter wrote back a wonderful letter to me saying he'd died but would have loved mine.

Was Durrell read at Oxford?

Not at all. The whole thing was rather thick - Dylan Thomas was great at the time. Some didn't like him, but he was regarded by many as great. George Barker swept through Oxford and we had great fun with him. We used to talk about Gascoyne, though less at Oxford. People hadn't really read Michael Roberts's book, or if they had it was Eliot. I was very keen on a poem 'The sun is black with nails.' Liked the early Gascoyne of those three best, not really serious. His book on surrealism and journals are very interesting.

Very difficult to place Thomas still. Graves had been sent by him in '37 what he told me in '43 were 'astonishingly badly accomplished' poems - understood, typically Gravesian remark. He thought Barker's sent at the same time were better. He did like *The Hand that Signed the Paper* and *Under Milk Wood* which he thought good prose. Wrote a really gleeful, nasty satire on Thomas in 18th century couplets which went into fantasies about his life, just after his death... unpublished.

Keyes's Eight Oxford Poets was a botched attempt to disprove the Audenesque with neo-romanticism. Was Auden read much in the later Forties?

People did but the longer poems had made him simply a bore to many. We thought essentially he'd gone off, and the *Four Quartets* were discussed with great awe!! Donne did know about Borges, even then, which I didn't and some of the Latin-Americans whom you know I got very interested in later. A book on the foreign influences on English poetry would be very difficult, the Italians

to start with naturally. Graves talked of a conspiracy.

He quoted you entire Rilke's Fourth Elegy in German.

He knew Rilke very well, but wasn't going to have it.

Until the Sixties with its translation boom many wouldn't chance on poets like Celan, the Cape series et al. That's why those Oxford translations interested me. To return to the Staples Press that Hall was sheeted in.

For war poets, Nicholson's not much read, Faber poet. Yes, like Richard Murphy - *boring* . Someone's claimed W.S. Graham as one of the two or three best English poets of the century?? *The Nightfishing*'s excited and real. But... *(adjourn to pub).*

The way earlier poetry was disseminated - difficult to gauge. How the neo-romantics were touted around London, Tambimuttu and 'Poetry London' ...

Their influence still left a whiff, even in my time. You still have MacCaig, eighty-three.

Did seem to have a very strong influence on what people perceived as the mainstream poetry which afterwards the Movement people could easily attack later through the medium of Keyes - Larkin's spite.

These ideas hadn't been invented - mainstream, modernism. It's essentially 'does this book mean something to me.'

They didn't exist as terms - just a convenient label one can retrospectively adopt for it. What depresses me - why I'm writing this - is that people don't, that... Morrison can write a ... history of the Movement.

He wrote an appalling volume of verse.

Dark Glasses, '84, when I first met you in '83 I wrote a predictive parody: Martian narrative praises, mock review. Another publicist, Tambimuttu was known to Oxford -

Tambi was a key man, it was either him or Wrey Gardiner.

What was Wrey Gardiner like?

Very quiet. Frightened. His Labour M.P. backer went to jail. Fraud. *Poetry Quarterly* was Kirkup - a mixture of absolute seriousness and the ridiculous.

Because he was wrongly regarded as part of some Ackerley clique he was unfairly dismissed in the Fifties. Just returned from Japan, as Radio 3 shows. But not to be taken really seriously. Tambi who had no taste was probably better than Gardiner, but neither knew anything, were anywhere near the level of the great editors like Ford and in his own way Frank Harris. Ford in his first number of the English Review asked Hardy - who was only too glad - to contribute a poem. Before 1928 that's the first thing any real editor would do. Later - no real honour...

A difficult man to explain, Tambi. Yes like Miron, same Catholic tastes! Tambi would publish anyone, never refused or meant criminal harm. Once had a huge project, conned only banks - there to be robbed if only we could do it... very different from robbing individuals. Surrounded by people: Richard March, *The Mountain of the Ukase Tree,* totally forgotten book of short stories, Michael Swan who announced to the police he'd cut his throat; told to bugger off and did and cut it, died not long after, cared for by his nurse.

You tipped off Tambi when you were sixteen in '44 about Ern Malley's 'your pelvis explodes like a grenade' being a hoax -pace Sitwell. Tambi didn't believe you.

McAuley and friend. I've got it here. You can do that now.

You did, in '76, the skinhead genius of eleven in your Who's Who. Your editor found out. Shame.

It was. Ackroyse Bream. Celan would have to be the influence now - it's a bit difficult, bad taste, I refuse to believe he's a great poet, desiccated critics hyping 'lyric contests'. That one you told me about between him and Rilke, arranged by some fucking translator of Lukacs. One must be compassionate towards someone who takes Lukacs as their life work now; that's karma enough. No-one will ever read him again. Interesting, but....

Some lines read straight out of Trakl, his language fluttering inside the body not touching at any point like the German he wanted to sanitise. Rilke's language informs its thingness.

You're absolutely right, reads like Goll and Trakl, tragic, but no he wasn't German; absence. They're *there* on the page.

'Sanitising language' brings me deliberately to Davie and his very different Purity of Diction in the English Language. Talking to George Fraser, remembering it, puritanised then writing it parochial - sanitising as retreat.

Yes - *puritanism,* skilful, knows he's no poet - yes admits it.

I was interested in the generation ignored then, like Fraser, your friend Terence Hards - yes hit and run death like Cornelius Cardew - almost a conspiracy by some left out of Keyes's anthology! Conquest. And you very precocious, David Wright and of course X.

X was extremely interesting, Brian Higgins, Wright.

Whole sceptical grouping, Wright's scathing of government - sponsored Movementites, complacency, Sisson's pessimism - Higgins' coruscations, totally at odds with Fifties Beveridge.

I was in X, it was discussed, my anarchism was regarded as left, Tony Cronin opposed. My copy of X had Sisson's stark poems, so I wrote through George who wouldn't have gone near, to David sending three or four stark poems - 'Found on a Building Site' - instantly taken. Then commissioned for the Sisson piece, he'd been turned down by Eliot. I'd never met him. Brian said they prided themselves on my supposed rejection everywhere - hadn't tried. Then David got *Tea with Miss Stockport* published.

Very harsh critic of one's poems. And good, I don't always agree with him. He's got a soft and a hard style, knows his hard's better, just as my funny's better than my lyrical, one doesn't like it. It was nice to write for X, they were people who understood what I was trying to do. Far more individualistic, anti everybody, like my song Graucho Marx in *Duck Soup,* Whatever it is I'm Against It, the system.

So you felt your funny side more taken up. He did 'Miss Stockport'? Elective affinities.

Yes it was bound to come to an end, I'm very unrespectable which makes some people uneasy.

Fraser's critical influence, based on his poems; realism as in the Tiller and infinitely finer Douglas writings of say belly-dancers, very different to Tambi's brand. Then affinity with prose - Douglas again, Billany, Hillary? Vivid realism getting into Douglas's poems. Fraser was in the romantic 'Salamander' group, which Jefferson claimed the 'Personal Landscape' people regretted since he was more their man... you think personal preference... Jefferson said Fraser was the only man he knew who could interrupt a sentence by going out, vomiting, then return to it exactly.

True. Yes a good poet, *The Traveller Has Regrets,* 'my simple heart, bred in

tenderness' - beautiful. Yes Fraser *would* review people like John Waller! Ian Fletcher said 'no standards', Ian being utterly different, not quite as warm, poignant man. Yes better than Fletcher, I could find about six very good poems of his. Fraser was a better critic than Ian (who had better standards), but more involute.

I was interested in Fraser's isolation - no didn't know he was quite so highly regarded, or wrote for the Statesman. Even Morrison admits Davie possibly took some ideas from Fraser.

His party nights were extremely well attended, they probably invented the Movement, incredible drinking. Miron there usually, Davenport of course, Frank Kermode, Murphy. Then we read our poems and they were discussed. It began sober. That was why the 'Group' was formed - they didn't drink and all rushed out at 10 p.m. Pathetic really, George Fraser's parties were much more fun. Warmer than Ian - you met him once? He used to come. Scott-Kilvert's dead, mean. David Wright. '54-'57. Then he went to Leicester, always behind hand, conscientious, you know - Forrest-Thompson. At the end he used to quote *Little Gidding*.

Eliot's influence seems to have waned in the Thirties, then with 'Four Quartets' and the times risen in the Forties. Alvarez has noted Eliot's remarkable for leaving little poetic as opposed to critical influence.

Can't imitate the *Four Quartets*. What was disingenuous about them was his non-acknowledgement of time from Gurdjieff, later denied it. Where he'd got the rather facilely expressed versions from was straight Ouspensky. I stated this in the *Spectator* in the late Sixties, was opposed, so I replied the man must learn. James pointed out he was 86, no idea. Known Orage so probably Ouspensky. Recurrence of time. {JW} Dunne? They didn't mention that. Dunne didn't plug recurrence in his *Experiment with Time* at least. Misunderstanding of Nietzsche.

Modified romanticism brings me obliquely back to X. Charles Madge who really ran Mass Observation knew the Apocalyptics. Treece he disliked like everyone, don't know why, faded out quite rightly with children's books. Hendry went to Canada, lecturer in German and did some extremely valuable translations on Gnostic texts, marvellous. A very serious person. Fraser was there, and Nicholas Moore. Though *he* published all with Fortune - not a single real poem, 'but darling, I still remember the unpleasant warmth of your legs' held against him. Extremely interesting as George really said he was probably greater than Blake! Became a market gardener like yes composer George Lloyd.

Wanted to point out this absurd wartime Apocalypse had no surrealism, mis-

read Dylan Thomas. When *X* came out it was a return to romanticism, like Ian Hamilton's *Review* - a modified romanticism in one sense.

Yes, I began too much delineating the romantic darkness with the Audenesque but Douglas and even Allison shade into its spectrum, through to Keyes, touched with Auden.

Any young man is bound to. Unless you're a Blaga, emotions mathematicised, insane womaniser - interesting. Rumanian melancholy.

Moore and Rumania recall Dorian Cooke. Translator of Serbo-Croat, Jefferson's student. Found him Cairo lodgings. Still alive, born 1916.

I expect he's still alive, very nice man, saw him in the BBC, very keen on Krleza. Peter Riley in Cambridge's published him? - good. Ruthven Todd did drink himself. I went in '43 to the bookshop he worked in, to buy Alex Comfort's *Elegies*, been with him at school. On my asking what's it like he said 'the size of a large telephone directory'. Yes his own volumes were much slimmer, surprised you discovered Comfort's 'promising' tag as poet before the *Joy of Sex*! Ruthven early published three very good Kafkaesque novels, like Warner's who brought it off. Very amusing man, nice. Wrote a very long letter back to a short note of James's from Mallorca. Don't think his poems were any good.

Comfort I went to school with. Blew his fingers off there. Sent on a voyage at seventeen, wrote a travel book and really made his reputation. Then very young with a succession of Zola-esque novels. By the end of the war, before I left school in '46, he became a missionary - yes. He ran a magazine, *Poetry Folio*, worth a lot of money now, used a couple of my poems, critical, excellent about them. Then I met him again when writing *Fallen Women*. It's very useful being old, seeing reputations, Comfort's poetic reputation - once high. No good...

Once we were meeting up at a hotel, when he was writing *The Joy of Sex* and I was finishing the *Fallen Women*, in 1969, I asked Comfort, 'Is it cunnilingus or cuntilingus?' He said 'Don't know, I just get on with it?' Well, the hotel lobby emptied in about five minutes, except two young women who were listening intently to everything we said. One of them was Christine Keeler... But having demolished everything I made some disparaging remark about our old school, Highgate Grammar, and he the great anarchist and sexual liberator suddenly protested: 'What? Run down the old school - I'm wearing the old school tie now.' And he was.

The army distinguished us in a certain way from those who weren't in it, Amis's *My Enemy's Enemy*, almost the best thing he's done, Larkin couldn't

have, nor Wain.

Larkin's obsession with drabness, would've hated Ken Tynan's purple suits. Yes I admire his novels very much. What do you think of Larkin's correspondents?

Letters are partly determined by the sensitivity of one's correspondents, he had no one to tell him, knew very little about the world, and has been over-inflated. One has to be selective, for instance James Reeves' poems. It's a problem with some ambitious long works of this period. Yes I know you think parts of *In Parenthesis* work. When it came out, Graves said he happened to know what it was about as he was in the same regiment, but couldn't imagine others understanding it - I didn't know, being a boy, what he really thought. Jones's *Agenda* pictures are beautiful.

Thanks very much.

Interview conducted by Simon Jenner

136 Seymour-Smith won a Scholarship to St. Edmund's Hall, Oxford, and an Exhibition to Downing College, Cambridge - both to read English. Feeling that Leavis and he might not suit, and that Oxford English was Lord David Cecil, he changed to read History at Oxford.
137 Andrew Duncan in a similar interview, conducted two months later, suggests Sig Rumann.
138 This is not quite fair. See Blake Morrison, *The Movement*, OUP, 1980: 'Tradition and Belief', III, pp. 218, 232-33.
139 Eldest daughter of Martin Seymour-Smith, born 1954.
140 This is too sweeping. Certainly the later 1940s volumes of *Cambridge Poetry* need to stand in contrast to Oxford poetry. Leeds began its importance in the early 1950s.

Simon Jenner

A Language Distrusting Itself: Martin Seymour-Smith's Oxford

'Despair is not enough colon' Martin Seymour-Smith good-humouredly mocked a line of his friend W. J. Harvey, an undergraduate who after living in Japan, became one of the new Keele academics.[141] A very robust group of professional poet-critics were to fuel the later 1940s, including Seymour-Smith himself, John Wain, and Al Alvarez - in addition to such academics as Amis. In 1945, a drift back to Oxford and the anthologies was ordered by those in place. Seymour-Smith, despite himself and the ministrations of his mentor Robert Graves, was a beneficiary. You didn't go to Lord David Cecil, but to your contemporaries. Seymour-Smith characteristically denied he had any of distinction bar Alvarez. But disclaimers are not enough colon.

The second Forties generation of Oxford poets were - like the earlier group of Keith Douglas, Drummond Allison, Sidney Keyes and Larkin - remarkable too. Keyes, as David Wright points out, was 'in succession to Keith Douglas, the reigning Grand Cham of Oxford poets.'[142] Seymour-Smith remembered the aura still surrounding his name in 1948.[143] More interestingly, the William Bell-edited 1947 More Poetry from Oxford contains a florid 'Lament for a Poet'.[144] This is a memorial to Keyes by J. D. James, a fashionable undergraduate poet.

Post-war Oxford took a far more vibrant interest in foreign poetry than one might expect from Larkin's dour siftings. The precocious Christopher Middleton was not a sole European voice when servicemen and women had departed. There were several translations of Neruda, for instance, by J.B. Donne[145], in the 1948-49 Poetry from Oxford. Also interested in Borges at this time, Donne later edited his own Poetry from Oxford volume, initially with Seymour-Smith, another poet acutely aware of modernist and foreign influences, in 1951.[146] Seymour-Smith, initially and wrongly labelled an Angry Young Man, in fact by 1945 already knew many older poets, from Graves, Cameron, Empson, and Barker to (later) Wright, whose X he naturally gravitated to. Later, as he relates, Cavafy's 'laconic tenderness' was taken up at Oxford.[147] Auden in 1951 wrote a preface to one of the first volumes in translation to appear in Britain.

Seymour-Smith, sharing the next editorship with Donne, does not remember the previous Fortune editor, Williamson, though he shared the same poems too (including his own) with the next Fortune Poetry from Oxford, Robert Robinson in 1951, and himself edited the subsequent Fortune volume of 1952.

Nor did Seymour-Smith retain his half-editorship of the 1951 Blackwell volume. They squabbled over a kneeling snake in one of Seymour-Smith's poems that Donne insisted on including when the former tried to withdraw it, after Robert Graves captain-like told Seymour-Smith: 'Snakes can't *kneel*.' Refused, Seymour-Smith rushed into the office brandishing his old service revolver like a fetish, but was disarmed with mutual laughter.[148] Donne became an expert on African sculpture. Seymour-Smith who discovered snakes could in fact kneel, edited *Isis* for two years, and effected an editorial attitude to poems that to some extent recalled that of Douglas's eight years earlier on the *Cherwell* (which *Isis* mercilessly lampooned for its subsequent 'aestheticism'). The one poem he admired in any of the *Poetry from Oxford* volumes, was by John Bayley, whom Amis and Michie selected in 1949.

Seymour-Smith's poetry was terse, Gravesian, and with a gnarled lyrical drive that has baffled some readers. His influences, even in 1945, included a wide foreign range. Another vein - a humorous anarchist one, is more approachable: 'Property is theft but the dirt's your own.' ('Living by the River'). Later poetry, where he abandons regular metre, is influenced by Audiberti, 'inadvertently' Berryman in the *Reminiscences of Norma* sequence of 1971, and 'more Browning than (he) would care to admit.' Several poets - Reeves, Graves, Sisson, Robert Nye, Douglas Dunn and even Ian Hamilton, have at one or another time regarded him as one of the finest poets since 1945. Those whom the critics wish to destroy they first hope someone eulogises. In view of his total immersion in such tomes as the famous *Guide to Modern World Literature*, this seems to those who've not encountered him almost farcical, and the quantity of his output certainly never sustained any such opinion, last aired in 1971, with his *Reminiscences of Norma*. He was creatively silent between 1974 and 1982, and this, like Matthews's silence, must be factored into any reassessment - and it undoubtedly placed him on the defensive creatively thereafter. His costive reputation was matched by his printing history and eventually what he termed 'the manufacturing side of' himself, which canalised too much.

He had clearly understood the implications of 'Beowulf' which he read in the Amis/Michie *Poetry from Oxford* of 1949. His own riposte to legendary stuff is contained in 'Lancelot', which the more garrulously generous anthologist Robinson also included, together with other poems of his. (Despite a quietly imagist but Audenesque poet, Michael Baldwin, the volume makes a curious impression, because it was too generous and contained little memorable material - not perhaps Robinson's fault).

> A tall slant hero on the golden field, you're lost:
> Your shield is cast away, and you
> > Go killing everywhere, each murder fresh
> To show you are yourself the enemy;
> For no old ease or fantasy of flesh

Could equal this defeat. You are love's ghost.[149]

The self-reflexive murder, perhaps a trope of post-war poetry, reaches a kind of gnarled apotheosis in Seymour-Smith, influenced as he was by Graves; unusually, the theme persisted into his mature poetry - an extraordinary blend of continental modernism and the sly arcane. 'Green Wall my Grave' (anthologised by Reeves in 1957) is an early (1946) example of Seymour-Smith's work, recalling military service.

Green Wall my Grave[150]

The green wall to which I turn for sleep
 Has told my curse upon its shining face;
In it, true-reflected, I have seen
 The land that is my dwelling place.

'O grave, O grave, when will you let me sleep?'
 I asked all night. The wall became the sea:
My drowned past selves came up, each one alone,
 And with the quarter-striking bells, mocked me.

The firelight flickered on the wall,
 Showed me my houses known and lost;
But I was dead, and as I watched
 The bugle sounded my last post.

But in my death at last I knew
 The living of a perfect grief: again
I held my weeping love, and from her tears
 I now return, in this thin rain

To my green wall. The fire's gone out;
 The bells are cold as still they sound
The quarters to a light I wait not for
 In a dark which I have not found.

Then comes the dawn. The early trumpet
 Blows the dead fire ashes far away.
And as I sleepless grieving rise
 I realize that to-day

We storm our enemies the flowers:
 I strike them down to make my woman weep;
And with her crying still I cry
 'O grave, O grave, when will you let me sleep?'

The wall is gloss green below matt eggshell, the epitome of barrack life. Gun ranges too were so painted into the 1970s to rest the marksmens' eyes (at this

time excluding women). The Gravesian voice hardly finds room for ornamental data, as Allison termed it, and this lack of modulated half-tone, a kind of classical oracular learnt from Cameron as well as Graves, was useful as a purgative, though it purged too much of the kind of incremental detail that makes up the density of a poet. But such lines as 'a light I wait not for/In a dark which I have not found' reflect the double-bound poet, in a green twilight of his own life reading. Walls have eyes as well as ears, and the ironic inverted narcissism serves the poem well. Prematurely prophetic of death - the poem was written in November 1946, and the poet saw active service in post-war duties - it is yet another of the period's peculiarly self-reflexive poems, here on the theme of a kind of premature moral exhaustion. 'The early trumpet blows/The dead fire ashes far away' has the authenticity of a military base, and waking into it. Seymour-Smith's voice here has a tremendous forward drive towards such vital lines as 'to-day//We storm our enemies the flowers' full of an incandescent growl, a sardonic enraged tenderness. The poem addresses the past skins, the past selves being - as suggested - a trope of the writer's in his mature poetry, and which Seymour-Smith renews 'He Came to Me, My Mortal Messenger', written in 1945 at the age of 17, which James Reeves and Wright so much admired, the latter (with Heath-Stubbs) anthologising it twenty years later.[151] The poetry is spectral, haunted and recalls (especially in the fifth stanza) the tussles of Douglas's 'Bête Noire'. 'Elegy' feeds a Henry James park version of waking, the language of innocence and betrayal opening to doppelgangers with prior claims, more authentic versions of oneself, of which self is the ghost.

Elegy[152]

It was a stranger child, she says, than I
 Who loved her first. Not I, but I, he stepped
 From a dream where while she slept
He, kissing lips he thought death-white, lay by:
And thinking her a fantasy, took rest
 In caressing her cold arms. Waking,
 He fled from this dream, her breath breaking
That safe love he nursed in his breast.

I saw her wheeling by a dusk-lit lake
 A child not hers, in ordinary afternoon:
 She was an elegy for some departure, soon
To tear anatomies of love, and make
Each loathed child her own. The sunlight
 Hovered for an instant on the haunted water:
 To leave that child her dark familiar daughter
Who cries out mischief and all ruin in the night.

So moving away from all past sorrow,

Care, or joy, I follow her from to-day to to-day
In no dream, forgetting my fear of her way
Which leads to real and undreamed death tomorrow.

A Beckett-like 'Not I, but I' introduces the child that haunted himself as man, through the medium of the woman's dream, told to him later. An ambiguity - 'he was part of my dream, but then I was part of his dream, too' intensifies the Alice-effect mirrors of 'I's. The 'stranger child' has independence of thought from the dreamer, and mistakes her death-white lips and herself as a fantasy. The next stanza is odder. The man less strange one imagines than the child, watches the woman enact stinginess in a reversal of roles, wheeling a pram by a dream 'dusk-lit lake' with the child in it perhaps. Yet it's 'ordinary afternoon' and if she's 'an elegy for some departure' it seems she is about to bear a string of her selves. Her 'dark familiar daughter' she's enjoined to leave, is the multiple mirror of the strange child (who clearly isn't in the pram, though you wonder over sibling interchangeability). In essentials, the dreamt authentic child of the man is merely strange, the woman's, 'loathed', which loads the dice - the final separate quatrain a kind of waking premonition that he will wake and forget the warning. A singular fantasy on how our dreamt demons can express our essence and go hovering before us.

A more Gravesian but now individual situation asserted itself in 'All Devils Fading', an early example of a writhing conscience:

All Devils Fading[153]

All her devils here to-night,
 Duly expected: a sour mouth,
And ache in the head, and her voice
Ceaseless in anger. In blurred sight
Angels on her wall rejoice
 At a sudden end of drouth;
But here, still this blight.

There were no easy years:
 Always, in glut, a vague hunger
At spring. 'You were never divine,'
She says, 'and over your affairs
The shadows will always incline,
 Closing in. It is your anger
At nature', she says, and stares.

Why then, with her slight smile,
 All devils fading, does she give
Me her hand? and close her eyes,
Thus in her sorrow to beguile

My death. It must be she too dies,
 But with no love to forgive
Me for her own betrayal.

Seymour-Smith always resisted Graves's White Goddess, who earned expletives from him, mostly quite inventive. His addressed characters tend to the quirkily human, and to take over the poem, leaving the poet as helpless interlocutor, a decoding of disappointment not always his alone, but something, as here, taken on to lisp over. The dream-like critique 'You were never divine,' to 'It is your anger/At nature' presents a private colloquy, a kind of lover's report on her experience with his nature, not his behaviour, an almost existential dismissal. Yet the twisted compassion at the end which could so easily become conventional, Draytonesque, is slipped with the act of compassionate betrayal using up any loving forgiveness, or indeed self-love, with 'no love to forgive/Me for her own betrayal.' Seymour-Smith is as complex and penetrating about the self-doubt of love as Jennings was of its situation - and implications. Seymour-Smith like others - Anthony Thwaite later - was influenced by the clarity of her example, as well as in this poem, by the ghost days of Graves.

His occasional antagonisms towards the literary establishment ('There is no literary establishment' he once rejoined to Peter Porter) have contributed to his neglect. Porter in fact recalled that he first aroused Seymour-Smith's wrath by trying to prevent him from shouting down a far-Right poet. '"Who the hell are you?" "It doesn't matter: let him read." I was a marked man from then on.' But it was Porter who abortively recommended *Reminiscences of Norma* as a Poetry Book Choice in 1971. Seymour-Smith never knew this. And Porter never knew that the first poem was intended as a satire on Porter. Seymour-Smith would have bitterly relished that, worthy of the side of Kipling he praised in his quirky biography; something out of 'Dayspring Mishandled'. His poetry is difficult but extremely rewarding. But his comic verse most easily introduces him. 'The Administrators', appearing in *X*, memorialised certain Group personalities:

Ignore most studiously of all
The letters of refusal they have to write
To those less fortunate but still living
Whose breathing - is it? - somehow stops their pens.

Seymour-Smith's neglect among the younger mandarins becomes thus more understandable. He was his own best target, picking off opponents with the final accuracy of a literary boomerang. As ready a controversialist as Wyndham Lewis, whom he castigated for doing the same, his only real failure as he himself realised, was not always to temper his humour into the ironic tenderness his poetry captures with a tangy Mediterranean flavour.

This is appropriate to some of the musical and other themes explored in the later work. *Reminiscences of Norma* (1971) won the praise of (as we've seen) not just Peter Porter, but Ian Hamilton, Douglas Dunn, C.H. Sisson, Robert Nye and Robert Graves. At its heart is a sequence of thirteen poems as 'versions' of *Norma* in the way that Liszt transformed Bellini's 1831 opera of the same name into a seamless pianistic commentary on set arias and sunny orchestration. The poetry is uniquely disconcerting. Here, the extensive familiarity with foreign languages and poetry began to emphasise in Seymour-Smith even more than previously an alien, even awkward quality, as if he were translating himself from some strange original. The English idiom seems commensurably more remote. The diction, sardonically plain and formal, illustrates his satirical as well as amatory gifts. But this together with too many satires hardly made him the PBS Choice that Porter had so selflessly argued for - selfless because he was the butt of Seymour-Smith in *The World Guide* and elsewhere. Not surprisingly, criticism and biography, which everyone paradoxically clamoured for, canalised his energies for two decades. His later collection, appropriately entitled *Wilderness* (1994) probes erotic disquiet with even more psychological exactitude. When one of the major poems of the collection, 'The Internal Saboteur', appeared in *The Scotsman* in 1982, it was hailed as an uncanny portrayal of that state:

> I twitch and jerk on my nerves' piano wire
> A traitor to a cursed cause self-condemned,
> Nor can the obscene execution end.
> Look at the evidence of desire:
> At how I die, and die, bizarre metaphor....

The repentant Wyndham Lewis is wryly alluded to in 'self-condemned', the title of possibly his finest novel. The poet has regrets too, and memorably continues: 'If I could only hear the animal speak/I should be spared such trials, and such defeat.' 'The Internal Saboteur' is a formally stressed poem in a collection balancing a return to metre with modernist devices Seymour-Smith employed in *Reminiscences*. Satirist and terse lyricist now combine with quirky power and originality. 'Nothing' asks 'Why do I/About you dream such exact lies?' Like other poems in *Wilderness* it addresses the haunted absences in projection, or desertion as in 'Colloquies' where a bewitched friend is consoled: 'my world too is full of harrowed magic.' But 'Rachmaninov' revives a valedictory humour, beginning and ending with the composer/pianist's breakdown gesture in a tram after the disastrous 1897 premiere of his First Symphony, given by Glazunov who was drunk. So forty years later in America his hands fly up: '

> ... Though I'm a melancholy exile
> I'll more than tell you what I'm like in bed.
> And while you go on repeating the perfect truth

That my Preludes are underrated
I'll put my hands terribly to my head.

It was valedictory too. Hardly anyone noticed the volume, put out by a brave small publisher (Greenwich Exchange). Four years later he was dead. One returns to the quiddity of Seymour-Smith's poetry, like something out of the Betocchi he so admired. It almost looks translated from the Italian. His work does not look, or read in any recognisable English way, and has the wrenched awkwardness of someone writing in a tongue he distrusts.

141 Seymour-Smith, Interview, 29. 6. 93. See above.
142 Wright, *Deafness,* p.97.
143 Seymour-Smith, Interview.
144 William Bell, ed. *More Poetry from Oxford,* London, The Fortune Press, 1947. p.26. Seymour-Smith, in his Interview ironically mentions J.D. James as a leading undergraduate poet.
145 Williamson, ed: *Poetry from Oxford,* pp.15-17.
146 Seymour-Smith, Interview.
147 *ibid.*
148 *ibid.*
149 J.B. Donne, ed: *Oxford Poetry, 1951.* p.31.
150 *ibid.* pp.32-33.
151 John Heath-Stubbs and David Wright, *The Faber Book of Twentieth Century Verse,* London, Faber, 2nd ed. 1965.
152 J.B. Donne, ed: *Oxford Poetry, 1951* .p.31.
153 *ibid. p.33.*

Martin Seymour-Smith

Six Poems of 1982-94

The Internal Saboteur

I twitch and jerk on my nerves' piano wire
A traitor to a cursed cause self-condemned,
Nor can the obscene execution end.
Look at the evidence of desire:
At how I die, and die, bizarre metaphor
For my loveless effort to live more and more
And yet defeat my concupiscent part!

Corrupted conscience, could it be but heart:
Allow an unpled innocence to start.
But black duty's the internal saboteur
Determines the penalties I must incur -
Trapped in the passion of fanatic thought
I presided over that infamous court
And as I dance upon the cutting ligature
Watch myself on film, as ordered, to make sure
That I squirm justly in the eternal pure.

If I could only hear the animal speak
I should be spared such trials, and such defeat.
I could transform that stuprate saboteur
Into a friend who'd bind us all together
And make my heart into the thinking part.

My heart's a beast whose words come from my head
But as here I jounce, nothing can be said
Until this internal saboteur is dead:
Give me the grace at last to understand
The language of God's creatures at their end.
There's such divinity within their lack
as would give me my conversation back.

Being Invented You

Being invented you to test itself
And that all things went cross-grained with me
Because of it, was no issue in
Such engines (are they?) as make creatures
Of desire like you. Endearments you
Forbade, and, as well, mute attendance;
It made my ferocious rococo
Strict, as not before. Forgive me though
If in uneasy sleep I mutter
Your name; not even I shall know it.
Nor are you in my dreams what you were
In others': unvictim now, and free.

Pool of Light

The air is bewitched around my red lamp's
Pool of light
When on the wire your voice
Charged with your whole body's warmth
Whispers good night good night.

Letters

A bloody rorschach
Stains the chlorotic sky
Of this ash-written day.
Transforms my letters to you
Into a cinerous alphabet.

I do not want to challenge
Or be an I who, since its futurity
Invaded your gaze, must stand and suffer
Hundredly your infallible destiny,
Face writhing like a mirror of your pain.

My days are disabled
By my history:
How could I say
'You are my Alpha'
Without your eyes clouding over

With multifarious qualms,
Closing to shut off with smooth lids
That half-doubtful, half-enchanted look?
How much is it my unripeness
That you're not resistible
In this land of chattering dead?

Your moon is ice and my moon in water
Are the same moon. I tremble
As I remember
When I was not there:
Your grief as you watched alone
Your heart's moon broken
In the spume of waterfalls.

Don't let this chlorotic sky, or my letters,
Make you weep.
Be in your old heart entire, asleep -
Watched over not by me
But my desire to keep
You enclosed forever
In ancient undefeat.

Don't weep because I weep.

North

There are some no times
In age's north
When you can be at one
With your younger face
Gazing at firs-distant
North.
I remember my first play:
SEEN: AN AROPLAIN.
Enter: The King and Queen
Aloan.
They were flying North.

Rachmaninov

Rachmaninov put his hands terribly to his head
As he found his own First Symphony
Insupportable
And at the end of the first movement
Fled,
Spent the night on a tramcar
Shuttling backwards and forwards.
It was so garish
That his mind broke down.
But it is well known
How he was hypnotised
And returned in triumph
To compose the Second Concerto.

Now I'm Rachmaninov:
Have seen all that dazzle-in-the dark
And dark-in-the-dazzle,
Have shuffled with wrecked mind between termini,
Recovered in the sterness
Of an obdurate Russian gaze,
Rediscovered winning musical ways.

Shrunk in my furs I menace
With whistling digits
Auditoria rapturously silent
In the spirit of polite adulterous tearooms.

How do you discern my true melody?
Leave the man you were going to be guilt with,
Come to my dressing-room instead.
Though I'm a melancholy exile
I'll more than tell you what I'm like in bed.
We'll play the Isle of the Dead
And while you go on repeating the perfect truth
That my Preludes are underrated
I'll put my hands terribly to my head.

Wilderness, by Martin Seymour-Smith, is published by Greenwich Exchange.

Contributors

Notes on Contributors

Tim Allen

From Plymouth edited (with Steve Spence) ten issues of *Terrible Work,* before closing that to concentrate on the avant-garde with criticism now primarily on the Internet. Specialises in post-modern and recent American poetry, which informs his own work.

Mark Bryant

Some of Bryant's extraordinary activities as writer, compiler, editor (of e.g. Nicholas Mosley and the late Michael Meyer) cartoon judge and current PhD researcher at the university of Kent, are advertised in the last few pages. But the foregoing is quite intimidating enough.

Helen Buckingham

Lives and works in Bristol.

Rosemary Drescher

Born 1957, lives in Germany. Contributor - of a peculiarly deft and ironic lyricism, to various magazines.

Martin Droschke

Born 1972, now co-editor *Laufschrift*. See biography for details. Otherwise known for perpetrating delicate outrages on English texts.

Andrew Duncan

Born Leeds, 1956, grew up in Loughborough. studied Modern Languages and then Anglo-Saxon, Norse, and Celtic at Cambridge. worked in industry for nine years and then for the Stock Exchange, writing software, for three. Left to write poetry full time, which was followed by the traditional poverty. Books of poetry include *In a German Hotel, Cut Memories and False Commands, Sound*

Surface, Alien Skies, Pauper Estate, Switching and Main Exchange, and the forthcoming *Anxiety before Entering a Room,* new and selected poems, from Folio-Salt in Australia. Edited (1992-98) the magazine *Angel Exhaust.* Irritated by the lack of recording of modern British poetry, began a project which includes *Centre and periphery (in modern British poetry)* and *The failure of conservatism in modern British poetry,* and possibly *The order in which sounds arrive.* Learns European languages as a hobby. Has an amateur interest in Australian surf music.

Kay Early

Born 1946. Primarily known as a painter. Early's fictional writing only began in 1996, but immediately showed remarkable control and evocation in a small space; one reason she has a small one here. 'I define writers as people who go back and edit.'

Jane Fell

Writer of a haunting blend of Welsh Gothic and humour. Primarily known for short stories; no other information.

Gerald Fiebig

Born Augsburg 1973, editor *Zeitriss* since 1991. Has won awards as both poet and editor, both in Germany and Austria (Brunswick) where he recently won a prestigious literary award. Known for coining English puns and poems, both of which appear in British periodicals.

Uta Fuchs-Prestele

Born 1959, *Zeitriss* editor and contributor; lives in Augsburg and escapes it occasionally in refusing to escape it in her fiction.

Michael Hamburger

Through the offices of Sarah Smith, Michael Hamburger has kindly consented to release his early 'Elegy for Sidney Keyes'.

Martin Jack

By 28, had spent 12 years in Waitrose's supermarket; and found his way out with a recent spurt of post-Seattle poems published in *First Time, Zeitriss* (Germany) and several American journals; now at university, the real world after such cyberspace.

Jürgen Jäcklin

His biographical details accompany his work. A co-editor of *Zeitriss*.

Douglas Jefferson

Professor Jefferson kindly supplied this Statement for the editor in 1992, during his doctoral research. Born in 1912, he has had a truly distinguished career at Oxford, and Leeds Universities in his writings on poets as various as his 1940s contemporaries, and the Metaphysical line that runs through that earlier (Charles) Churchill and even Crabbe.

Simon Jenner

Editor, *Eratica*. Born Cuckfield, 1959. Since Leeds and Cambridge where the paradox of writing his PhD *Dreaming Fires: Oxford Poetry of the 1940s* was hardly lost on anyone who tried to read him. Has been trying to make it intelligible to a Pelican Niece ever since. Two volumes of poetry published in parallel English/German by *K-Tek* and *Zeitriss* respectively. His work regularly appears in Germany, and wherever a half-prestigious marginal British magazine is fully folding. Currently editing texts for Waterloo Press, and writing the biography of 1890s poet Lionel Johnson. His latest BBC commission was 'A Poem for the City of Brighton & Hove' broadcast throughout the day on 11 May 2001.

James Keery

Writer on Burns Singer and much else of the period. Probably the sharpest collector of early modernist and pre-1960s poetry. Recently picked up Joseph Macleod's *The Ecliptic* (Faber, 1930) with d/w, for £4; another scholar had to rush outside. His acumen borders on the criminal. James Keery's edition of Burns Singer's poetry will be published by Carcanet late in 2001.

David Kendall

Raised on a Yorkshire farm. Took a dislike to killing pigs at an early age, vegan and Cultural Studies at Greenwich. Tried all the usual labouring jobs. Best was four years of motorcycle despatch, worst was four weeks in a paint factory. Jumped into teaching, jumped out. Now works as Literature Development Worker for West Sussex Libraries. Stories published in magazines such as *The Edge, Subtext, BloodSongs* etc.

Martin Langanke

Born 1972, Co-editor (with Martin Droschke) *Laufschrift,* Fürth. Biographical insert tells everything but that he's steadily translating Shakespeare's Sonnets, the most ambitious attempt for decades. And that, having escaped a Prodigy Son existence, he plays Reger rather well on Bavarian organs.

Caro Rusch

Born Munich, 1958. Her poetry, translated by her twin sister, has won praise from several sources, Augsburg professors and scholars of mid-century poetry among them. Her work - wholly out of step with much contemporary German poetry - is thus about as diametrically opposed to other work included here as is possible. Regular contributor to e.g. *Fernsehen Feuilleton,* Augsburg.

Sarah Smith

Has a particularly long link with Sidney Keyes, since her father organised an exhibition and conference of his work at Keyes' old school where he was headmaster, Dartford Grammar. PhD Greenwich University, where Keyes' material had been deposited. With John Heath-Stubbs now the leading authority. *The Proud Talker, a Life and Study of Sidney Keyes* available from Waterloo Press.

Steve Spence

Lives in Plymouth. Co-editor, with Tim Allen, of *Terrible Work,* which has finally closed after ten issues. Perpetrates poetry on egg-faced fu-yung politics.

Jean Symons

Known to all the modernist magazines that have recently closed down, for good or 'but sleepeth for new editor' like *Angel Exhaust,* and *Terrible Work.*

Kathleen Walne

Discovered in the Thirties and re-discovered in the Seventies, as the enclosed article elucidates. Kathleen has generously given permission for her paintings to be reproduced here. For biographical and other details, please see said article.

Park Art

Cartoon Books

The Complete Colonel Blimp edited by Mark Bryant (Foreword by Rt. Hon. Michael Foot). The very best of Low's immortal Blimp cartoons with essays on the character by Robert Graves, V.S. Pritchett, Orwell, Churchill etc. 'A gem... brilliant' (Nicholas Garland). 192pp, over 200 B&W cartoons, 20pp Introduction by Low's biographer Prof. Colin Seymour-Ure, 155 x 234mm, £9.95

Cruel Britannia by Bryan Reading. Town and country cartoons in the first collection by Bryan Reading, from *Countryman, Private Eye, Punch* etc. 96pp, c.100 B&W cartoons, 150 x 210mm, £3.95 PB.

Dictionary of British Cartoonists & Caricaturists 1730-1980 by Mark Bryant & Simon Heneage. Unique biographical dictionary detailing life and work of over 500 artists from Hogarth to Matt. 'Wonderful' (George Melly), 'Erudite, comprehensive and elegantly witty' (Rt. Hon. Kenneth Baker), 'A splendid guide by two experts on the subject' (Rt. Hon. Michael Foot). 272pp, 150 B&W cartoons, 148 x 210mm, £29.50 HB

Don't Talk, Kiss by Enzo Apicella. A collection of cartoons on the theme of love incorporating red lipstick kisses contributed by real women. 48pp, 42 B&W (plus red) cartoons, 220 x 170mm, £5.95 HB

JON's Complete Two Types by 'JON' (Foreword by Lord Cudlipp). Classic 'Desert Rat' cartoons from World War II. 'Excellent... a feast indeed' (Cartoonists' Club of Great Britain). 192pp, over 200 B&W cartoons, 40pp Introduction by 'JON', 155 x 234mm, £9.95 PB

Larry at War by Larry. A brilliantly funny anthology of nearly 200 new cartoons on the World War II by Britain's best loved cartoonist. 'The only great silent comedian still in business' (Alan Coren). 96pp, c.200 B&W cartoons, Introduction by Larry, 148 x 210mm, £3.99 PB

Larry on Larry: My Life in Cartoons by 'Larry' with Mark Bryant. A self-portrait in
words and pictures by Britain's best-loved cartoonist. 'The only great silent comedian still in business' (Alan Coren). 128pp, 200 B&W cartoons, 245 x 185mm, £6.99 PB

Mouthfool by Enzo Apicella (Foreword by George Melly). A gourmet collection of Apicella's stylish foodie cartoons from *Private Eye, Harper's & Queen, Observer* etc. 'Very amusing' (Michel Roux). 96pp, c,100 B&W cartoons, 220 x 165mm, £5.99 HB

The Oldie Book of Cartoons chosen by Richard Ingrams. More than 200 of the very best cartoons from *The Oldie* magazine chosen by the editor Richard Ingrams. 'I grasp the *Oldie* to my wrinkled bosom every night with the utmost pleasure' (Sue Townsend). 112pp, c.200 B&W cartoons, Introduction by Richard Ingrams, 154x 234mm, £5.99 PB

A Sense of Permanence? Essays on the Art of the Cartoon. A collection of eight essays on political cartoons to celebrate the 21st anniversary of the Centre for the Study of Cartoons & Caricature at the University of Kent. Contributions by John Jensen, Ralph Steadman, Steve Bell, John Harvey, Roger Law, Kevin Kallaugher and Mark Bryant. 80pp, c.50 B&W cartoons, 205 x 205mm, £9.99 HB

Vicky's Supermac, edited by Mark Bryant. A unique anthology of the finest examples of Vicky's best known creation, 'Supermac' (Harold Macmillan) to mark the 30th anniversary of his death. 'The best cartoonist in the world' (Michael Foot). 96pp, c.180 B&W cartoons, Introduction by Michael Foot, 205 x 205mm, £9.99 HB

Order Form

For UK sales, please include £1 P&P for orders under £10 and £2 for orders under £20. Orders over £20 post free in UK. For overseas sales postage prices please contact us by phone, fax or e-mail.

Payment can only be made by cheques drawn on a British bank or by international money orders. Unfortunately credit cards cannot be accepted. Cheques should be made out to 'Park Art'.

Please send me the following books:

___ copies *Complete Colonel Blimp* @ £9.95

___ copies *Cruel Britannia* @ £3.95

___ copies *Dictionary of British Cartoonists*
 & Caricaturists 1730-1980 @ £29.50

___ copies *Don't Talk, Kiss* @ £5.95

___ copies *Jon's Two Types* @ £9.95

___ copies *Larry at War* @ £3.99

___ copies *Larry on Larry* @ £6.99

___ copies *Mouthfool* @ £5.99

___ copies *Oldie Book of Cartoons* @ £5.99

___ copies *Sense of Permanence* @ £9.99

___ copies *Vicky's Supermac* @ £9.99

Name _____

Address_____

Please make out all cheques to 'Park Art' and send your order to:

Park Art
PO Box 6026
London SW2 5XT

tel/fax: 020 7733 4744
e-mail: mark.bryant@virgin.net

... Coming in *Eratica* 2

Andrew Duncan on the Wilson era

The temptation for the historian must be to take the whole period, 1945-79, of governments striving to manage the economy in detail, draw a line round it, and scrub out all the details inside it... The Labour Party was very deeply split; Wilson's genius was expended in conjuring tricks to keep the two halves in the same party... It was because Wilson's men were marching in two different directions that he always led them in circles.

And on Rosemary Tonks

Reading Tonks made it clear how many English poets were fantastically boring yet covered this up by astute manipulation of guilt so that to admit boredom seemed heartless. Tonks reminds you that intelligence is the capacity to be bored, that is almost its first quality...

Amanda Sewell on Lorna Sage, Robert Lowell and Jonathan Raba

He read Shakespeare's ... ingly about the failure of his relationship with ... nal; his soul-mate; his other half. I wonder if ... d Raban snobbishness still managed to surfa ... ou know', he said, in shocked tones, 'her fat ... , I thought, there's still hope for me.

Colin Wilson on Robert Graves

Conversation - as always between two writers meeting for the first time - was cautious, like two boxers sizing one another up. I asked him about T.E. Lawrence, and he was distinctly unforthcoming... So we moved cautiously over the cliff-face, perhaps ten feet above the rocks. It quickly dawned on me that this was a test... But as we clambered up the beach, he turned round and slapped me on the shoulder. 'You'll do'. I knew I had passed.

Nick Burbridge on Jethro Tull

The actual Tull set was incomparable. The man himself, in tattered frock coat and leggings, twirling his flute in the lights while he pranced and postured like a demented pelican, performing an extraordinary concatenation of vocal and instrumental sounds, was mesmeric...

Design &
Typesetting

TRISTAN GREEN DESIGN

SUITE 4 50 GRAND PARADE BRIGHTON E. SUSSEX BN2 2QA
T/F: 01273 602988 M: 07980 271563
E: tristan.green@virgin.net